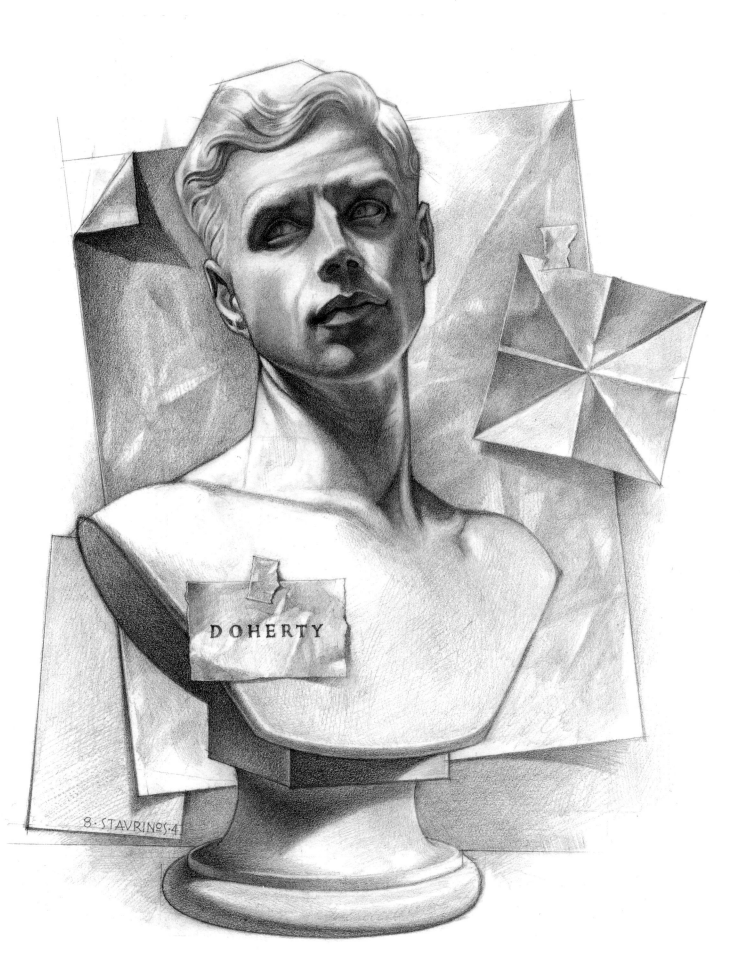

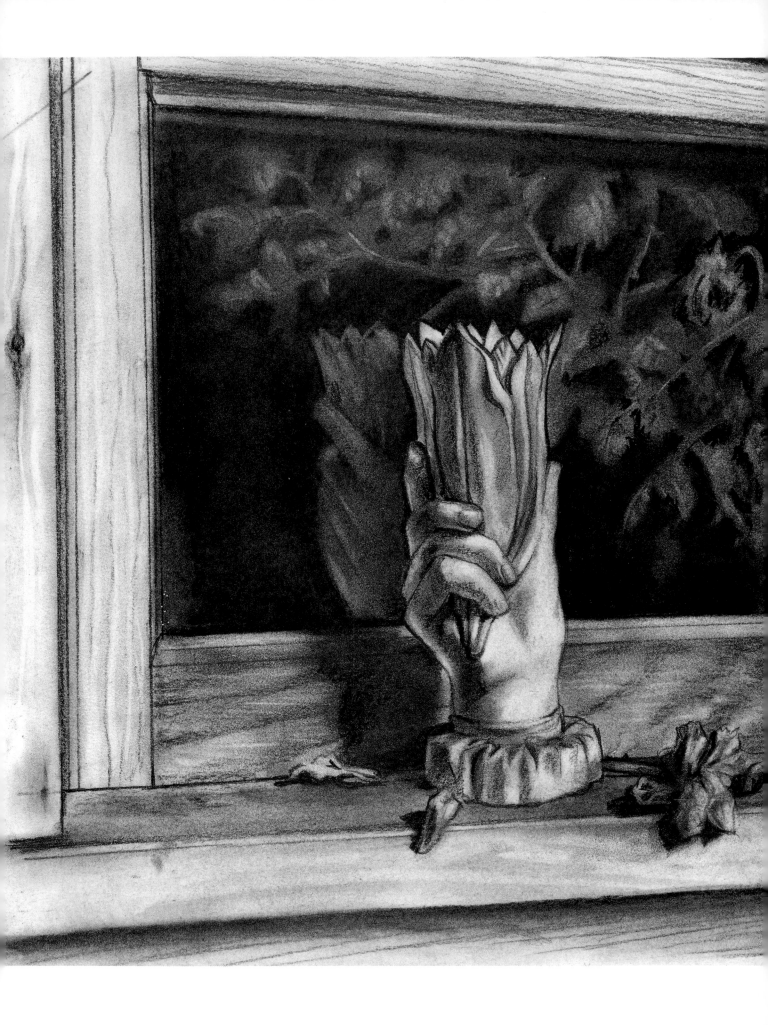

DEVELOPING IDEAS IN ARTWORK

M. STEPHEN DOHERTY

WATSON-GUPTILL PUBLICATIONS/NEW YORK

(Page 1)
PORTRAIT OF M. STEPHEN DOHERTY,
by George Stavrinos, 1984.
Pencil 9″ × 11″ (22.9 × 27.9 cm).
Collection of M. Stephen Doherty.

(Pages 2–3)
STILL LIFE WITH VASE,
by M. Stephen Doherty, 1986.
Charcoal, 14″ × 17″ (35.6 × 43.2 cm).
Collection of the artist.

Edited by Brigid A. Mast
Designed by Bob Fillie
Graphic production by Ellen Greene

First published 1988 in the United States and Canada by Watson-Guptill Publications, a division of Billboard Publications, Inc., 1515 Broadway, New York, N.Y. 10036

Library of Congress Cataloging-in-Publication Data
Doherty, M. Stephen.
 Developing ideas in artwork / by M. Stephen Doherty.
 p. cm.
 Includes index.
 ISBN 0-8230-1329-4
 1. Art—Technique. I. Title
 N7430.D64 1988 88-11946
 750′ .28—dc19 CIP

Distributed in the United Kingdom by Phaidon Press Ltd., Littlegate House, St. Ebbe's St., Oxford

Manufactured in Japan.

First Printing, 1988

1 2 3 4 5 6 7 8 9 / 93 92 91 90 89 88

CONTENTS

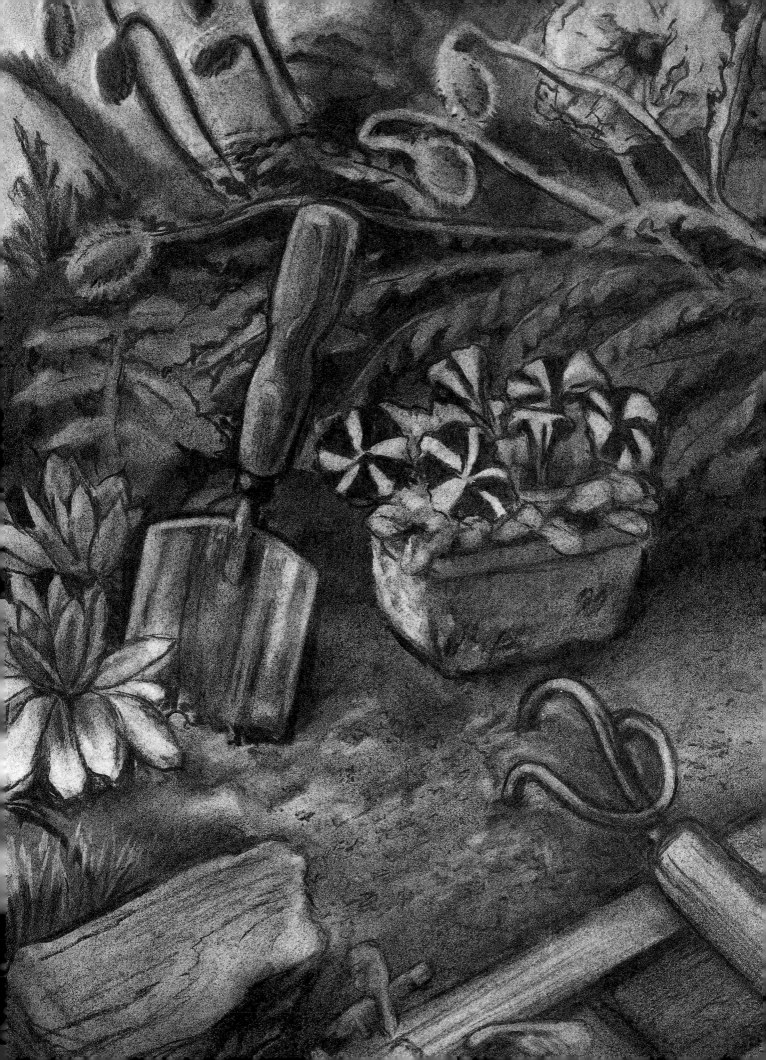

INTRODUCTION

The Need to Grow as an Artist

Many people beginning their involvement in art are searching for a way to recreate on canvas or paper some specific and emotionally charged image. They want to be able to paint an imagined subject or recreate a picture they saw in a museum. They felt a strong emotional response to the face of that sleeping child or that Andrew Wyeth painting and they want to express their feeling to others in their own painting.

A budding artist soon confronts two unexpected situations. The first is the recognition that in order to make a picture, he or she has to spend a fair amount of time just learning to use brush and paint. The second is the realization that copying someone else's picture or snapshot is not quite as satisfying to the artist or to those who view the paintings as he or she had expected.

Once the novice painter accepts these realizations, he or she is ready to begin searching for images that will have greater significance both for themselves and for those who view his or her pictures, and the artist will identify a medium and style that facilitate the presentation of those images.

Unfortunately, many artists are persuaded to adopt a certain medium and style to the exclusion of all others. They study with someone who believes oil painting is the most important medium, so they are never encouraged to try any other, or they work in a studio where everyone is painting still lifes illuminated by north light, so they never explore a broader range of subjects or lighting situations. Before long they become experts at presenting a variation on the accepted theme and have no hope of discovering a truly unique point of view.

Many art books, television programs, and magazines have also encouraged artists to follow a formula approach to using materials and presenting subject matter. Having worked in the art publishing field for nearly ten years, I am as familiar with those approaches as anyone could be. I have seen the demonstrations of the "correct" way to paint a tree, for example, and I have read the tips for getting "magical" results from watercolors. These demonstrations always appeal to those looking for an easy way of making a picture—preferably a picture that meets the expectations of the greatest number of people.

The thoughtful person will see the weakness in all of these approaches to art instruction. The teacher insisting on oil paint and the television personality making magic paintings are both ignoring the needs of the individual who is watching them. What they should be saying is: "I learned how to use art materials and now I paint or draw a certain way. Your task is to gain a similar understanding and then make your own pictures."

This book is dedicated to the proposition that the search just described is one that never ends. Artists must always pursue new ideas, restatements of old ideas, or clever ways of expressing either. The need exists because neither the artist nor the audience can be satisfied having only what has been done before. The considerations of content and materials are ever present, therefore, and an artist must constantly reevaluate the images being created in his or her artwork and the manner in which they are being presented.

The material that follows has been organized in a way that will, I hope, stimulate and direct your search for those new ideas and means of expression.

GARDEN STILL LIFE

by M. Stephen Doherty, 1987. Charcoal, 10¼″ × 14″ (26.0 × 35.6 cm). Collection of the artist.

I tried developing a charcoal drawing of a section of my garden in much the same way that I had been making drawings and paintings of still-life objects set up indoors. I looked for shapes that would work together in a composition, moving the tools around until everything was in balance and then sketched in the shape of each object.

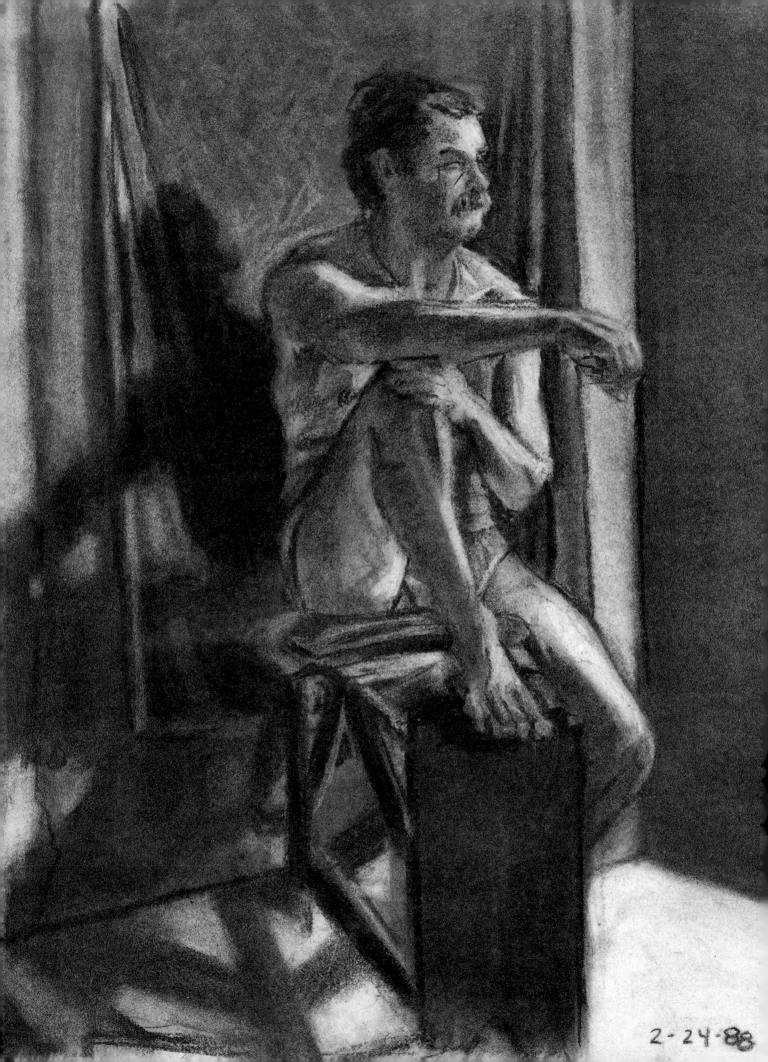

2-24-88

DRAWING

The Laboratory for all Media

Unless your education as an artist includes an extensive study of the history of art, or unless you had the benefit of studying with someone who received what is known as classical training as an artist, it may come as a surprise to learn that until the late 1940s and early 1950s it was mandatory for an artist to spend thousands of hours drawing from live models and plaster casts of classical sculptures, copying the works of the old masters, and otherwise engaging in skill-building exercises. Before a student learned to be a sculptor, a printmaker, or a painter, he or she would have to become proficient in drawing and also have an expert knowledge of the human anatomy and of linear perspective. Even modernists like Paul Cézanne, Pablo Picasso, and Henri Matisse—artists whose styles might suggest they were not educated according to this tradition—received a highly disciplined education.

Only in recent years have art schools either eliminated or reduced the importance of courses in materials and techniques, anatomy, perspective, art history, and drawing. Indeed, many professors today believe there is something inherently wrong with expecting a student to develop skills and gain a thorough knowledge of the practical information he or she might use in making artwork.

As a result of this laissez-faire attitude, many artists who attended art schools in the 1960s and later, left with the feeling that they were deficient in both their awareness and their ability as artists. Consequently, many of those individuals have made an effort to return to the skill-building process of drawing on a regular basis and using drawings as a way of establishing and communicating their ideas.

The process of making drawings helps keep the mind and hand working together to control the appearance of a developing image, and it allows the artist to literally push and shove at a picture until it seems satisfactory. The exercise might be compared to what a writer does when scribbling ideas on a restaurant napkin or what a musician does when sounding out disconnected chords on a piano. The activity may only have significance to the creative person undertaking the exercise, but it can be an essential part of the communication process.

The first section of this chapter shows some of the drawing instruments and surfaces that are available to the artist. Examples of different techniques will be presented, as well as demonstrations of how these materials might be used to develop images. Drawings in the various media by a number of artists will also be included.

The drawings that are described and demonstrated in the following sections include those made in preparation for other works of art and those that are done as finished works. Preparatory drawings are studies artists make in trying to establish, refine, and resolve an image that will ultimately be recreated in paint, ink, or sculptural material. The drawing may be as indecipherable as an exercise drawing or as detailed as the finished work. It may be laid out under or over a grid pattern, covered with smears of color, or carefully preserved in a French mat, but it informs us about the creative process itself and reveals the thought processes that ultimately lead to the more complete picture.

The second section of this chapter offers some specific suggestions for those who want to employ preparatory drawings in their own creative process. A caution is also expressed that there are times when it is advisable not to define a composition so carefully as to reduce the act of painting to nothing more than a process of filling in the spaces defined by a preparatory drawing. An artist should not, of course, allow formula or habit to get in the way of creative thinking.

The quality of a drawing is not defined solely by the way in which it serves as an exercise or prepares for later paintings; it can also be considered a work of art by itself. A drawing may express a completely independent idea, one that is best realized in a medium as direct and simple as charcoal or graphite. In the third section of this discussion on approaches to drawing, a number of pictures that were conceived of by the artists as independent works of art will be presented.

FIGURE STUDY

by M. Stephen Doherty, 1988. Charcoal, 15″ × 11″ (38.1 × 27.9 cm). Collection of the artist.

This drawing was done during a visit to the American Academy of Art in Chicago. Since I usually travel with some basic drawing materials, I was able to sit in on a two-hour class. I drew this with sticks of General Pencil's willow charcoal on a sheet of Rising Stonehenge paper.

Drawing Materials and Techniques

Most artists consider drawings to be those black-and-white pictures they make with pencils, charcoal, or ink on paper. Colored pencils and pastels are used less frequently but are also labeled drawing media, though in recent years pastelists have campaigned to have their works classified as paintings. Nevertheless, there seems to be a general understanding among artists that if they sign up for a drawing class or join a sketch group, they will be working with paper; pencils or a few sticks of charcoal; and several different kinds of erasers.

Among museum curators and private collectors, however, almost any unique work of art executed on paper is considered a drawing. Pictures made with watercolors, pastels, or acrylics on paper would be submitted to the curator of drawings if they were offered to a museum for acquisition. This reasoning is based on historic precedent because many artists of the past made their drawings with impermanent materials in preparation for more important oil paintings. The fact that artists today use quality materials and consider their drawings to be independent expressions has had only a slight impact on curators and collectors.

This somewhat antiquated definition of drawing does allow artists the latitude to employ a wide range of materials, but it also has the effect of categorizing pictures made in almost every medium except oil paint as second-class works of art. Since this book is concerned with the development of ideas, not the definition of a museum collection, there is no point in pursuing this debate further. Suffice it to say that while artists have always considered drawing to be an essential part of their creative expression, there is a certain prejudice against it because of the materials employed.

When you ask professional artists why they choose to work with certain drawing tools, they will often give you the accurate but indefinite answer: "It feels good when I am working with it." Over the next few pages of this chapter, we will examine why a variety of drawing materials might "feel good" to an artist. To accomplish that, we will examine the size, shape, and weight of each tool, the ways in which it makes marks on a page, and the color, intensity, and sharpness of those marks. We will also see how the tool responds to various drawing surfaces.

GRAPHITE AND CARBON PENCILS

While not the oldest drawing materials employed by artists, graphite and carbon drawing pencils are now the most accessible tools available for making marks on paper. Everyone has a yellow no. 2 pencil or a mechanical pencil in his or her pocket, purse, or desk drawer and uses it all the time to draw maps, doodle, or sketch fleeting images.

Artists, designers, architects, and engineers use these slivers of graphite or carbon encased in a wooden holder or slipped into a mechanical pencil to make lines that are light in value and easy to erase. The marks don't smear as easily as those made by other drawing materials, and neither graphite nor carbon resists paints that might be applied over it. A watercolorist can obliterate preliminary pencil lines with paint, and a drafter can erase pencil guidelines once permanent ink lines have been drawn.

There are very few drawing instruments made today that are actually made with lead. Most contain shafts that are made by combining particles of graphite with clay or other binders and compressing the mixture into a specific shape. The more binding material added to the mixture, the harder the resulting drawing instrument.

Graphite is a pure form of carbon, so pencils identified as being made of carbon, such as Wolff's carbon pencils, produce lines that look quite similar to those identified as graphite, or general layout pencils.

Hardness and Softness. An artist should become familiar with the number and letter scale used by almost all manufacturers of graphite pencils to indicate the relative hardness and softness of the leads. Likewise, it is useful to have a sense of how a pencil feels as the graphite is being drawn across a sheet of paper. The very soft leads will make dark marks, even when little pressure is applied to the lead, that quickly broaden out as the point grows duller. Extremely hard leads, on the other hand, will make light gray marks and will hold a sharp edge that cuts into the surface of the paper. The relationship between the pressure applied, the darkness and blackness of the marks, and the width of the marks will change accordingly as the numbers change.

The scale of those numbers might be thought of as a continuum with the softest lead, 8B, on the far left and the hardest lead, 8H, on the far right. The numbers progress, from left to right, as follows: 8B, 7B, 6B, 5B, 4B, 3B, 2B, B, F, HB, H, 2H, 3H, 4H, 5H, 6H, 7H, 8H. Some manufacturers will use another, shorter scale of 1 to 4, with 1 being the softest lead. It's helpful to buy a half-dozen pencils from across the full range available to understand how each of them might be used in making a drawing.

MIKE
by Kent Bellows, 1987.
Graphite, 20¼" × 16¼" (51.4 × 41.3 cm).
Private collection. Photo courtesy of
Tatistcheff Gallery, New York.

This reproduction only begins to suggest the extraordinarily rich and detailed graphite drawings being made by Nebraska artist Kent Bellows. Working from photographs and sketches, the artist uses the variable medium to create stark images of nude and clothed figures, often using himself and his neighbors as models. Other drawing or painting materials would perhaps suggest more warmth than the artist wants to allow in his depictions of human forms. The graphite is, by its very nature, sharp, precise, and linear.

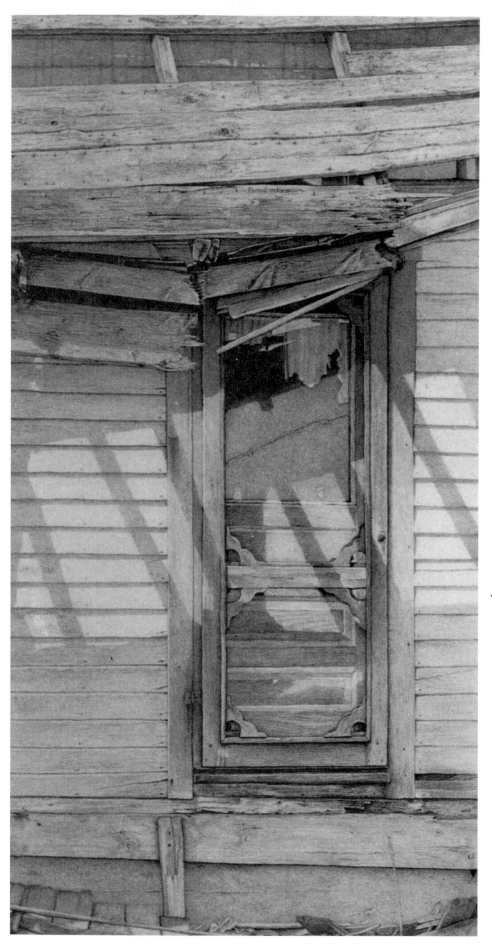

ESCANABA

by Toni Herrick, 1984.
Graphite, 8″ × 4″ (20.3 × 10.2 cm).
Collection of the artist.
Photo: Eeva-Inkeri.

"When I see an abandoned house, I think of nature's continuance after mankind's brief claim on the land," says Toni Herrick of Southampton, New York. Beginning with photographs of the doors, windows, and facades of these abandoned structures, Herrick spends from three months to a year developing her small graphite interpretations.

The precision of graphite, especially when used to combine or interpret photographic images, lends itself to this kind of straightforward presentation of the world. By bringing the viewer close to her small drawings and having him or her look directly at the decaying architectural forms, Herrick expresses her ideas quite clearly.

STANBERRY, MO #2

by Toni Herrick, 1980.
Pencil, 6¾" × 7"
(17.2 × 17.8 cm).
Private collection.
Photo: Eeva-Inkeri.

STANBERRY, MO #3

by Toni Herrick, 1980.
Pencil, 8" × 5" (20.3 × 12.7 cm).
Collection of Carole Harrison.
Photo: Eeva-Inkeri.

CHARCOAL STICKS AND PENCILS

Charcoal is a drawing medium particularly well suited to the development of images for other media because an artist can readily work with both line and value. Graphite pencils, by comparison, are generally used to make either lines or tones built up by laying in parallel lines. Charcoal can be applied with the broad side of the stick, smeared with fingers or a stump, or drawn in sharp lines. Because the particles of charcoal tend not to bind to the fibers of the paper to which they are applied, an artist can remove lines or tones quite easily and thus approximate what will occur during the painting process. Obviously the artist is not dealing with the critical component of color, but in most other respects charcoal can serve as an easy transition to oil, watercolor, acrylic, or other painting media and is perfectly suited to developing ideas for graphic media like etching, engraving, and lithography, where images are traditionally black and white.

Charcoal is thought to be the oldest drawing medium. Prehistoric artists used the charred wood from their fires to make marks on the cave walls. The instrument has changed little over the centuries; charcoal drawing materials are still made with the charred remains of burned wood. Today, charcoal is made in vacuum-sealed ovens that carefully control the burning process.

In making their preparatory drawings or laying in the first outlines of an image on canvas, artists of preceding centuries used irregular sticks of charcoal made from either vines or willow branches. These are still widely used and are available to artists in six-inch lengths boxed in cardboard or plastic containers. The sticks are quite brittle and, because of their irregular shape, somewhat awkward to handle, but the softness of the charcoal makes them suitable for drawing bold lines or smearing in large areas with a uniform gray tone. The willow sticks are straighter and more solid than the vine sticks and usually come packed in different widths. The degree of hardness and softness does not tend to vary much with either of these kinds of sticks because no other materials are added to the charcoal.

Compressed charcoal pencils and sticks are made by mixing particles of charcoal with a binder, usually clay, and then compressing the material into a round or square-sided stick. The more clay that is added, the harder the drawing instrument. Charcoal pencils are rated on the same scale as graphite pencils, but the material itself makes it impossible to produce a comparably hard pencil. For that reason, the range of charcoal pencils is limited, starting with HB for the hardest through a medium 2B, a soft 4B, and an extra-soft 6B. Sticks of compressed charcoal—that is, compressed charcoal without a wooden casing—are rated according to the same scale.

Techniques and Applications of Charcoal

All eight of these illustrations were drawn from the same daffodil to show how the use of the materials and techniques would affect the resulting images. It is easier to consider the variations in the drawings if the subject remains constant. The drawings on these two pages were made with various charcoal sticks and pencils.

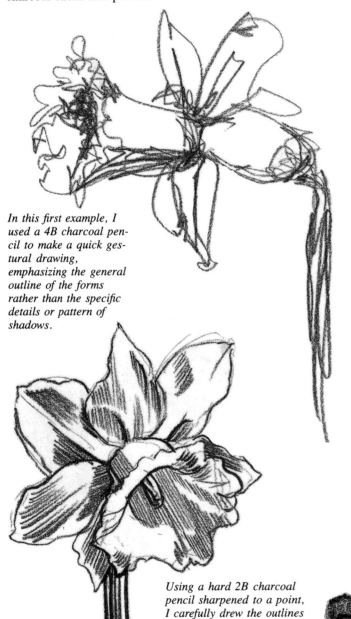

In this first example, I used a 4B charcoal pencil to make a quick gestural drawing, emphasizing the general outline of the forms rather than the specific details or pattern of shadows.

For this presentation, I used a softer 6B charcoal pencil to draw only the outline of the petals and stem of the flower, something that might be done as a preliminary stage in the development of an oil painting. I rubbed a bit of charcoal into the shadow areas, using a stick of soft charcoal, then rubbed that with my finger in the direction of the lighter areas.

At this point I began to think less about the outline and more about the volumes of the shapes I was observing. I thought of the interior of the blossom as one gray shape, and the side of the trumpetlike form as the intersection of two planes of space. Those observations called for broader strokes, made with a stick of medium charcoal about a quarter of an inch in diameter.

Using a hard 2B charcoal pencil sharpened to a point, I carefully drew the outlines of the petals and stem and established the pattern of shadows with parallel lines. Each of these lines was started in the area of darkest shadow and quickly drawn out in the direction of the light, reducing the pressure on the pencil as the line got longer so that it would become thinner. A few of the darkest lines were drawn with a 4B charcoal pencil.

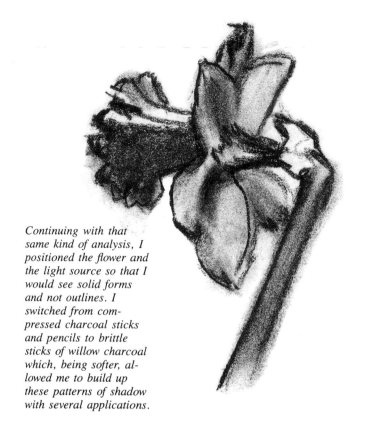

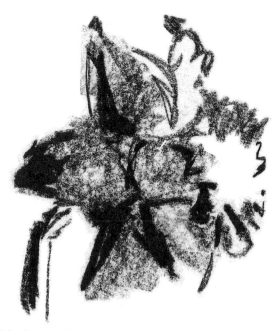

Continuing with that same kind of analysis, I positioned the flower and the light source so that I would see solid forms and not outlines. I switched from compressed charcoal sticks and pencils to brittle sticks of willow charcoal which, being softer, allowed me to build up these patterns of shadow with several applications.

I broke a stick of compressed charcoal so that I had a piece about one inch long and a quarter of an inch thick and drew the outline of the flower with the sharp edges of the charcoal and the solid forms with the broad side. I liked the pattern established by the hard charcoal riding across the surface of the paper, so I left it alone.

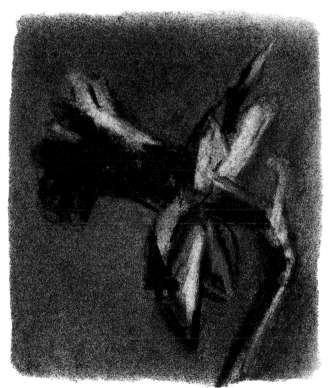

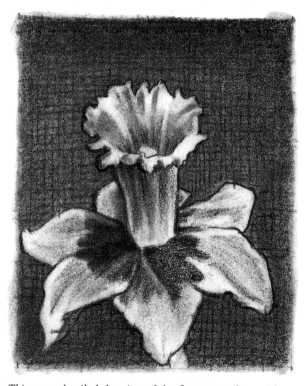

Going back to the willow charcoal, I filled a rectangular shape on the paper with random marks, then smoothed them out with a chamois cloth. Next, I "drew" the brightest areas of the daffodil by lifting charcoal off the page with a kneaded eraser. Then I added the dark shapes with another application of willow charcoal.

This more detailed drawing of the flower was done with three charcoal pencils, 2B, 4B, and 6B, used in that order. A light drawing established the image on the page, the 4B pencil allowed me to carefully record the medium-range shadow, and the soft 6B was used for both the dark edges and the deepest shadows I was observing. To emphasize the bright, soft appearance of the flower, I added a gray background with a gridlike pattern of lines applied with heavy pressure at the top and lighter pressure along the bottom.

Demonstration

DRAWING WITH CHARCOAL

In order to demonstrate some basic uses of charcoal in making a drawing, I selected three objects with very different shapes and surfaces for this still-life setup. The vase has a solid, geometric form with a shiny surface; the towel has a billowing, soft appearance; and the sprig of ivy has a flowing, linear character, with leaves that catch fragments of light. The objects form a composition that is simple yet calls for control of the drawing medium.

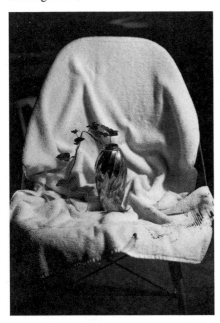

I held my drawing paper upright when working on the early stages of the drawing so the plane of the image would be parallel to my plane of vision of the still-life objects. That is, I didn't want the drawing to become distorted because I was looking at it at an angle. As I became more concerned with details and wanted to control the particles of charcoal, I lowered the drawing surface.

The folds of the towel were adjusted so that the lines would serve as a counterpoint to the movement of the facets of the vase and the line of the ivy. The light source was positioned at the upper right of the arrangement to accentuate those folds. I wanted to throw a highlight on the ivy leaves resting on the towel so that they would become more prominent, but that was difficult to do without spoiling the pattern of cast shadows. I decided to exaggerate these highlights in the drawing to achieve the desired effect.

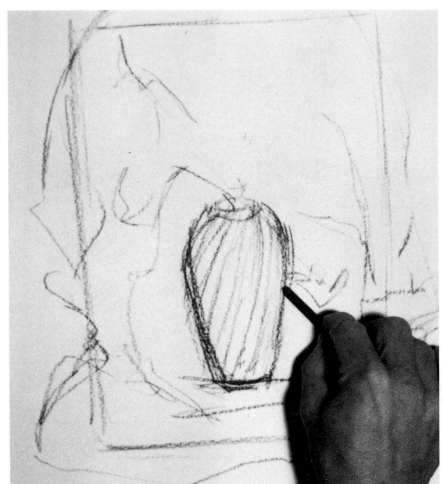

1

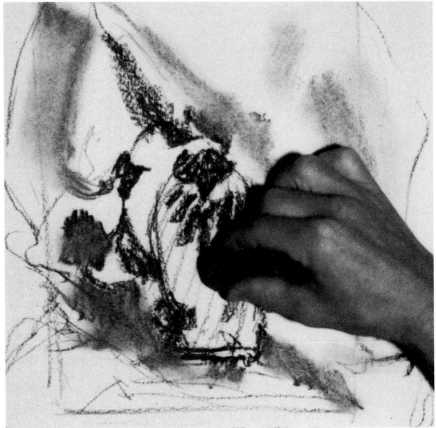

2

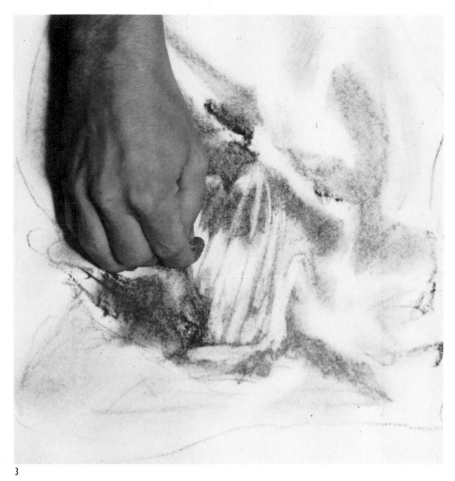

3

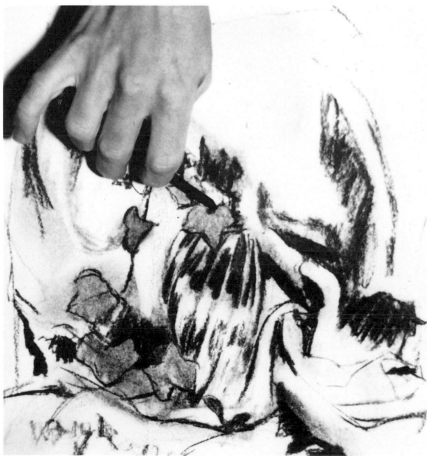

4

1 Using a stick of willow charcoal held loosely with the tips of my fingers, I lightly sketched in the general shapes of the objects and their shadows. At the point shown in the photograph, I had begun to resolve the shapes in the vase. I was still trying not to make tight, detailed lines because I knew that I would later rub out much of what I had drawn at this early stage.

I blocked in the drawing and made decisions about the dark and light values within the total composition, as well as the patterns of charcoal that would appear as metal, fabric, and plant life. Any shapes that would be brilliant white in the finished drawing were not covered with charcoal at all since some particles of the material would imbed themselves in the fibers of the paper and could not be erased, making it impossible to get that clean white shape.

2 As a way of building gray tones in the drawing, I scribbled the willow charcoal into a general area and rubbed it with a piece of cotton cloth, repeating the procedure until I had the tone I wanted. What was happening, of course, was that the fibers of the paper were gradually filling up with particles of charcoal. The results depend on several factors: the density of the charcoal used; the manner in which the charcoal is smeared around with a cloth, finger, or stump; and the physical characteristics of the paper being used.

In this demonstration I used soft willow charcoal, which lifts off the page quite easily. The cotton cloth was one I used quite frequently, so it lifted off less charcoal than a clean rag or finger but more than a stump. The paper was a sheet of Rising Stonehenge taken from a 14" × 17" pad of the white, acid-free paper. The physical properties of paper will be discussed more completely in the section on watercolor, but for now I should establish that this paper has a modest amount of sizing for a drawing paper and therefore allows the fibers of the paper to hold a fair amount of charcoal.

3 Even though the drawing was quite light in value at this point, I wanted to clean up the edges of some shapes and keep particles of charcoal from blowing over into the areas I was trying to keep pure white. To do that, I used a kneaded eraser, pulling it until it had a pliable consistency and folding it over to make a sharp edge that I could run along the border of a clean area.

When you work with a kneaded eraser, some of the particles of charcoal lifted from a drawing will transfer to your fingers as you "knead" the gray material, and others will remain buried in the eraser. You'll find it necessary to wash

your hands frequently as you work with the material, and eventually you'll have to replace the eraser because it becomes brittle and inadequate for lifting any drawing material.

4 I applied the second and third layers of charcoal using a thin stick of willow, rubbing the particles into the fibers of the paper after each application. The more control I wanted in applying the charcoal, the smaller the stump I used to rub the charcoal. I applied the charcoal in the darkest areas of shadow and then smoothed the particles in the direction of the shadow, toward the light, so that there would be a gradual transition between dark and light passages.

5 I needed darker, thinner lines to establish the edges of important shapes and intensify certain passages of shadow, so I switched from willow charcoal to three General Pencil charcoal drawing pencils rated 6B, 4B, and 2B. For the most intense blacks, I used the 6B; for middle-range shadows, the 4B; and for the sharp lines and details, the 2B.

While the 2B and 4B pencils can be carefully prepared with a mechanical pencil sharpener, the 6B must be sharpened with an instrument less likely to break the point. I use an X-Acto knife or a single-edged razor blade, cutting away from myself as I shave the pieces of wood casing into a garbage can.

6 At this point I used the charcoal pencil to exaggerate the degree of contrast between the leaves and the towel behind them so that the viewer would find it easier to distinguish those forms. Note the rich surface texture that develops in a charcoal drawing.

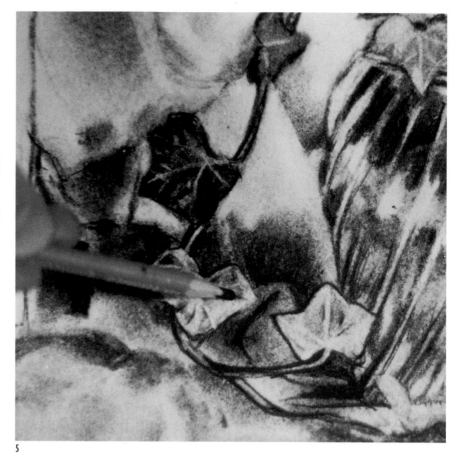

5

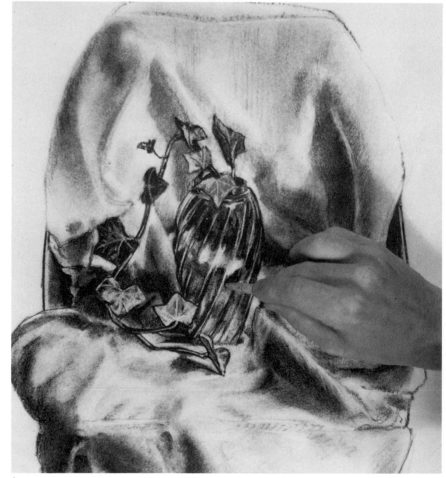

6

18

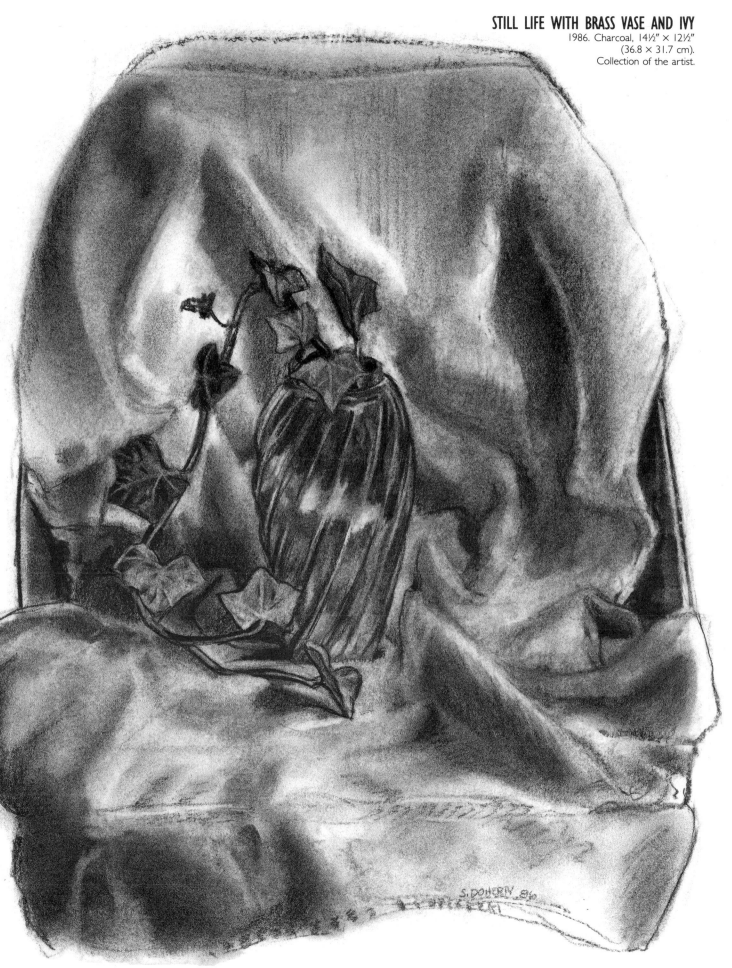

S. DOHERTY 86

Demonstration

DRAWING A PORTRAIT IN CHARCOAL

Robert Speller, a studio model and manager of the models department at an art school in New York, posed for this demonstration of how the same charcoal drawing materials just described can be used for a portrait drawing. Because the techniques are basically the same, the demonstration will be confined to a few steps, with the emphasis on how the shapes were established rather than how the charcoal was applied to the paper.

Drawing someone's face can be one of the most difficult tasks an artist can undertake because of two factors. The first is that everyone who knows the artist's subject personally has a well-formed conception of what that person looks like, and that concept is often quite different from the way the person may actually appear to the artist at any one time. The other problem is that artists are influenced by *what they know* rather than *what they actually see*.

To solve the first of these two problems—the conception of how someone appears—an artist needs to find the best pose, lighting situation, and environment that present the sitter in a way that is familiar to people. For example, a good portrait painter will select the clothing, room setting, posture, and lighting that best reflect the client's personality and/or position of importance.

The second common problem has to do with the different functions of the brain. One hemisphere tells the artist that a face has two eyes, one nose, two ears, and one mouth, and each of those parts is placed in a standard position on an egg-shaped form. Under the influence of that side of the brain, the artist is inclined to draw two eyes that are mirror images of each other, two lines leading down to evenly spaced nostrils that are quite prominent, and an almond-shaped mouth, outlined with strong lines, resting below these forms. Look at almost any child's drawing and you'll see exactly what we all *know* about the human face. Look at your own first attempts at the same subject and you'll see that you were giving in to the urge to show the face staring out from the page with hard, clearly outlined features.

The answer to the problem is to put the other side of your brain in control of the hand drawing the face. Analyze what is in front of you as if it were an inanimate form with protrusions, crevices, and varied textures. Let your eye move from one

shape to the other as if it were sizing up boxes stacked on top of one another, each with a distinct shape, each connected to the next. You will then come to the startling realization that some parts of the face are defined by the outlines of their forms while others exist as the negative spaces between darker forms. Instead of drawing the bottom lip, you discover that you should draw the shapes around it. Instead of drawing both sides of the nose, you need only define it with a dark cast shadow and a highlight on the tip.

This approach is actually one that applies to making a drawing of any subject, but it seems that people are less apt to rely on objectively observable facts when drawing a face than they are with any other subject. Other forms are perhaps less familiar, or less often scrutinized, so artists are more likely to analyze what the eyes are observing.

I'll try to demonstrate how that kind of analysis can be made in describing my drawing of Robert Speller.

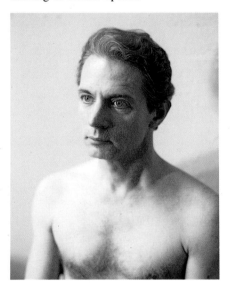

No matter how skilled a model may be, it is impossible for anyone to hold a pose perfectly for an extended period of time, and for that reason it's advisable to concentrate on the most important areas of the drawing when the model is feeling fresh and relaxed, saving less important details like hair, clothing, or background till those times when the model becomes fatigued and needs to take frequent breaks. That's why I didn't draw Robert's hair, neck, and shoulders until the later stages of the drawing.

I worked on the drawing standing up, facing the pad of paper, which was propped up on a painting easel. This reduces the likelihood of the distortion that often occurs when the paper is tilted away from my plane of vision. Furthermore, I tend to draw with larger motions of my whole arm when the paper is vertical. The only disadvantages I can see in this approach are that particles of

charcoal fall down across the drawing and that it is awkward to draw careful lines and small details when I'm not able to rest my hand on something. Both of these problems can be easily corrected, of course, by covering the lower portion of the drawing paper with tissue and resting your arm on a maulstick.

I usually try to work from left to right and from top to bottom when making this kind of drawing because that procedure allows me to clearly see the marks I've already made and prevents me from smudging those lines. I wouldn't want to start at the very top of the hair, however, because there aren't enough distinct and measurable shapes to allow for an accurate record of the subject. The forehead is a better shape with which to begin.

Robert was posed in such a way that the line established by the left side of his forehead and his hair was easy to draw accurately. I made that line with light pressure on the stick of willow charcoal, then moved down to the edge of the left eye. From that curved shape I moved in to draw the eye itself, then the left side of the nose, and back out to the left edge of the face. Another line brought me back to the nose, and then I drew the right side of the nose.

Moving around from one feature to another helped keep me from dwelling on the identity of each feature, and thus I avoided the negative influence of my *understanding* of that shape. As I continued drawing, I drew part of the nose, then part of the eye, then the mouth, and back to the nose. My eye kept glancing and moving, and that helped me draw the face accurately.

By the time I stopped to photograph this stage of the drawing, I had carefully considered each part, compared its shape

to those around it, adjusted the lines, and then applied one dark line over the most accurate preliminary line. In other words, there were a number of light scratches lying under each of the dark lines that show up well in the reproduction.

As you can see, I drew the shadow on the face as definitely as I did the features. In part that's because the lines would help me apply the dark shadow tones, but the contours of the shadow also helped me bridge the space from one feature to another as I was developing the drawing.

I held the stick of willow loosely in my fingers and tried to move my whole arm when drawing the lines you see because I didn't want to tighten up and draw heavy, harsh descriptions of the details of the face. Charcoal drawings can become overworked very quickly.

2 I was working with soft willow charcoal on paper that had a fair amount of sizing in it, so I knew I could build up the tones of the face very gradually without being concerned that the marks I made would either scratch the surface of the paper or become indelibly bound into its fibers. For that reason, I began establishing the shadows in every area of the model's face with quick strokes of the charcoal that were then smeared into the paper to produce a light value.

The tones got darker as I added successive applications of the charcoal in the same areas of the drawing, so I kept working from the lightest to the darkest values. I didn't concern myself with sharp lines, of white highlight or of shadows, because they are difficult to maintain when I am smearing charcoal around broad areas of a drawing with my finger or a cloth. I did, however, try to keep certain areas of highlight as clean as possible by erasing any stray marks with a kneaded eraser.

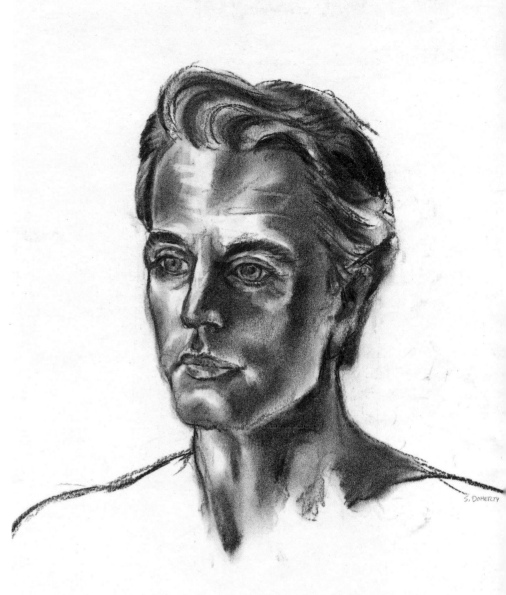

ROBERT SPELLER
1986. Charcoal, 11″ × 12″
(27.9 × 30.5 cm).
Collection of the artist.

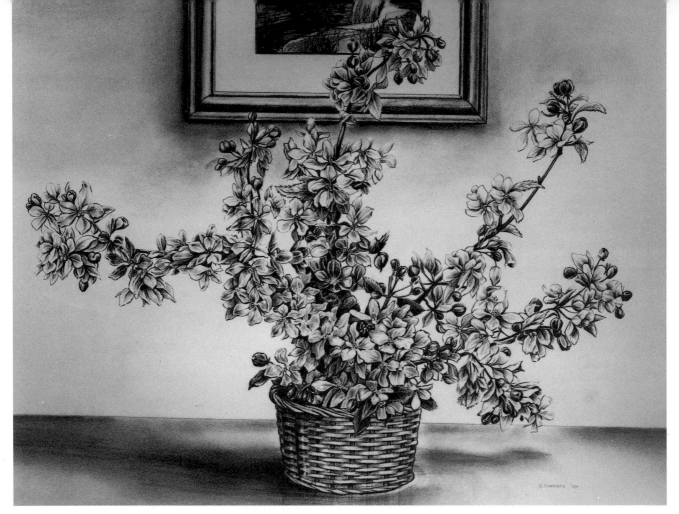

CRABAPPLE BLOSSOMS

by M. Stephen Doherty,
1984. Charcoal, 22½″ × 28½″
(57.2 × 72.4 cm).
Collection of Phil Desind.

This drawing was done from life with 2B and 4B charcoal pencils. I sketched in the basic outlines of the flowers and buds, established the pattern of shadows at various places around the drawing, and then filled in the rest of the drawing after the blossoms had long since died.

After living with the drawing of the blossoms, the basket, and a slight shadow, I decided to actually place the still life in a defined space. I felt there was something incomplete and artificial about an arrangement of blossoms floating in space, and I wanted to change that feeling in my drawing.

I extended the shadow out along a table and created an arbitrary pattern of shadows on the left side of that table. Then I invented a picture on the wall behind the blossoms by drawing a portion of a Dana Van Horn pastel hanging in my living room.

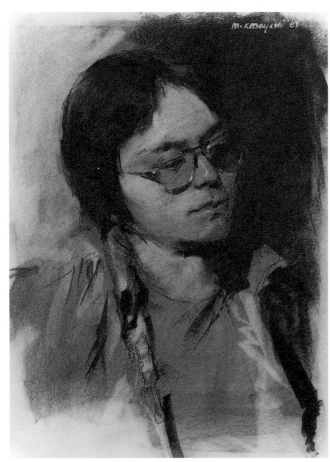

SELF-PORTRAIT

by Milt Kobayashi, 1983.
Charcoal, 8½″ × 11″ (21.6 × 27.9 cm).
Courtesy of Grand Central Art Galleries, New York.

Milt Kobayashi has a more aggressive way of handling charcoal, though he is no less concerned about the volumes of space he is drawing. For this self-portrait, the young artist made sharp strokes with the edge of the charcoal stick and then lifted some of the particles away from the paper with a kneaded eraser. Touches of white paint—probably gouache—were used to put bright accents on the eyeglasses.

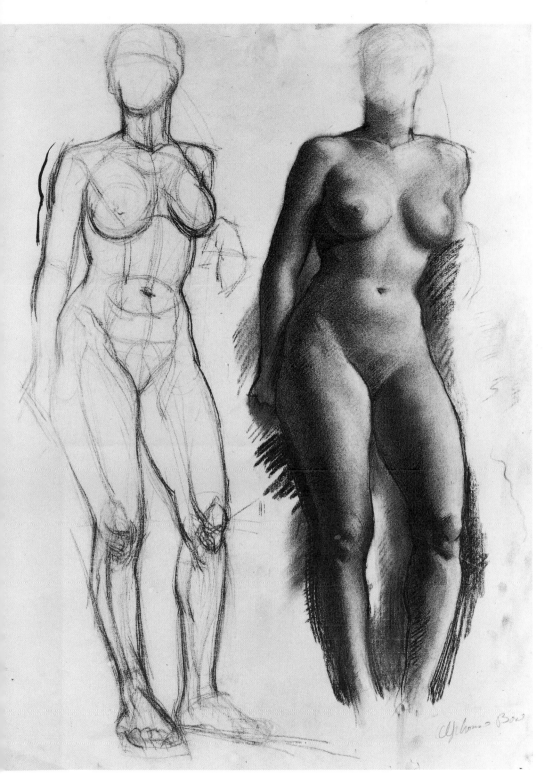

TWO SKETCHES OF STANDING FEMALE NUDE

by Alphonse Bond, ca. 1930. Charcoal and black ink on paper, 24⅞″ × 19¹/₁₆″ (63.2 × 48.4 cm). Collection of the National Academy of Design, New York.

On one sheet of paper, Alphonse Bond has shown us the way artists have traditionally analyzed the appearance of a live model and executed a drawing of that figure. My guess is that Bond made the two separate drawings of the model for the express purpose of demonstrating this traditional approach to his students at the National Academy.

The lines running through the chest, pelvis, and legs of the figure drawn at left were probably the first marks made; they quickly established the proportions and pose of the woman. Next, the volumes of the body were drawn around this skeletal sculpture, with the marks becoming darker and shorter as the artist concentrated on the individual parts of the body. Finally, the ink line alongside the figure's right shoulder indicates how the artist would impose one dark line on top of the lighter approximations.

Bond probably redrew the same lines on the right side of the paper and then proceeded to show his students how he would move on to draw the pattern of light and shadow. Using a softer piece of charcoal, he made diagonal marks to slowly establish those subtle transitions.

23

PASTELS

Pastels are not often thought of as a black-and-white drawing material because it is their softness and their availability in brilliant colors that usually attract artists to them. Still, they can yield a richer and more painterly image than graphite or charcoal, one that more closely approximates the appearance and "feel" of an oil or acrylic painting. The stick of pastel acts almost like a bristle brush to create broad, thick strokes on the surface of a piece of paper and therefore can give an artist a closer examination of the image to be developed in a painting medium.

Even if you restrict yourself to making a drawing with black, white, and gray pastels, you can choose sticks that are either warm or cool. That is, the pastels may actually have some blue or brown pigment mixed in with the black, yielding either a cool or a warm gray, respectively. The white might also be closer to a blue or brown than to a pure white. As a result, the pastel drawing will again come closer to suggesting the appearance of the painting than a charcoal drawing might.

DORINNE WITH HEAD BACK
by Deborah Deichler, 1986. Pastel, 25¾" × 19¼" (65.4 × 48.9 cm). Courtesy of Maxwell Davidson Gallery, New York.

Pennsylvania artist Deborah Deichler spends hundreds of hours creating her figurative paintings on specially prepared canvas-covered panels that are perfectly smooth and inflexible. Because of her time-consuming procedures, Deichler spends a fair amount of time deciding exactly what image she will paint. She uses photographs extensively, but she also makes pastel studies of her subjects in order to determine how best to present them.

In preparing to paint the captivating picture entitled Night Owl, *Deichler made a black-and-white study of the figure with soft pastels. She could have used charcoal or perhaps even oil to create this value and composition study, but instead Deichler chose pastel because she enjoys the richness and painterly feel of the medium.*

NIGHT OWL
by Deborah Deichler, 1986. Oil on linen on aluminum panel, 40⅛" × 30⅛" (101.9 × 76.5 cm). Courtesy of Maxwell Davidson Gallery, New York.

Demonstration

DRAWING WITH BLACK AND WHITE PASTELS

It will become obvious to you as you look through the reproductions of my drawings and paintings in this book that I am interested in making cast shadows as much a part of my pictures as the solid objects placed within the compositions. The placement of the light sources and the manipulation of the resulting shadows are particularly fascinating to me. I find that the general mood of a painting or drawing can be changed dramatically by making the most of these shadows.

In this particular still life, I wanted to explore the various connotations of the word *communion* by using the wine and bread of a ceremonial communion and the intersection of two strong light sources. Unfortunately the photograph of my setup doesn't accurately define the shadows, but you get the sense of how I arranged the linear stalks of freesia and irises, placed the bread and wine in the shadow area at right, and created a strong horizontal break across the background by placing the left-hand light source below the level of the table.

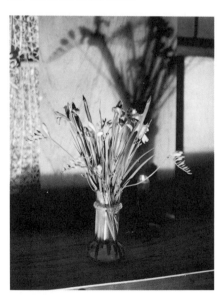

1

2

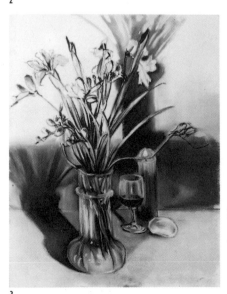

3

1 Using a middle-value gray pastel, I quickly drew in the outlines of the objects and cast shadows on a 24″ × 18″ (61.0 × 45.7 cm) sheet of Strathmore 500 Series, 100 percent rag charcoal paper. I used a relatively firm Rembrandt pastel because I wanted to minimize the amount of pastel deposited in the fibers of the paper. As the drawing progressed, I moved to softer Sennelier pastels.

2 I tend to zero in on the most fragile or the most difficult areas of a drawing first, figuring that I should try to resolve those sections while I am still fresh and energetic. With this drawing, the wineglass and blossoms demanded my immediate attention, so I tried to define the outside shape of each blossom, establish the details of one or two irises and freesia, and then carefully study the pattern of light and shadow on the partially filled wineglass. The hot lights caused the blossoms to change and the wine to evaporate, so most of my work on those subjects had to be done during the first few hours of drawing.

I was only using three sticks of pastel up to this point: the same piece used to make the preliminary lines, a darker gray, and a black. With pastels it is possible to work both from dark to light and from light to dark, so I knew I could either lighten or darken these shapes at a later point. My purpose at this preliminary stage was to accurately record the appearance of the objects.

3 In drawing the rest of the composition, I followed my standard procedure of blocking in the large masses first, taking all sections of the picture to the same degree of completion before focusing on the details of any one particular object.

4 With the larger masses blocked in, I concentrated on more subtle shapes and lines, paying close attention to the relative value of each object. That is, sometimes I had to make an object lighter or darker than its actual perceived value so that it would clearly stand apart from those around it. The lines defining edges of shapes were also accentuated when the tangential values were very close.

I did not use a spray fixative on the drawing until it was completely finished. At that time I applied a light spray of Blair's odorless workable fixative so the drawing wouldn't smear.

COMMUNION
1987. Pastel, 23″ × 17½″ (58.4 × 44.5 cm).
Collection of the artist.

Conté Crayons and Lithographic Pencils and Sticks

Two drawing materials that are not as commonly used as graphite and charcoal are Conté crayons and lithographic pencils and sticks. They have physical characteristics that make them ideal for certain kinds of drawing techniques, which will be described here briefly.

Conté crayons are hard, square shafts of pigment bound by a greaseless substance. They are available in a wide range of colors, but the most commonly used colors are sanguine and dark brown. Because there is no grease in the crayon, Conté is often used by printmakers to make the preliminary marks on a lithographic stone or plate. These marks wash off the plate or stone when it is prepared for printing.

Conté can be used to make sharp lines of variable width or to build up a uniformly even tone.

Lithographic pencils and sticks, by contrast, are made with a greasy material used as the binder. The more grease, the softer the pencil or stick and the darker the mark it will make. Litho pencils and sticks produce a strong black line or tone and do not smudge as easily as other drawing materials. These tools are ideal for getting interesting textural effects by riding a hard pencil across a rough paper, scratching lines into an area filled in with the pencil, or combining parallel lines.

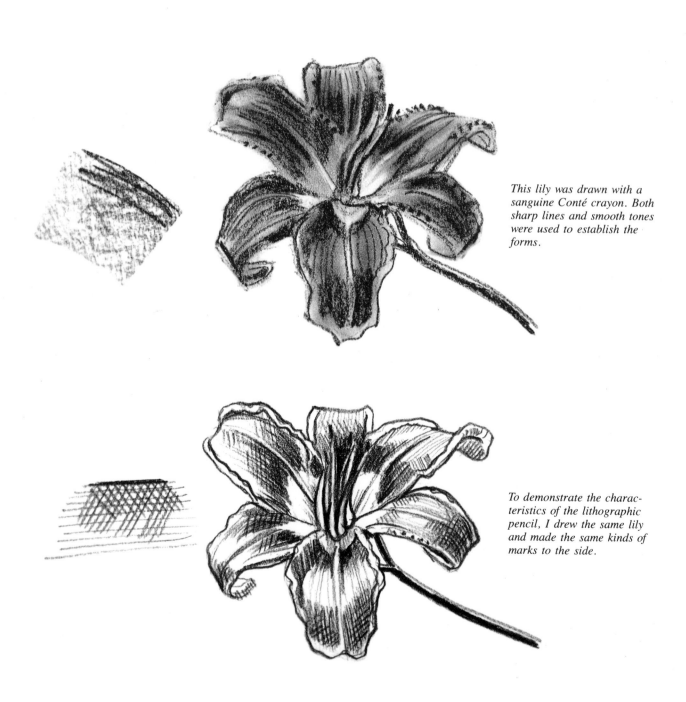

This lily was drawn with a sanguine Conté crayon. Both sharp lines and smooth tones were used to establish the forms.

To demonstrate the characteristics of the lithographic pencil, I drew the same lily and made the same kinds of marks to the side.

28

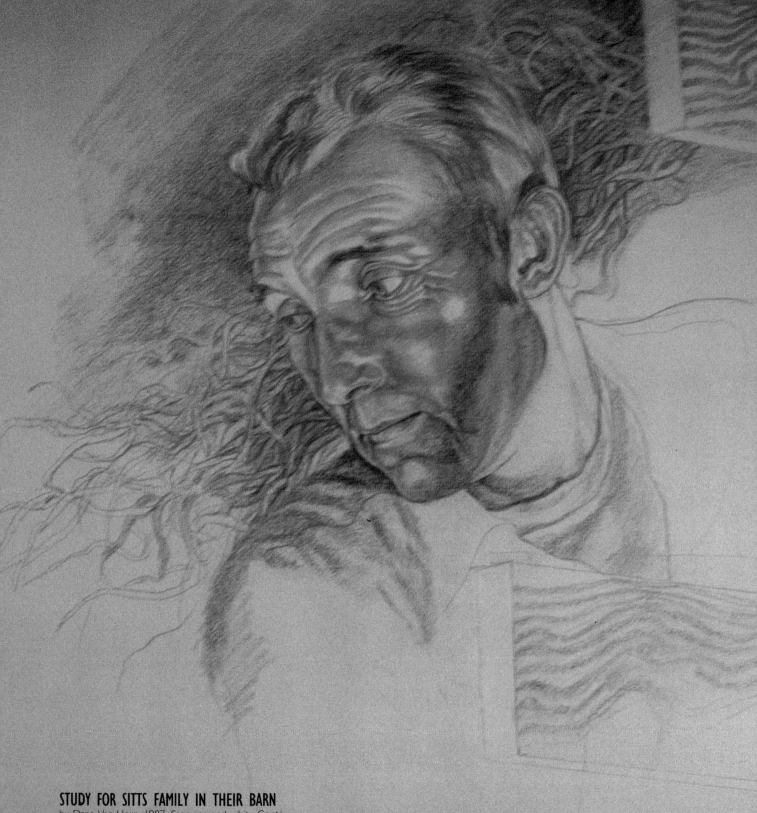

STUDY FOR SITTS FAMILY IN THEIR BARN

by Dana Van Horn, 1987. Sanguine and white Conté,
19½" × 25½" (49.5 × 64.8 cm). Courtesy of Sherry French Gallery.

*Conté is a particularly good medium for making preparatory
drawings of figures because it is available in a range of colors
that approximate skin tone and because it allows the artist to
make a wide variety of marks. The sharp edge of the Conté
stick can be used for making sharp lines, such as those around
the eyes and across the forehead of the man in this drawing,
and the flat side of the stick is excellent for establishing smooth
transitions, such as those in the cheeks and jaw. This drawing
was useful to the artist when he painted the image of this figure
in the large oil painting entitled* The Sitts Family in Their Barn.

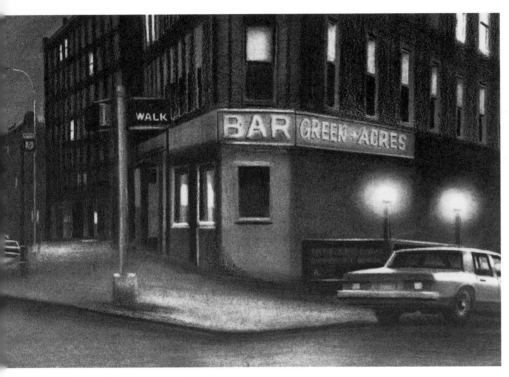

GREEN ACRES TAVERN

by Matthew Daub, 1985. Conté,
10½″ × 14¾″ (26.7 × 37.5 cm).
Private collection.

*Though he has lived in rural Illinois and
Pennsylvania for the last few years, artist
Matthew Daub continues to focus his
attention on the urban environments of
Chicago and New York. He roams the
streets of these cities, taking photographs
of storefronts, rows of apartment build-
ings, expressways, and abandoned lots.
The snapshots serve as the beginning of
drawings and compositional studies as
Daub refines his ideas and plans the
stages of his painting process. This Conté
drawing is typical of Daub's polished
studies of urban landscapes.*

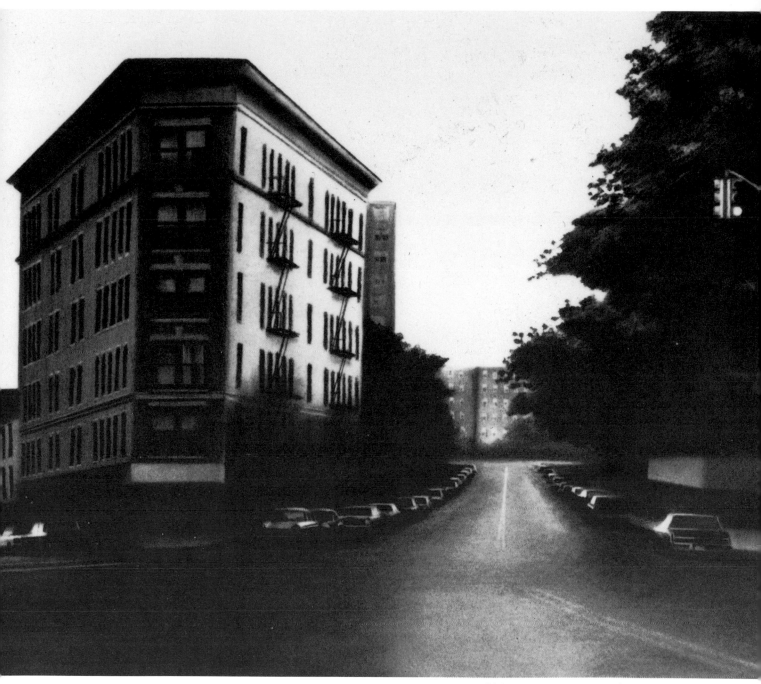

BRONX LANDSCAPE

by Matthew Daub, 1985. Conté,
19" × 31" (48.3 × 78.7 cm).
Private collection.

While this drawing has been resolved to a point where it functions as an independent work of art, you can sense that the artist is studying the way streets, intersections, and corner buildings affect our perception of space. This reminds me of the great French landscape painters of the eighteenth century, who shaped the space within their pastoral landscape by creating flowing streams, fragments of classical architecture, and vegetation. Daub is pursuing the same idea, but he is using landscape forms with which we are more familiar.

Demonstration

DRAWING
WITH CONTÉ

Matthew Daub, who teaches
in Pennsylvania and exhibits
his Conté drawings and water-
color paintings at the Sherry
French Gallery in New York,
offered this demonstration of
his drawing techniques. First
we see the photograph of a
Chicago street scene, which
provided the starting point for
the drawing. The sharp edge
of the Conté crayon was used
to draw the horizon line, the
major diagonal lines, and the
fire hydrant, while the flat
face of the crayon was used to
establish the square of gray
and the dark vertical line.
Then, continuing to use the
broad surfaces of the crayon
to lay in patterns of gray,
Daub developed the picture as
if sewing together patches of
tone.

11TH AVENUE
1984. Conté,
14" × 21" (35.6 × 53.3 cm).
Private collection.
All photos of artwork courtesy
Sherry French Gallery, New York.

INK AND INK WASHES

Whether ink is used to draw studies for later works, technical or commercial illustrations, or independent works of art, there are basically two techniques for applying it: you can draw lines or you can paint with washes of diluted ink. There are a variety of tools, inks, and methods that can be employed, each of which responds differently to the surface on which the drawing is made.

The most common drawing ink is India ink, a dense black liquid that dries permanently on paper, board, or fabric. It mixes easily with water to make graded washes, as will be demonstrated in the next few pages, or it can be applied in uniform lines with a crow quill dip pen or a technical pen.

There are also colored permanent inks on the market as well as nonpermanent inks, non–water-based inks, and colored dyes that can be applied with a pen. Each of these is suited to certain techniques or drawing surfaces. For instance, if you were making technical drawings on sheets of acetate, you would use an ink that is not water soluble so the drawing would be permanently bonded to the plastic drawing surface. Artists who use photographic printmaking processes often draw on Mylar or acetate with such inks.

Whatever tool or ink you are using, it is most likely that you will develop your drawing by building up layers of parallel lines, or hatched and crosshatched lines, and adding pointillistic dots in areas where lines would appear too harsh. Most artists begin with light guidelines drawn with a pencil or thin-tipped technical pen, then work from the strongest shadow areas into the halftone and highlighted shapes. For example, an artist would pull the lines from the deep cast shadows beside the bridge of the nose into the eyelid and cheek, gradually reducing the number or thickness of the lines as a way of graduating the tones.

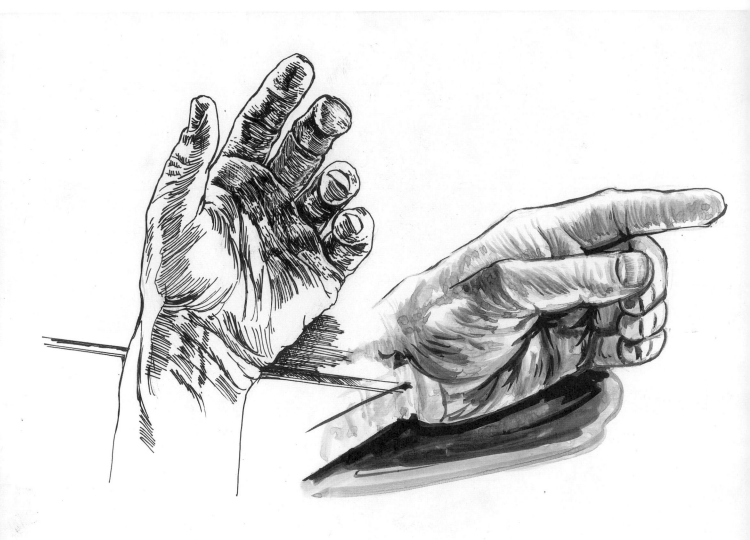

If you are working on coated illustration board or Mylar, it is also possible to scrape lines back into areas already covered with ink, thus lightening the tones and adding another texture to the drawing. You might also combine ink washes with the lines to enrich the drawing.

Before the 1960s, when technical pens became readily available to artists, pen-and-ink drawings were done with crow quill pens that had flexible nibs. A student learned to vary the amount of downward pressure on the pen so as to get thin lines with light pressure and gradually thicker lines with increasing amounts of pressure. The more expert the artist became at handling the pen, the more he or she was able to establish the sense of volume, space, and distance in a drawing. There were also special tools that made broad strokes or that laid down more than one line, and an artist could use these to complete a drawing.

Since that time, technical pens have become the principal drawing tool used by artists and designers who work with ink. The pens are neater, have a reservoir of ink, and lay down a uniform line. They do not, however, allow for the subtle variations that were characteristic of the pens with flexible nibs. To vary the thicknesses of lines in a drawing, the artist has to either employ several technical pens with different-sized nibs or draw lines next to each other so they create a thicker line.

Because most inks sold for technical pens dry permanently, it is especially important that you screw or push the cap back on the pen when it is not in use and properly clean the pen periodically. If this care is not taken, the ink will dry within the body of the pen and nib and will be very difficult to remove. As simple as the tools appear to be, it is advisable to carefully read the instructions provided with the pens so that you understand both the proper use and care of the technical pen.

To illustrate the techniques described here, I drew my own hand, first with lines and then with washes of ink. I began both demonstrations by making a light pencil sketch. For the line drawing, I proceeded to outline the fingers and major folds of skin using a technical pen with a no. 1 size nib. Then I drew parallel lines to establish the shadow areas, curving the lines to follow the contours of the hand and putting those lines closer together in the darker areas of shadow. You'll also note that on the index finger, which, because of its position relative to the light source, was defined by a strong contrast between dark and light values, I put small dots of ink along the division between those contrasting values.

For the wash drawing of the hand, I mixed a brushful of India ink in a cup holding about three tablespoons of water. This gave me a light gray wash, which I applied to any area of the hand that would be defined by shadow. Adding another brushful of ink, I made a slightly darker wash, which I painted everywhere except where the light gray value was appropriate. I continued this procedure until I was painting in the dark lines inside the cupped hand, and at that point I dipped the brush directly into the India ink bottle and painted dark black lines along the line established by the bottom edge of the hand.

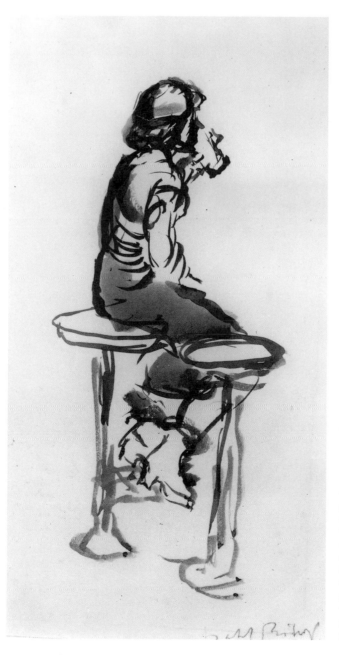

GIRL DRINKING

by Isabel Bishop, ca. 1960. Ink wash, 11″ × 5″ (27.9 × 12.7 cm). Courtesy of Midtown Galleries, New York.

The drawing above was made by Isabel Bishop, an artist known for her drawings and paintings done on the streets and in the shops of New York City. I've included this picture to show how ink washes can be used for sketching on location. The artist limited herself to a few distinct values and a quick, gestural style, but she was able to produce an accurate record of the woman sitting on the stool.

Techniques and Applications of Ink Washes

Again it seems appropriate to demonstrate the impact a given technique can have on the presentation of an image by first using it to render a subject previously depicted with another medium and then drawing several versions of another subject, using variations of the technique. The theory is that by holding one factor in the equation constant it will be easier to judge the variations in the others.

For all of these demonstrations of India ink washes I used one bottle of Pelikan India ink, one old no. 4 sable hair brush, and two plastic drinking cups—one holding half an inch of water and the other nearly full.

India ink is an intense, permanent liquid that is difficult, if not impossible, to remove from most papers, boards, and fabrics. It is possible to scratch or erase the ink off of some specially treated surfaces, but those materials and techniques will not be discussed here.

Working with a black-and-white glossy photograph or newspaper illustration makes it easy to evaluate the progressive stages of gray to be applied when making a wash drawing. For that reason, I chose a reproduction from the sports section of the New York Times *for this demonstration. The action taking place in the photograph and the arrangement of black, white, and gray values were well suited to the medium.*

All eight charcoal drawings of the daffodil shown on pages 14 and 15 bear the typical characteristics of the uniformly black, powdery material from which they were made. The same flower rendered with graduated washes of India ink has quite a different appearance owing to the subtle change in color of the washes and the action of the brush.

In order to do each of the three following demonstrations, I drew the outline of each shape on a piece of tracing paper with a technical pen filled with permanent ink. As you can see, I eliminated certain details in order to simplify the composition. This line drawing was then transferred to the surfaces I would be painting by placing a piece of Saral carbon paper between the tracing paper and the paper or board and retracing the lines with a sharp pencil.

This illustration was done in the same way as the daffodil, except I was working on a piece of Crescent 180 hot-pressed illustration board. I first put one brushful of India ink in the glass filled with half an inch of water to make a very light gray that could be painted in every area that wasn't pure white. As I added another brushful of India ink, and then another, the gray wash became progressively darker, allowing me to paint smaller and darker shadows. Of course the first layer of gray combined with the subsequent layers to make each successive wash darker.

While the smooth hot-pressed board is well suited to tight rendering, the same illustration board can be used for a controlled use of flowing bursts of pure ink. To create these, I painted pure water in selected areas with one brush, and then touched another brush loaded with ink to the wet surface. The ink quickly rushed into the wet shape, creating a graduated, though random, gray pattern.

The same techniques used in the first two wash drawings were employed here, but the surface of the paper was radically different. The washes were dragged across the coarse surface of a sheet of heavily sized 300 lb. rough watercolor paper in such a way that its texture became an integral part of the picture.

Preparatory Drawings and Paintings

The process of making preparatory drawings and paintings is particularly important for artists interested in creating large, complicated figurative paintings. The physical demands of the process, as well as the aesthetic concerns, require that the artist carefully plan the development of the picture. If the work has been commissioned for a specific location, the studies must be brought to a high degree of completion so that the client and anyone else employed to help execute or install the painting will be well informed about the final appearance and structure of the piece.

Dana Van Horn has been involved in the creation of a number of large figurative paintings, starting in the mid-1970s when he apprenticed himself to Jack Beal during the design and execution of a series of four murals on the history of labor for the United States Department of Labor offices in Washington, DC

In the early 1980s, Van Horn worked for two years on a mural commission for the Cathedral of Saint Catharine of Siena in Allentown, Pennsylvania, completing two enormous paintings that flank the apse of the cathedral. A number of friends and neighbors posed for the large groups of figures in each painting, all of them acting out two important events in the life of Saint Catharine.

These mural commissions established a high level of complexity and ambition in Van Horn's work, and he has continued to create large paintings of individuals and groups of figures engaged in an identifiable action. One of his recent paintings was purchased by the Metropolitan Museum of Art in New York.

Even when he turns his attention to smaller landscapes, portraits, and figure studies, Van Horn often makes drawings and paintings as studies for these oil paintings.

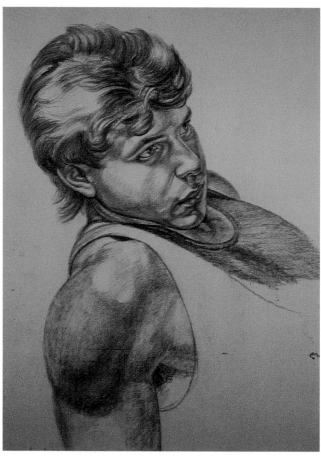

This is typical of many of the head studies Van Horn made in developing segments of his large figure compositions as well as individual portraits. It was done on a tan sheet of Canson's Ingres acid-free paper, using Koh-I-Noor sanguine colored lead held in a large mechanical pencil holder. The sanguine lead is deeper in color than its name might suggest, and it yields a range of tones that Van Horn finds works well on this paper. The white highlights were drawn with the same wax-based drawing material; it can either be rubbed smooth into the fibers of the paper or laid on in linear strokes that accentuate the texture of the paper. No spray fixative is needed to hold the particles to the paper because of the wax in the drawing leads.

In this study, Van Horn used loose washes of watercolor to evaluate the way he would paint the figure in oil. A fairly limited palette of earth tones and a dark blue was used.

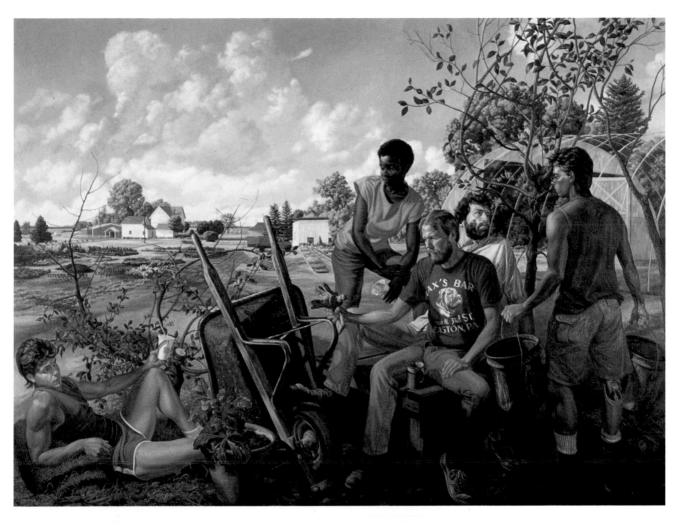

WORKERS ON BREAK I
1987, oil on canvas, 9'2" × 12'2"
(279.4 × 370.8 cm). Courtesy of
Sherry French Gallery, New York.

*Because of the complexity of this large
multifigure composition, Van Horn did a
number of studies of individual models,
the landscape in the background, and the
overall arrangement of the pictorial ele-
ments. The fact that each figure is look-
ing at another worker, and that all of
them are arranged in a large triangular
foreground shape, helps to unify both the
composition of the picture and the ac-
tivity being depicted.*

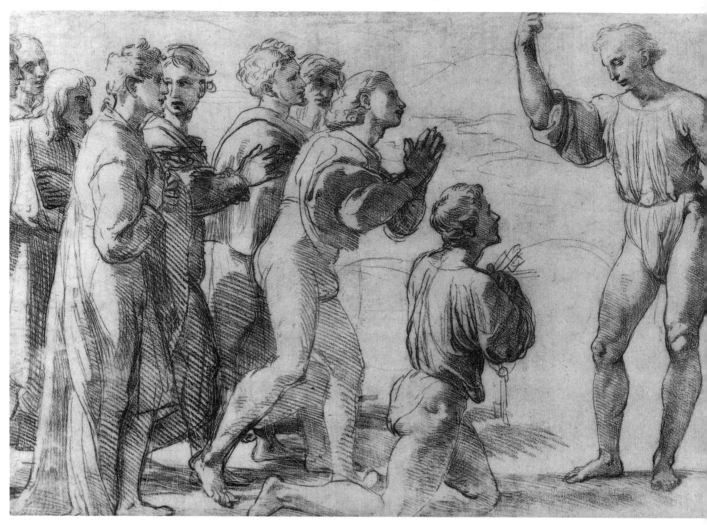

"FEED MY SHEEP": CHRIST'S CHARGE TO PETER

by Raffaello Santi, called Raphael, ca. 1515. Offset of a drawing in red chalk over stylus, 10″ × 14¾″ (25.7 × 37.5 cm). Collection of Her Majesty Queen Elizabeth II. Windsor Castle, Royal Library. Photograph courtesy of the Pierpont Morgan Library, New York.

Old Master drawings provide a fascinating glimpse of how these extraordinarily gifted artists refined the ideas expressed in their frescoes, oil paintings, and tapestries. This particular drawing shows the early stages in the development of a tapestry commissioned by Pope Leo X that was to be hung in the Sistine Chapel on ceremonial occasions. The subject is Christ's charge to Peter, who is identified by the keys, which Raphael has drawn in two alternative positions.

This drawing is actually an offset of a previous drawing made by dampening the paper and pressing the two sheets together. It was made so that Raphael could evaluate the reversal that would normally take place when a tapestry was made. The artist wanted the action to "read" from left to right, as most people would expect the story to unfold.

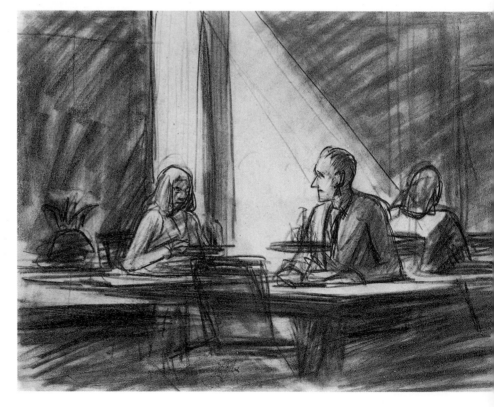

STUDY FOR PALISADES MURAL

(right) by Thomas Hart Benton, ca. 1919–1921. Graphite, 9″ × 13″ (22.9 × 33.0 cm). Courtesy of the United Missouri Bank of Kansas City, N.A., and Lyman Field, co-trustees of the Thomas Hart and Rita P. Benton Testamentary Trusts.

Missouri artist Thomas Hart Benton promoted the use of an elaborate system for developing multiple-figure paintings. He would make careful studies of the planes of space within the picture, as indicated by the block figures in this drawing, and constructed actual clay models of the scene. These dioramas were set up in front of the artist, carefully illuminated, and were used as the principal reference during the painting process.

In the 1930s, Benton taught students at the Kansas City Art Institute to follow the same careful procedures for developing their paintings and prints. Other Regionalist artists took up the same practice and a viewer can almost sense that the artists were painting a truncated space when observing their paintings. Despite the somewhat artificial appearance of the pictures, the practice did allow the artists to arrive at well-composed paintings of figures and landscape.

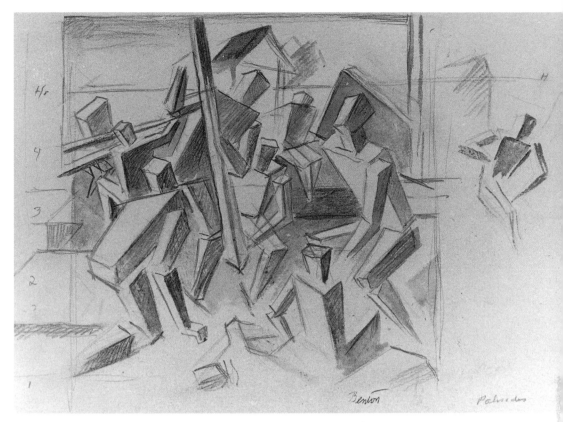

LIGHT FALLING ON AN INTERIOR (Study for "Sunlight in a Cafeteria")

(left) by Edward Hopper, date unknown. Charcoal, 8½″ × 11″ (21.6 × 27.9 cm). Courtesy of Hirschl & Adler Galleries, New York.

Edward Hopper made extensive studies for many of his paintings, and a comparison of the sketches of posed and observed figures with the finished paintings demonstrates the ways he imposed his feelings about the subjects. In this drawing of figures in a cafe, we see convivial people who are aware of each other. In the final painting, as in many of his studies of urban dwellers, people take no notice of each other and are lost in lonely isolation.

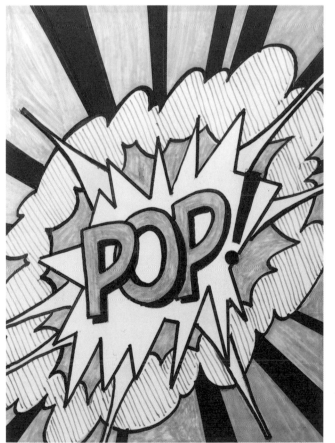

STUDY FOR "POP"

by Roy Lichtenstein, 1966. Cut and pasted printed paper and felt-tip pen on board, 28½″ × 22″ (72.4 × 55.9 cm). Collection of Mr. and Mrs. Jorge Halft. Photo courtesy of the Museum of Modern Art, New York.

Artists have a greater self-consciousness about their drawings today than they did when these graphic images were not considered independent works of art. In the case of this drawing by Roy Lichtenstein, for instance, it is clear he was conscious that he was making something that would be published, exhibited, and collected. His choice of materials and the degree of finish of this drawing reflect this consciousness. The drawing was originally made as a study for a Newsweek *cover illustration published on April 25, 1966 and was included in an exhibition of the artist's drawings at the Museum of Modern Art in New York in 1987.*

41

ROLLAND GOLDEN
Preliminary Studies in Graphite

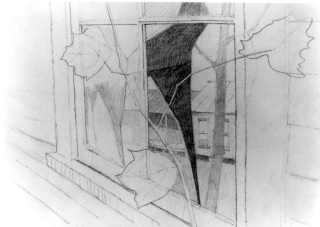

Study for *Signs of Fall*, 1987. 11″ × 8½″ (27.9 × 21.6 cm).

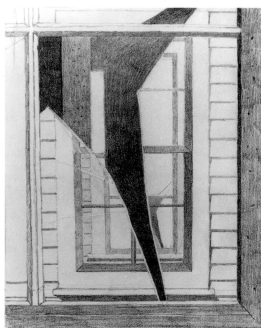

Study for *Signs of Fall*, 1987. 8½″ × 11″ (21.6 × 27.9 cm).

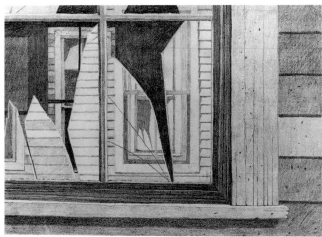

Study for *Signs of Fall*, 1987. 8½″ × 11″ (21.6 × 27.9 cm).

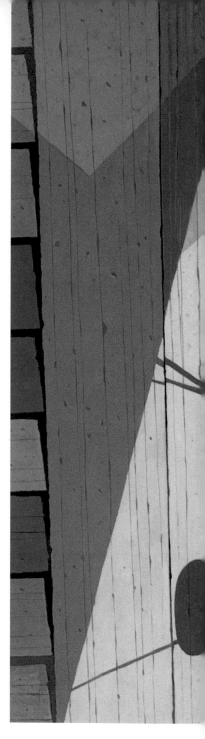

The three drawings reproduced on this page are all preliminary studies for the drawing *Signs of Fall*, which is itself a preparatory drawing for the watercolor of the same title. All of these were created by Louisiana artist Rolland Golden.

As all of these reproductions suggest, Golden often does graphite sketches and value drawings as a way of editing information provided by the actual scene, photographs, and his imagination. In so doing, he arrives at a composition that effectively presents his ideas. This approach is particularly appropriate when Golden is combining or overlapping fragments of various images, as is the case with this watercolor.

Noting that the pattern of light shining on a door or window gives evidence both of what is inside and what is outside the space, Golden tried various patterns on windows and doors until he came up with the imaginary scene recorded in the value drawing. This was used to develop the watercolor.

Like many artists, Golden has recognized that one of the most fertile ideas an artist can use in developing his or her paintings is the way light establishes the shape, color, and value of objects. It is easy to understand why light is such an important subject when you consider that everyone's perception of the world depends on the way light filters through the atmosphere and falls on objects.

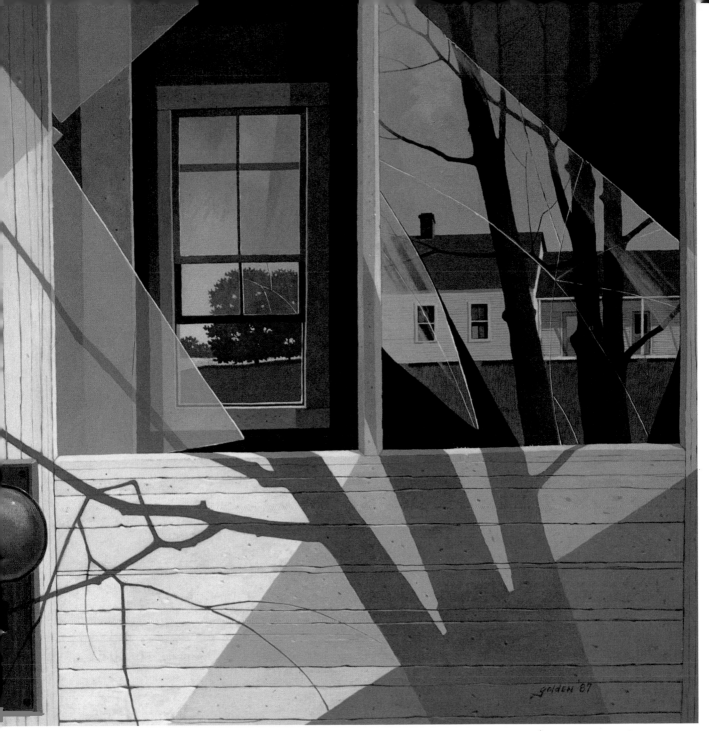

SIGNS OF FALL
1987. Watercolor,
26″ × 34″ (66.0 × 86.4 cm).
Collection of the artist.

SIGNS OF FALL
1987. Graphite,
8½″ × 11″ (21.6 × 27.9 cm).
Collection of the artist.

Drawings as Independent Works of Art

Because drawings are collected and exhibited by themselves, many artists create drawings that are not studies or sketches for other pictures or sculptures but, rather, stand alone as works of art. Now, it could very well be argued that all drawings are works of art and all of them have the potential to become source material for other pictures. So how does one distinguish between the two? The answer to that question depends on the artist in question and the relationship between a particular drawing and all the other pictures the artist has created.

In my own case, I consider a drawing to be preparatory when it was created primarily for the purpose of resolving questions about the development of a painting or print. I consider a piece to be an independent work of art when it is either conceived or finished in such a way that it has the same degree of completeness and complexity as my paintings. If I can hang the drawing in an exhibition and feel that its scale and level of accomplishment are consistent with the paintings on display, then I consider it an independent work of art.

The degree of completeness and detail of my drawings makes it easy to accept the notion that they are independent works of art. I obviously went beyond the point of making studies for some other painting or print. In the case of other artists whose style is more loose and gestural, the independence of the image might not be so apparent.

The absence of color in these drawings also helps to separate them from any paintings that might recreate the same or a similar image. That is, the physical qualities of the drawing materials—graininess, softness, and black color—presented certain compositional problems that would be completely different from those that painting materials would present. The leaves in a floral arrangement had to be distinguished by the pattern of the marks and the relative values since I could not use different colors to create their image. The resolution of the value composition might help me compose a subsequent painting, but the marks would be completely different.

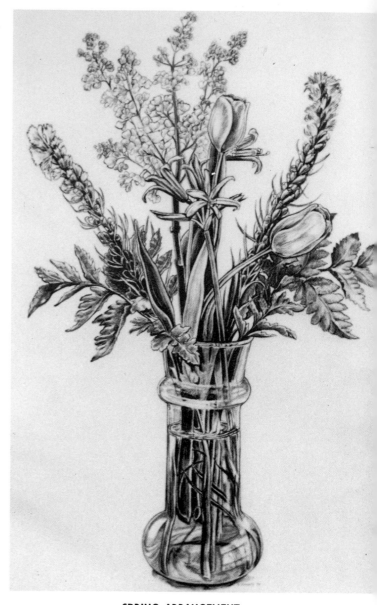

SPRING ARRANGEMENT
by M. Stephen Doherty, 1984.
Charcoal, 21" × 14" (53.3 × 35.6 cm).
Collection of the artist.

This was one of the first in a series of floral drawings I did from 1984 through 1986; it presents the subject in great detail and in a shallow space. After looking at this drawing for a long time, I decided to use a more dynamic arrangement of still-life elements in a deeper space. The two drawings reproduced on the opposite page show where that interest took me.

VIGIL FOR A
BROKEN BLOSSOM

by M. Stephen Doherty, 1986.
Charcoal, 23″ × 22½″ (58.4 × 57.2 cm).
Courtesy of Capricorn Galleries,
Bethesda, Maryland.

*I think this is one of the best charcoal
drawings I did in 1986 because every
part of it works to express the tragedy of
something dying just as it is about to
bloom. The broken blossom lies on an
agitated table just below cut flowers that
are preserved in vases of water. In the
background, a burning candle suggests
that this is not just a picture of spring
flowers but rather a metaphorical state-
ment about the life and death of human
beings.*

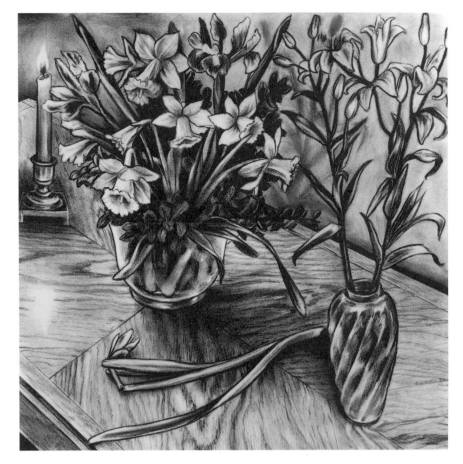

DIAMOND PATTERNS

by M. Stephen Doherty, 1986.
Charcoal, 23¼″ × 22½″ (59.1 × 57.2 cm).
Courtesy of Capricorn Galleries,
Bethesda, Maryland.

*With some of the same ideas in mind, I
came up with this still-life composition of
daffodils and seashells. The shells and
the diamond patterns seemed to suggest
symmetry, order, continuity, and beauty,
so I looked for other objects that would
amplify those concepts. I started with the
vase of flowers and the shells on the table
and kept adding shadows, rug, walls, and
wood grain until the picture seemed rich
and interesting.*

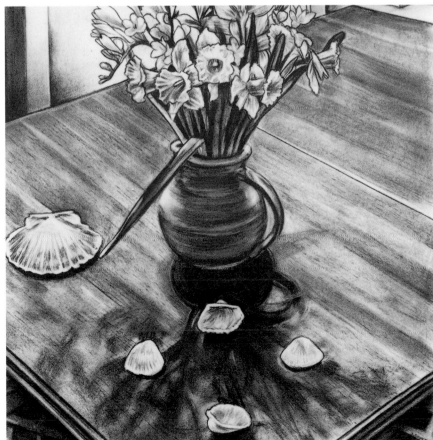

STYX STILL LIFE

by M. Stephen Doherty,
1985. Charcoal,
24″ × 21″ (61.0 × 53.3 cm).
Collection of the artist.

Each of the next three draw-
ings is shown with a photo-
graph of the setup I was
working from at the time. The
fact that the photographs are
of poor quality should indi-
cate immediately that they
were not used in any way
while I was making the pic-
tures. They were taken with
whatever film happened to be
in my camera.

I was thinking about a
friendship when I was select-
ing the elements for this still
life, and the two pictures that
seem to be reproduced in the
magazine on the end table are
of me and my friend. The
pairing of the flowers, as well
as the chairs in the back-
ground, and the inclusion of
the matchbook and pencil all
relate to this friendship. I
can't quite explain why I
chose all of them, but often
an artist will be attracted to
certain objects without being
able to explain why. The
shapes, or the colors, or the
history of the object has an
importance that is too deep or
personal to be expressed any
other way.

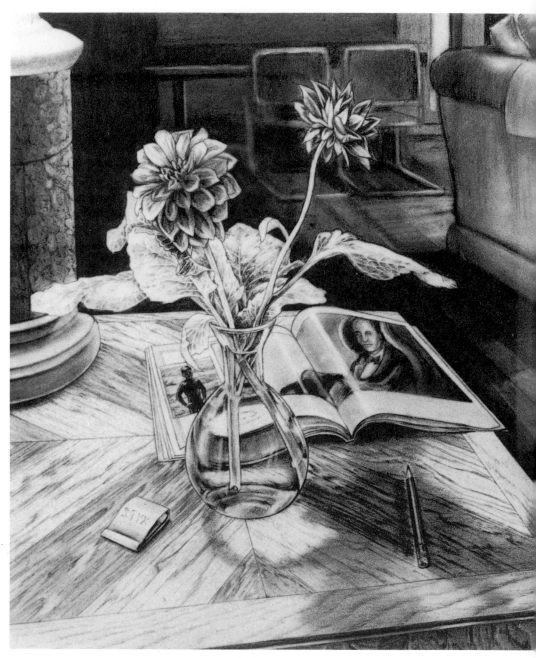

STILL LIFE
WITH SCISSORS

by M. Stephen Doherty,
1986. Charcoal,
20" × 14" (50.8 × 35.6 cm).
Collection of the artist.

*Using the same objects that
appeared in earlier still-life
drawings, I continued to ex-
plore the ways beautiful
spring flowers could be used
to suggest both the bright and
the dark sides of life. The
round plate suggested con-
tinuity; the candle, vigilance;
and the cut flowers, temporal
beauty. The strong pattern of
shadows gave the entire scene
a menacing feeling. To make
that feeling even more appar-
ent, I drew a pair of sharp
scissors lying across the plate
and exaggerated the grain of
the plywood on which every-
thing was resting.*

*All of these elements were
drawn with a consciousness of
how their introduction
changed the composition of
the total picture. The shadows
obviously pulled the viewer's
attention directly into the cen-
ter of the picture, so the grain
of the plywood, the line be-
hind the flowers, and the scis-
sors had to draw attention to
other parts of the still life.*

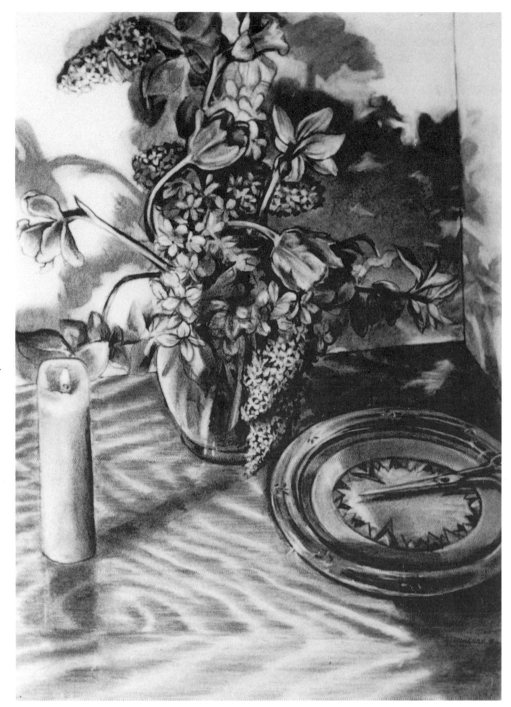

STILL LIFE WITH ROSE

by M. Stephen Doherty,
1986. Charcoal,
20″ × 16″ (50.8 × 40.6 cm).
Collection of the artist.

Beautiful objects often seduce an artist into making a painting that comes off as being too sweet, or too common, or too romantic. They either look like greeting cards or poor copies of some name-artist's paintings. The challenge, therefore, is to find some unusual way of presenting those appealing objects.

This drawing is my attempt at finding such an unusual presentation for two roses in a vase, a crystal bowl, and a linen napkin. I tried to work them all into a complex arrangement of opposing diagonal forces, hoping that the dynamic movement of forms would add greater interest to the presentation.

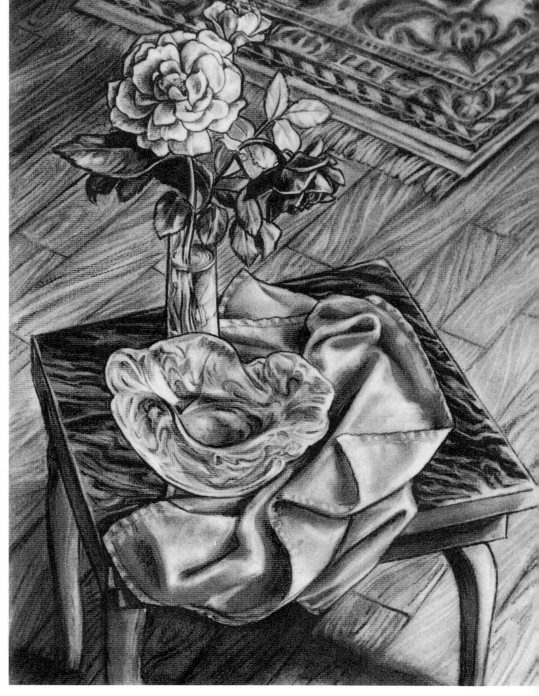

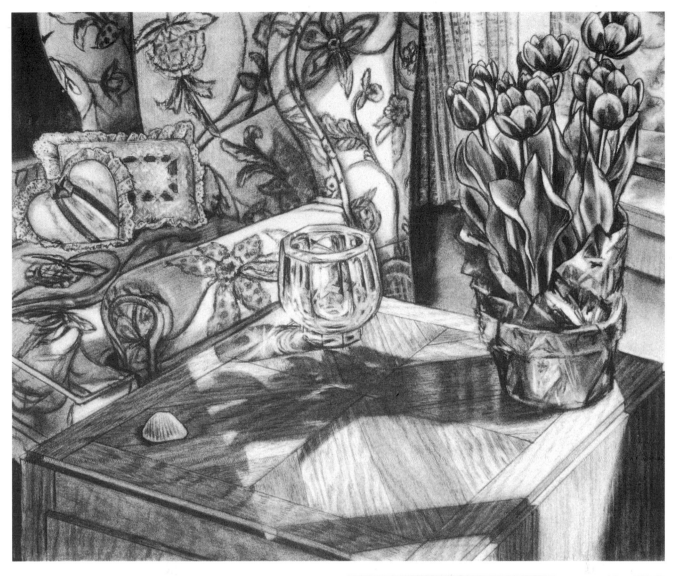

LIVING ROOM STILL LIFE
by M. Stephen Doherty, 1986.
Charcoal, 20″ × 24″ (50.8 × 61.0 cm).
Collection of the artist.

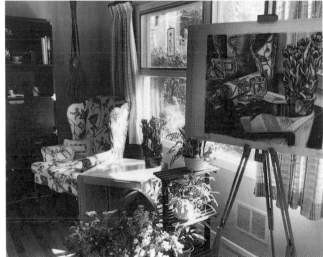

As you can see, I did this drawing in the living room of my home with a sheet of printmaking paper taped to foamboard and mounted in a portable Charvoz-Carsen easel.

After using General Pencil willow charcoal to make a rough sketch of the basic shapes I would be drawing, I carefully drew the tulips, as the bright sunlight would obviously cause them to open within a matter of hours. On the next day, at approximately the same time in the morning, I sketched the pattern of shadows on the end table and chair, since that too would change quickly.

With the basic patterns established, I could then embellish the various parts of the scene, starting with the embroidered chair, then moving back to the oak table, and finally concentrating on the crystal vase. The left side of the table seemed empty, so I erased a small area of charcoal and drew in a shell. That set up an interesting relationship between the four quadrants of the veneer tabletop.

Demonstration

STILL LIFE WITH AZALEA

The thought process involved in making a drawing that stands as an independent work of art is not that different from what one would employ when creating a sketch or preparatory drawing. The difference is usually in the degree of completeness in the presentation of the underlying idea. This demonstration is included here to show how an idea can evolve through various stages and then be presented in a refined drawing. I developed this still-life drawing by working from a quick sketch to a refined image, using the technique of smearing soft charcoal over entire areas and lifting out portions with a kneaded eraser. I was working on a sheet of lightly sized Strathmore printmaking paper with Koh-I-Noor charcoal sticks and General Pencil charcoal pencils (2B, 4B, and 6B).

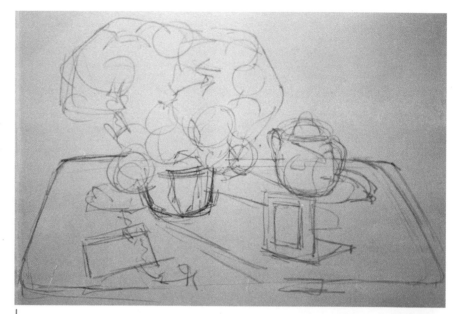

1

1 Working with a stick of medium-soft Koh-I-Noor charcoal, I quickly sketched in the general shapes of the objects in my still-life composition. At this point, I was concerned with the way the objects filled the page, how the shapes related to each other, and how the drawing would eventually convey my feelings about the antique jar, potted plant, and photographs of my grandmother.

2 I treat charcoal drawings almost as if they were paintings in that I first tone portions of the paper by smearing soft charcoal with aggressive, broad strokes and smoothing them out with a clean cotton rag. At the stage shown here, I have done that twice in the background area, once over the objects on the table, and three times where the pattern of shadows appears. Each time I smeared the charcoal into the fibers of the paper, the drawing became darker. Because that impregnated charcoal is difficult to remove completely, I took care not to draw into those areas that were to be the brightest highlights in the picture.

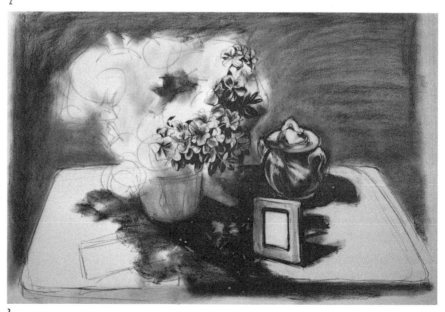

2

3 The shapes of the picture frame and covered jar seemed inaccurate, so I took time to study those objects carefully and improve their rendering with a charcoal pencil. That done, I moved on to the azalea plant, since live subjects change so dramatically from one drawing session to the next. Although I had a general sense of how I wanted to draw the blossoms, I needed to come up with a pattern of values that was convincing.

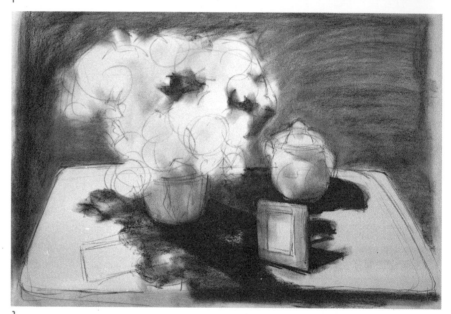

3

4 The background of the picture seemed too empty, and the still life was starting to look too comfortably simple, so I decided to expand the implied space and add complexity to the composition by drawing a chair in the back at right, again using the stick of soft charcoal. I angled the Lincoln rocker so that it faced the center of the picture, since I wanted to hold together the seemingly disconnected and conflicting elements by emphasizing a symmetrical arrangement of those forms.

5 With interest created by the rocker, I had to add something in the upper left corner of the picture, so I chose an object that introduced a new directional force that would relate well to those implied by the other objects. Obviously, I worked more on the rendering of the other elements and continued moving around to different sections of the page so as to bring each object to a similar degree of completion. As I became more concerned with details, I made greater use of the three charcoal pencils.

6 After the preliminary stages of drawing, I used a kneaded eraser almost as much as I did the stick of charcoal. I constantly lightened values, "drew" lines to establish highlights, and kept the lightest areas clean. My finger was also an important tool; I used it to rub the charcoal into the fibers of the paper, giving a rich, velvety quality to the drawing. For small areas where my finger wouldn't fit, I resorted to various-sized stumps to smooth out the charcoal.

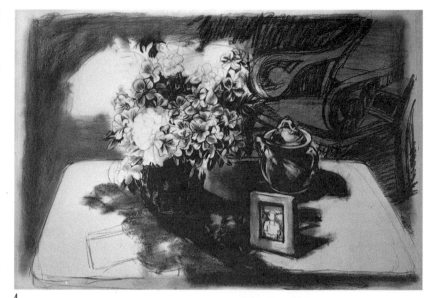

4

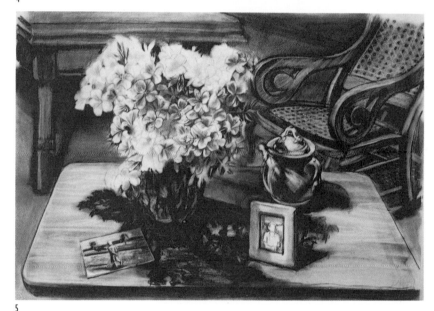

5

STILL LIFE WITH AZALEA
1986. Charcoal, 20″ × 30″ (50.8 × 76.2 cm). Courtesy of Capricorn Galleries, Bethesda, Maryland.

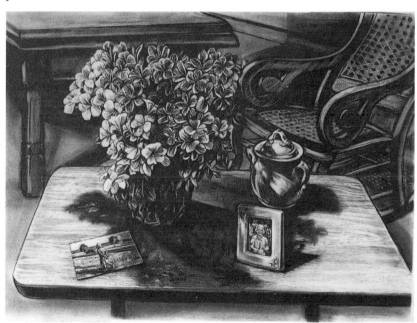

6

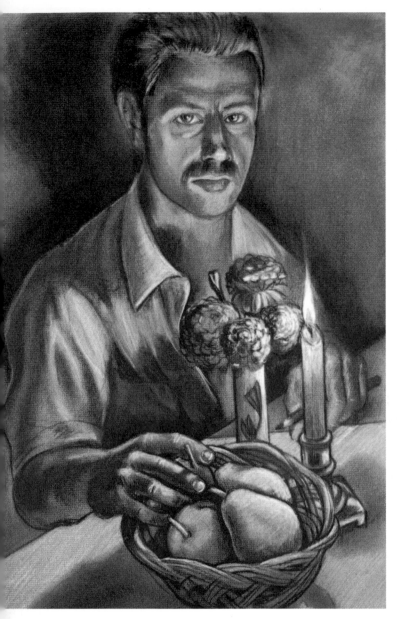

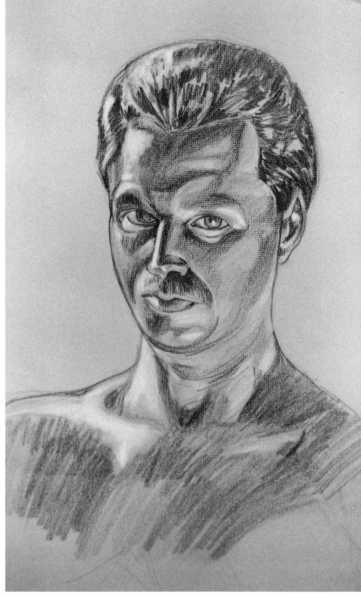

SELF-PORTRAIT BY CANDLELIGHT
(above) by M. Stephen Doherty,
1985. Charcoal on colored paper,
18″ × 12″ (45.7 × 30.5 cm).
Collection of the artist.

SELF-PORTRAIT WITH BARE CHEST
(right) by M. Stephen Doherty,
1985. Litho crayon on colored paper,
18″ × 12″ (45.7 × 30.5 cm).
Collection of the artist.

SELF-PORTRAIT WITH BOW TIE
(opposite page) by M. Stephen Doherty,
1985. Charcoal, 21″ × 20″ (53.3 × 50.8 cm).
Private collection.

*Artists have always found it handy to paint portraits of them-
selves because the model is always available and doesn't
complain about the results. They do these drawings and paint-
ings to exercise their skills and to experiment with new ideas.
The pictures not only become records of the artist's appearance
and personality but also give us a glimpse of what new
directions the artist was considering.*

*In that spirit, I did a number of self-portraits in 1985 as a
way of improving my ability to draw a figure from life and to try
out some of the lighting arrangements I saw in the paintings of
J. C. Leyendecker (1874–1951). An extraordinarily gifted il-
lustrator, Leyendecker is best known for his creation of the
Arrow Shirt advertisements, which showed elegant young men
lounging on leather couches or stepping down staircases. His
unique way of lighting the models and rendering their ap-
pearance with bold diagonal strokes of fluid paint made him
one of the most successful and admired artists of his day. I tried
to use that combination of soft light from below and strong light
from the side to illuminate my own face in two of the drawings,
and then I tried using the flickering yellow light from a candle
for the other.*

SEVENTY-SECOND STREET

by David Schofield, 1984.
Pen and ink, 36½" × 48" (92.7 × 121.9 cm).
Private collection. Photo courtesy of
Gallery Henoch, New York.

Florida artist David Schofield makes periodic trips to New York City, where he makes sketches of buildings in a small notebook, using a felt-tip pen. He takes these back to his studio in Key West and spends months working up large pen-and-ink drawings of these scenes, using both the sketches and his imagination. He uses a Rapidograph technical pen to build up layers of hatched and crosshatched lines until his drawings have both the appearance and the texture of the urban subject matter. He sometimes works on a paper with a vellum finish and, because of the smooth surface of that paper, he has to sharpen the point of his technical pen.

AMARYLLIS

by Harvey Dinnerstein, 1975.
Silverpoint, 28¼" × 17" (71.8 × 43.2 cm).
Collection of the Norton Gallery of Art,
West Palm Beach, Florida.

For centuries, artists have used thin slivers of silver, and occasionally copper, to make drawings that are sharply defined yet delicately soft. The technique involves putting the metal into a holder and drawing on a surface that will scrape off particles of the metal as it moves across the surface. The prepared paper will hold those particles in the indented lines caused by the sharp instrument, making it impossible to erase the lines. As the metal tarnishes, the drawing becomes darker and richer.

Either acrylic gesso or white casein paint can be painted on the surface of stiff paper to make it a good working surface for silverpoint drawing, and there are commercially prepared papers sold under the name "video media board" that will also work quite well.

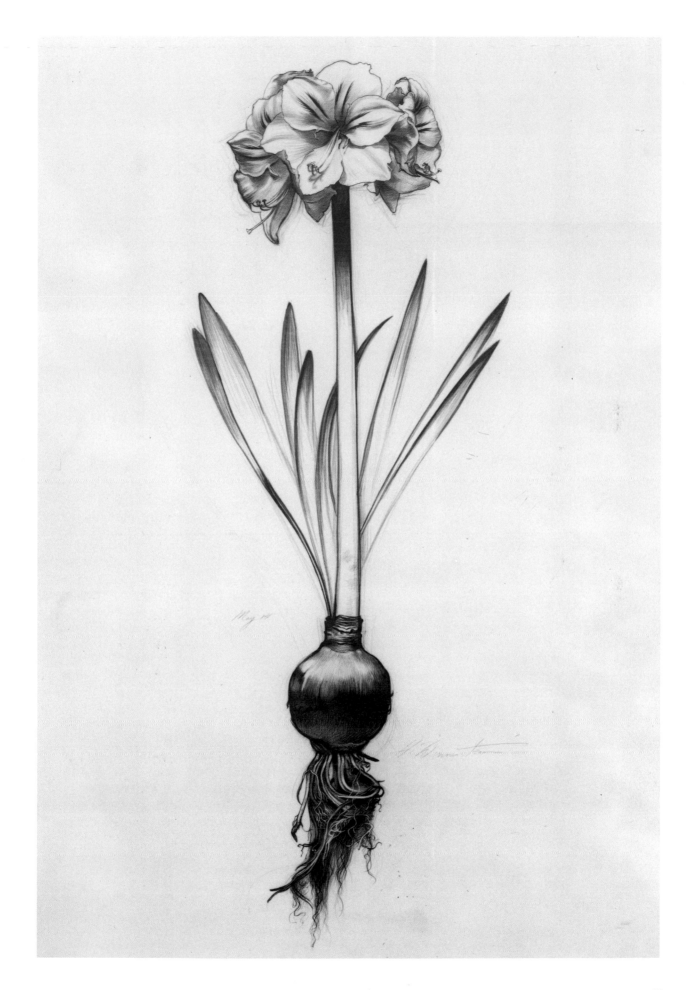

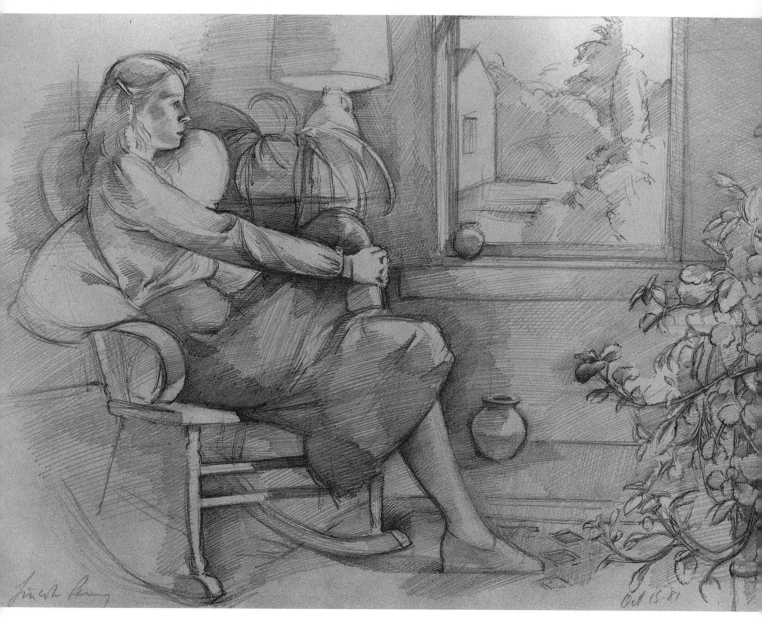

FIGURE IN INTERIOR

by Lincoln Perry, 1981.
Pencil, 12¼" × 16" (31.1 × 40.6 cm).
Private collection. Photo courtesy
of Tatistcheff & Co., New York.

*Virginia artist Lincoln Perry makes a point of drawing from live
models on a regular basis, both on his own and with a group of
artists that meet every Wednesday evening. Unlike many artists,
however, he moves freely from the real to the imaginary in both
his drawings and his paintings. He often begins with carefully
observed records of a posed figure and then moves on to totally
imaginary landscapes, interiors, or figure groupings. In the
case of this drawing, for instance, the figure sitting in the chair
seems to be a portrait of an actual model, while the landscape
outside the window seems to have been created solely for the
purpose of projecting a space beyond the room. The vases on
the floor and window seem to be devices to connect the plane of
the figure to the plane of the window and lead the viewer's eyes
from the foreground to the background.*

AUNT MARION

by Leslie Enders, 1986.
Pastel, 12″ × 14″
(30.5 × 35.6 cm).

New York artist Leslie Enders says that she fell in love with drawing materials years ago and continues to be fascinated with the tools that make marks—both black and colored—as well as the surfaces on which an artist can draw. She worked in the Department of Drawing at the Metropolitan Museum of Art in New York after graduating from college in 1968 but has been a full-time artist and mother in recent years.

The birth of her first child marked a significant change in Ender's artwork as well as her personal life. "I hadn't done any figurative work for ten years, but when my son was born I became interested in drawing the figure. Since that time, and especially since the birth of my second child, I have been drawing nothing

but figurative subjects—most often the members of my family," she explains.

Enders works exclusively from photographs as she says she is "shy and uncomfortable with a live model posing. Besides, I like the instantaneous moments that photographs capture."

The colored drawing "Nana Rose & Dana Rose" is of the artist's grandmother and daughter, respectively. As the title of the other drawing indicates, it is of Ender's aunt Marion.

NANA ROSE
AND DANA ROSE

by Leslie Enders, 1985.
Pastel and colored pencil,
18″ × 12″ (45.7 × 30.5 cm).

S. DOHERTY

PAINTING
The Vocabulary and Language of Art

This book puts an emphasis on the use of drawings as a way of establishing a point of view as an artist, and it supports the notion that drawings should be considered as independent works of art. But the history of art is the history of painting, not of drawing, and for most artists, painting materials and techniques offer the most important means of expressing something worthwhile to a viewing and buying public. Therefore, the rest of the book will offer descriptions and demonstrations of paints available to artists and examples of how artists have used those materials to create unique works of art.

Water-based paints are the most convenient to use and therefore have tremendous appeal to artists who must contend with limitations on their time, workspace, or budget. The fact that there are over a hundred national, regional, state, and local watercolor societies in the country attests to the appeal of the medium. But that popularity does not mean watercolor is a less significant or creative painting material. As will be demonstrated in the sections on watercolor, gouache, and egg tempera, water-based paints offer as many technical and creative possibilities to artists as do oil-based media.

But again, going back to my statement that the history of art is the history of painting, most of the major historical art movements of the last four centuries have focused on oil paintings created by major artists. The history of prints, drawings, sculptures, and watercolors has been well documented, of course, but developments in oil paintings established the styles of impressionism, cubism, and abstract expressionism.

When you read through those accounts of historical art movements, you will find that changing ideas and attitudes about art are reflected in changing approaches to composing and creating paintings. For example, art historians regard Caravaggio's dynamic arrangement of figures and dramatic use of light as changes that had far-reaching significance. Likewise, Cézanne's desire to eliminate the illusions of depth and volume in painting had a dramatic influence on early twentieth-century painters. By thinking creatively about the basic components of painting—color, form, and composition—these artists were able to have a long-lasting influence on the history of art.

History is shaped by a much more complex set of circumstances than those I have just suggested, of course, but I think my simplification makes it easier to understand what an artist can and should be doing. When an artist understands both the technical and the aesthetic aspects of what he or she is doing, and begins to think of these components as the vocabulary and language of art, then great things can be accomplished. Caravaggio knew that by offering a radically different arrangement of well-known Biblical figures, and by illuminating them with a strong, raking light, he would challenge people's perceptions of painting, and perhaps their attitudes about matters that went beyond the scope of art as well. He used the vocabulary and the language of art to say something new.

Cézanne's ideas became so important because they influenced so many other artists and, therefore, one is likely to assume they were more significant than anything we could think of today. Without minimizing the importance of Cézanne's ideas, I would suggest that they evolved through a series of his drawings and paintings, in much the same way that ideas have occurred to other artists. That is, each time Cézanne painted the houses and trees on the side of Mont Sainte-Victoire (one of his favorite subjects), he thought about the patterns being established by the natural movement of his brush and considered how he might do more with those patterns. That exploration, I suspect, led to the consideration of a picture made up of flat patches of color that suggested the planes of space—a simple concept, but one that later gave the Cubists something to expand upon as they painted the human figure as a multi-dimensional form made up of flat planes of space.

As a way of exploring the possibilities artists have available to them, I have developed this chapter of the book so that a variety of painting materials are described and demonstrated: watercolor, gouache, acrylics, egg tempera, and oil paints. Pastels are also covered, since works done in this medium are more akin to paintings than drawings.

STILL LIFE WITH PETUNIAS

by M. Stephen Doherty, 1985. Watercolor, 11½″ × 8½″ (29.2 × 21.6 cm). Collection of the artist.

The texture and coloration of petunias in my garden caught my eye and presented a challenge for a watercolor painting. To make those visual qualities override the sweetness and sentimentality of the pretty flowers, I had to devise a composition that would make the picture look like anything but a greeting card.

Watercolor

The simplicity of the materials and the variety of possible techniques make watercolor painting one of the most accessible and popular media for both amateur and professional artists. A few simple, portable, and nontoxic painting materials make it possible to execute anything from a quick sketch to a mural in styles that vary from the tightly realistic to the expressively abstract. You can join up with other sociable artists for a workshop or "paint-out" or clear a space on the kitchen table to make a watercolor painting. There are few absolute rules dictated by either the materials or conventional practice, though some individuals will argue strongly about the wisdom of their particular approach.

The three basic ingredients involved in the creation of watercolor paintings are paint, brush, and paper. Many other materials can be used to supplement or modify the performance of these three elements, but at the beginning an artist should understand the characteristics of these three.

Watercolor paints are simply raw pigments bound together with water-soluble gum arabic. They are sold in either a liquid form in tubes or a solid form of paint molded into square (half-pan), rectangular (pan), or oval dishes. They need only be liquefied to the desired degree of fluidity and opacity to be painted on paper. Because there is no other binding agent in the paint than the gum arabic, the paints should be applied to a porous, textured, or fibrous surface that will trap or absorb the pigment once the paint is dry.

Almost any tool can be used to apply watercolor paint, though brushes are the most commonly used. These can be made with many different synthetic or natural hairs, though most professionals find that sable hairs—particularly Kolinsky sable hairs—make the best painting brushes because of their ability to hold a quantity of paint, release it in a controlled manner, and then return to their original shape. For certain kinds of effects, however, artists will use sponges, sticks, pens, air-powered brushes, or other tools to apply the paint to the paper.

The paper, board, or fabric on which watercolor paint is applied should be able to hold the particles of pigment under normal conditions. Most artists use one of the many papers manufactured specifically for watercolor painting, and these are available in three different surfaces and a range of different weights. The surfaces are hot pressed, which is smooth; cold pressed, which has a medium texture; and rough, which has a rippled surface. Some foreign paper mills use the term "not" instead of "cold pressed" to identify paper with a medium texture. Hot-pressed paper is most often used for highly detailed images or linear drawings, such as commercial illustrations or architectural renderings, because the paper allows for sharp edges and straight lines. Rough watercolor paper is most often used by artists who want to allow the texture of the paper to become part of the composition. Cold-pressed paper allows an artist to get both textural richness and detailing and is therefore the most popular of the three surfaces.

The most common weights of paper used by watercolorists are 90 lb., 140 lb., and 300 lb., the choice being made according to whether the artist intends to mix a great deal of water with the paint. A 90 lb. sheet would most likely be stapled or taped to a rigid surface if the artist were going to saturate the fibers with watery paint, but a 300 lb. sheet would be thick enough not to buckle or warp when covered by these same solutions.

The amount of sizing the manufacturer has added to the paper also affects how paint will behave on the surface. Sizing is like starch in a shirt—it can be either soaked into the fibers or lightly applied to the surface so that the fibers of the paper will absorb less moisture from the paint. Without sizing, the paint crawls away from the line painted with a brush as the surrounding fibers of paper absorb the moisture. On some occasions an artist might want to remove some or all of the sizing in order to achieve a soft, subtle blending of colors on the paper.

In recent years, paper mills have been binding watercolor papers to acid-free board so that artists can have a less expensive rigid surface on which to work. One of those boards, manufactured by the Whatman Paper Mills of England, was chosen for the step-by-step demonstration of the amaryllis painting on page 65.

Some of the most commonly used techniques and applications of watercolor will be demonstrated in several different ways. The first exercise follows the format established in previous sections of the book, where one subject was painted in several different styles using the same basic materials. In this case a still-life setup was painted six times, with a different approach being taken to each rendering.

The second demonstration of watercolor techniques focuses on the step-by-step development of one painting, and the third shows photographs of certain subjects and the watercolor sketches that were done at those locations in a limited amount of time. All this is to press the point that the more an artist understands and can control a medium, the more he or she will be able to express something unique.

Techniques and Applications of Watercolor

For this demonstration, I set up a porcelain covered jar inside a cardboard box and placed the light source off to the right. My purpose was to focus on a limited range of colors and values and on a clearly defined pattern of shadows.

I made one pencil drawing of the subject and then transferred the outline of the shapes and shadows to six pieces of watercolor paper and illustration board. The first four demonstrations were done on 140 lb. Arches cold-pressed paper; the fifth on 300 lb. Saunders rough paper; and the last on Crescent hot-pressed illustration board.

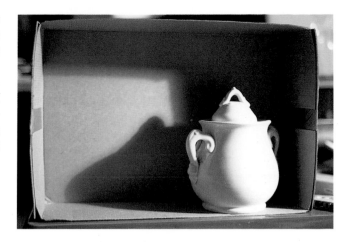

My first approach to painting the still life demonstrates the kind of techniques often used when an artist is painting out of doors with a limited amount of time. The brushstrokes were made quickly, and the mixtures of paint were fairly opaque so that the subject could be recorded in one sitting.

You'll note that I drew the outline of the covered jar with a fluid blue paint rather than allowing the edges to be established by the juxtaposition of dark and light shapes. That's an approach often taken by watercolorists in these situations.

It is also clear that I have introduced washes of manganese blue and raw sienna in the painting of the cardboard box; this too is a technique used by watercolorists who want to add richness and diversity to their paintings. Those extra colors were applied while the broad areas of umber were still wet.

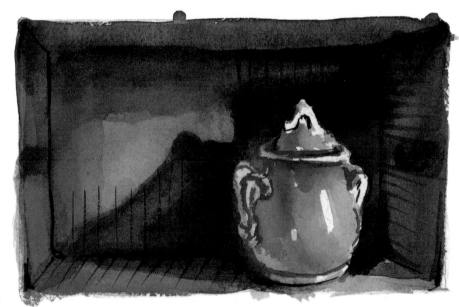

For this demonstration I tried to render the subject as carefully and accurately as I could, adding detailing to the dry surface of the painting to heighten the sense of realism. The point was simply to show that an artist can achieve a sharply defined, almost photographic depiction of a subject. This approach requires a broad palette of colors and a deft handling of the brush, since arbitrary mixtures of paint and water and free-flowing movement of the brush will not yield this kind of precise rendering.

Quality paints and brushes obviously make a great difference with this kind of approach, since Kolinsky sable brushes and finely ground pigments will offer the artist more control of the painting process.

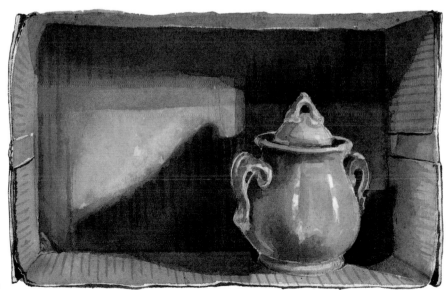

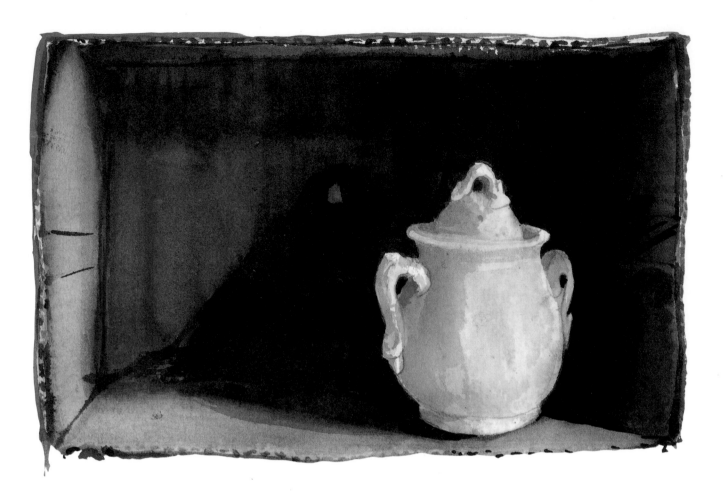

Whenever I am in the Brandywine River Museum in Chadds Ford, Pennsylvania, I find myself staring endlessly at Andrew Wyeth's watercolor paintings. He has developed a palette, a sense of composition, and a method of building up the paint surface that fascinate me. In the first place, he works on a paper that seems too thin for the aggressive way he attacks it, so the surface is often buckled. Furthermore, he uses a very limited palette of black, blue, green, and the earth colors. Most of his subjects are indicated by quick, gestural strokes of burnt umber, ochre, burnt and raw sienna, or combinations of those colors. Black is obviously mixed in with the earth tones to send parts of the composition into deep

space while one brilliant object or thin line moving across the picture catches our attention. We may see a waterfall reflecting sparkling moonlight in an otherwise dark winter landscape, or we may enter a room and confront a figure whose youthful flesh is indicated by a thin wash of ochre and raw sienna.

To demonstrate how to use a limited palette and strong contrast between light and dark forms, as Wyeth does, I painted the still-life subject almost as if the jar were Helga, the artist's famous model, sitting beside an open window. I deepened all the shadows inside the box and brightened the light cutting across the space, putting the faintest indication of blue on the surface of the jar itself.

There are a number of different products that can be used with watercolor paints to alter the performance of the paint or the receptiveness of the paper. For this demonstration I filled in the entire shape of the covered jar with Winsor & Newton's liquid masking fluid. This light yellow liquid can be painted on the paper with a synthetic brush and allowed to dry so that it will resist any watercolor paint applied over it. At any point, you can rub the dried masking agent and remove it from the paper, revealing the area that was protected.

I blocked out the jar and splashed paint on the exposed paper with both a paintbrush and a toothbrush, creating a controlled pattern on the paper. When that was dry, I removed the masking agent, put a paper stencil over every other area of the picture, and flicked paint in a pattern that described the shadows on the jar.

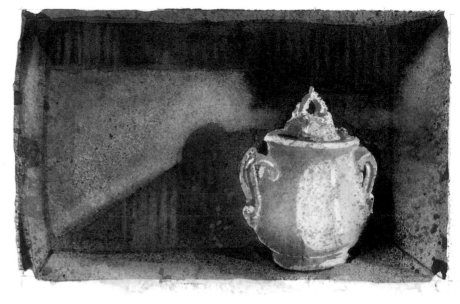

In this demonstration the paper is more important to the resulting image than any other factor. I wiped the surface of the paper with a sponge filled with clean water to remove a good bit of the sizing put into the paper by the manufacturer, then stapled the paper to a rigid surface so that it would dry flat and painted the still life with fluid mixtures of paint. The result is a totally different presentation of the subject.

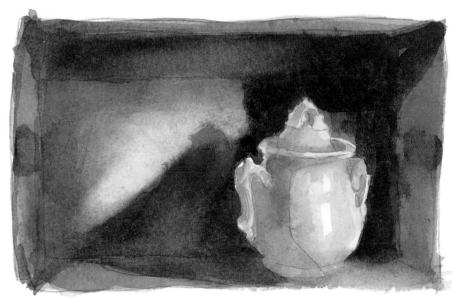

When you take a workshop in watercolor, you quickly learn that according to many artists, you should never use the tube of Chinese white packed in the standard sets of paint—despite the fact that John Singer Sargent, Winslow Homer, Burt Silverman, and David Levine, among many other well-known historic and contemporary artists, have created extraordinary paintings with opaque mixtures made from the transparent tube colors and that Chinese white.

For this demonstration, I mixed white into all of the colors previously used to paint the same subject and rendered the subject on a smooth sheet of hot-pressed illustration board. The milky appearance of the paint and the slow absorption rate of the paper cause the colors to pull in on themselves and create interesting painterly effects.

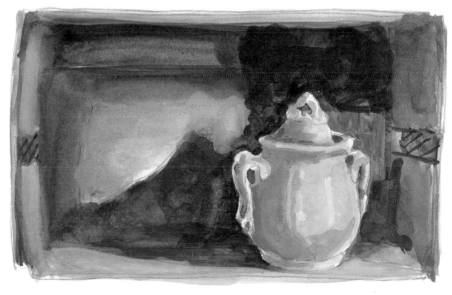

Demonstration

APPLYING WATERCOLOR

These six illustrations show how the watercolor paint was applied and modified in order to establish the color and appearance of the amaryllis blossoms in the demonstration that follows.

1 After first painting a solid area of red, I allowed the wet color to seep into a part of the petal painted with clean water.

2 Once the seeping red paint produced the graduated tone I wanted, I blotted the surface with a clean paper towel to stop the action.

3 In this case, I painted clear water over a large area, using heavy brushloads of water in order to saturate the fibers of the paper.

4 While the paper was still soaked, I touched its surface with brushloads of different red paints. The colors then exploded into the area, never extending beyond the wet shape.

5 I rewet the previously painted area with brushloads of tinted water and introduced a new red color into that shape, adding richness and variety to the painting.

6 A light wash of a complementary green created a ridge on the darker side of a vein, adding depth and detail to the petal.

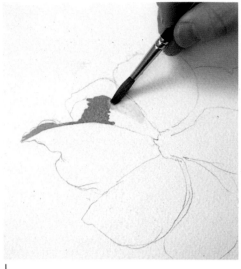

1

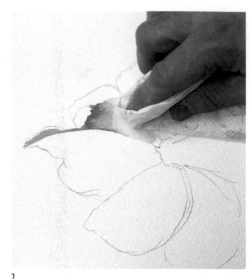

2

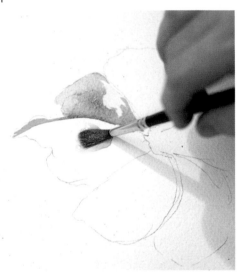

3

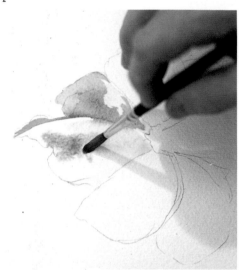

4

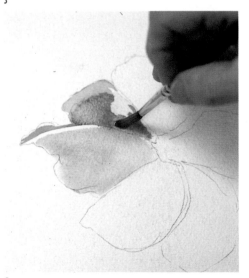

5

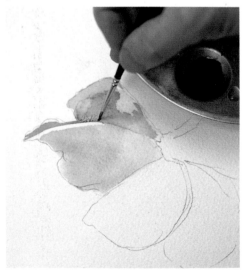

6

Demonstration

PAINTING WITH WATERCOLOR

The purpose of this demonstration is to explain how and why watercolor paints were used to record a flowering plant. I don't mean to suggest that these are the only subjects or techniques to be considered. As I've mentioned above, the medium allows for as many stylistic approaches as there are artists to use it. Some of the possibilities are suggested in the demonstration and in the descriptions of paintings by other artists.

The most important thing to consider when following my description of the developing painting is the way in which the characteristics of the paint, brush, and paper either limit or facilitate my ability to accomplish a presentation and an interpretation of the subject.

My wife came home with a flowering amaryllis plant one Friday afternoon, and I was overwhelmed by the large, deep red, trumpetlike blossoms. I decided to immediately begin working on a watercolor painting of the plant. I chose watercolor because, as I mentioned above, it is a medium that allows for the kind of immediate response with simple material that is difficult to realize with other painting materials.

I turned the amaryllis around several times to consider the way the blossoms, stalks, and leaves would align, and I put it on furniture of different heights to decide which would be the most desirable vantage point and lighting situation for my painting.

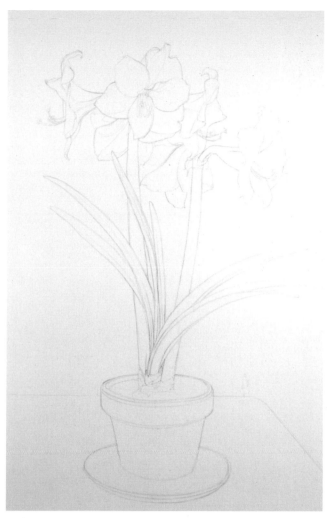

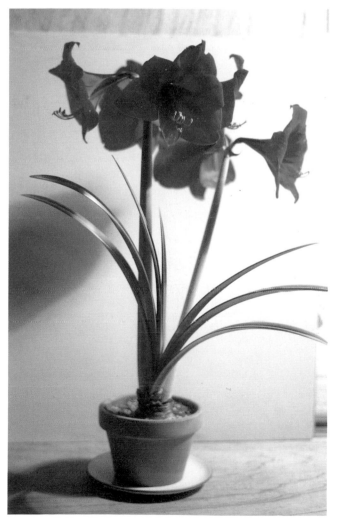

With another subject, I would probably have done a number of preliminary drawings and color studies before sketching on the watercolor board, but my time was limited because the blossoms would wilt soon. I cautiously began lightly sketching in the plant, adjusting the proportions to fit the space, then carefully detailed the outlines of the blossoms and leaves. When I was satisfied with the composition, I drew fairly dark lines over the most basic shapes, then erased any extraneous lines with a kneaded eraser.

I knew I was inviting some compositional problems by placing the plant dead center on the page, so I considered a number of ideas for the background and cast shadows. At first I thought I might include some of the living room furniture in the background, and in fact I drew in lines for walls, chairs, and a table. These seemed too distracting, so I erased the lines and considered various flat-wall treatments. Without being certain of which I would ultimately use, I decided the flat wall would work best with a plant that would dominate the pictorial space.

2 With both time and my ability to concentrate being limited, I painted two blossoms completely and established the basic appearance of the others before stopping to photograph the first stage of the painting process. I filled several compartments of my paint dish with four different red tube colors (alizarin crimson, cadmium red, permanent rose, and Winsor red) as well as a contrasting Hooker's green dark.

Working with various transparent mixtures of all four reds, I tried to accurately record what I was seeing. The blossoms were a deep purple-red in some parts and a thin orange-red in areas where the light was filtering through the petals. I used a no. 6 Winsor & Newton Series 7 Kolinsky sable brush for the broad areas of color and a no. 4 Raphael Kolinsky sable brush for more detailed patterns.

3 With the exception of small details that could be painted without direct observation, the painting of the blossoms was essentially complete at this stage of the painting. It's often risky to bring one section of a painting to such a degree of completion without at least laying in some other basic areas of color. The risk is that a painting developed in this fragmented way may not hold together as a unified composition.

In this situation, I was willing to take an unorthodox approach because I wanted to paint the blossoms without having to use drawings, color sketches, or photographs. The challenge was to paint the brilliant and varied reds of the blossoms as directly as possible. The fact that those forms would undoubtedly dominate the painting meant that everything would have to respond to the shape, color, and value of the flowers. That being the case, I figured I was better off finishing them

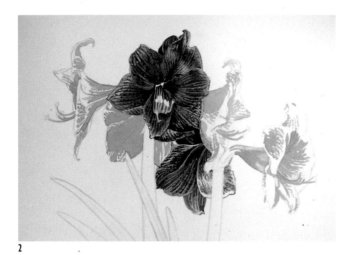

2

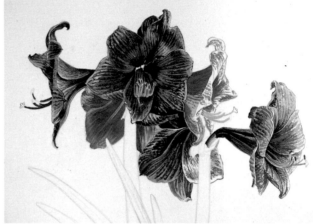

3

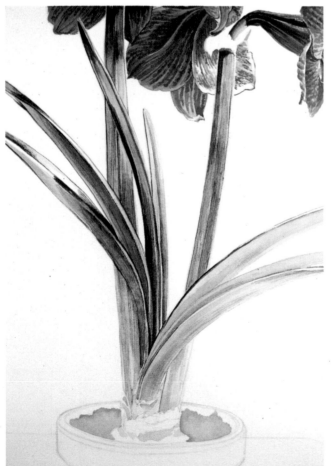

4

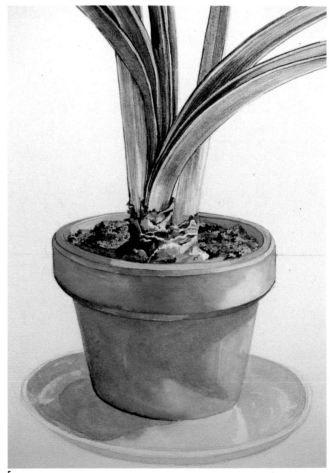

5

before I considered any other part of the composition.

4 I washed out my paint dish, mixed up several different green tube colors, and started blocking in the stalks and leaves. Because the various greens were dramatically different in their degrees of opacity and staining power, I painted all of them on a scrap piece of watercolor paper and tried various combinations of overlays. I also mixed up a couple of greens by combining blues and yellows so that I could give vibrancy to the painting.

With greens that were difficult to control once thinned with a lot of water, like Hooker's green dark, I mixed in a small amount of gum arabic so that they would not leach out beyond the shapes I painted. You can also detect that I painted some pure yellow in the leaves that, because of the strong light source, appeared translucent.

5 Working with a very transparent mixture of burnt sienna, I painted in the shape of the clay pot, adding a bit of cerulean blue in the shadow areas. I also added some alizarin crimson to give a more reddish color to the pot.

I painted a light wash of burnt umber inside the clay pot to suggest the dirt around the base of the plant. There were some white particles in the soil, but they drew attention away from more important objects so I left them out.

I continued developing the clay pot with combinations of the same burnt sienna, cerulean blue, and alizarin crimson and established the plate on which the pot sat with light washes of cerulean blue and Payne's gray.

I used an elephant-ear sponge dipped in a half-pan container of burnt umber to dab on the texture of the soil, and then used a brush to give the appearance of shadows being cast by larger clumps of dirt and the side of the pot. I had to hold a piece of scrap paper over parts of the painting to avoid having the sponge texture extend too far.

6 Using washes of burnt sienna, yellow ochre, and burnt umber, I defined the tabletop, carefully observing the shadows cast by the plant, pot, and plate.

7 I added thin grain lines with a no. 4 brush and fairly opaque mixtures of burnt umber and burnt sienna. These lines are actually made of a random pattern of dots and dashes that I made by lightly touching the brush to the surface of the painting. The two patches of reflection on the edge of the table were made by wetting the surface of the paper and lifting paint off with a tissue.

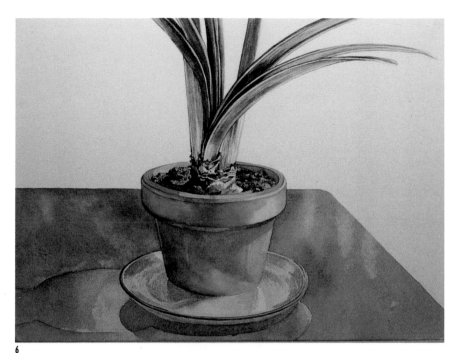

6

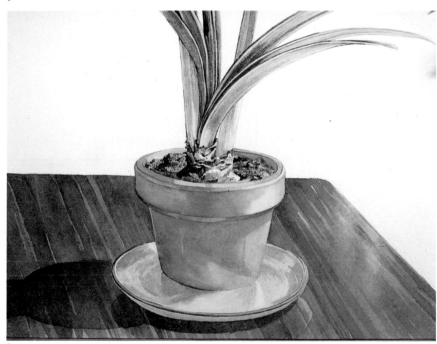

7

8 After staring at the painting for days, I finally decided to try out an idea I had been thinking about for some time—a backdrop of what might best be described as an abstract expressionist painting imbedded in marble.

I looked through a number of interior design magazines carrying reproductions of marble surfaces and made some studies of a marble cutting block to determine how best to paint a convincing picture of marble.

8

9 I divided the background into rectangular shapes with a T-square, then painted various wet-into-wet patterns in each section. I varied the use of three washes—Payne's gray, indigo, and burnt sienna—giving each imaginary slab of marble a different pattern of lines, solid shapes, and colors. The thin vertical panel served as a dividing point in the symmetrical pattern of five of the six panels, with the one panel behind the blossoms being the exception to that compositional balance.

10 Before the painted panels were completely dry, I went back into each area and applied darker, thinner lines to further establish the appearance of marble. These lines tended to blend into the existing paint and became lighter in value as the surface dried, so I went back with a thinner line after the paper was completely dry.

There is a certain random, fragmented character to the pattern of marble, so I kept reworking the surface of the painting with light washes of color, lines dragged along in an irregular pattern, and tints of random color splashed into each panel.

Most of the panels of marble I had observed in trying to determine how to paint this imaginary background seemed to have beveled edges. The way those slanted edges caught the light or introduced a shadow seemed to give a sense of weight to the stone. For that reason, I included beveled edges around each of the panels I painted.

The final area to be painted was the patch of floor visible to the right of the table. I decided to invent a floor of black marble that served to push the space down and back, away from the other objects. It also helped to give a sense of depth to the wall and floor molding.

Further details were added to the tabletop, pot, and leaves using two small brushes, a no. 0 and a no. 00. I also introduced colors from one area of the painting to another. For example, I applied some red to darken the green stalks and leaves and laid a light wash of green over some of the red blossoms.

Finally, I repainted the patches of opaque white (Chinese white) on the largest blossom to approximate the dull white reflected light on the silky petals.

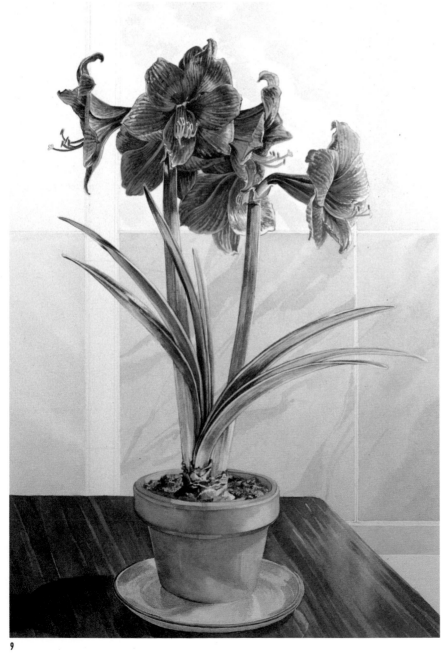

9

AMARYLLIS
1987. Watercolor,
29½″ × 19½″ (74.9 × 49.5 cm).
Collection of the artist.

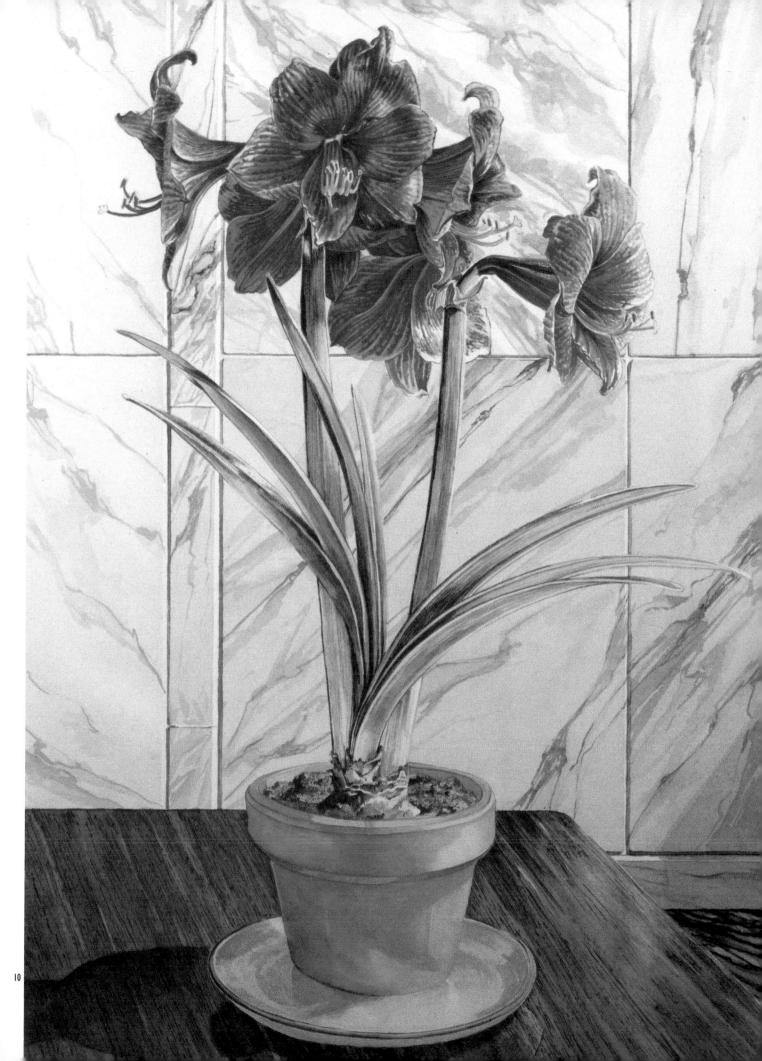

Developing an Image for a Watercolor Painting

There is a difference of opinion among artists as to whether the act of painting should be spontaneous, unrehearsed, and immediate or planned, controlled, and gradual. Furthermore, there is even more debate as to whether the execution of preliminary studies predisposes an artist to one or the other of those approaches.

One color field painter I knew has an established way of developing images—first in pastel sketches and then in oil studies—and he feels that these allow him to be more free and responsive as he creates his large, gestural paintings. Another artist spent years studying the human anatomy, and he feels his instinctive understanding allows him to draw and paint the figure more freely than someone who does not have that knowledge. A third friend would disagree with

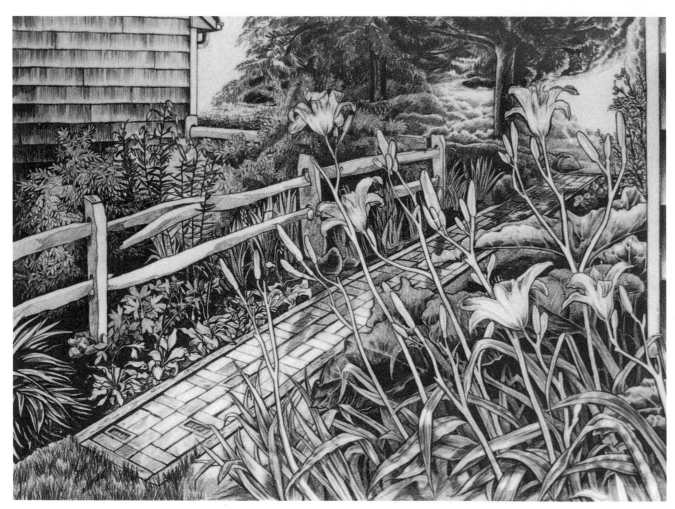

GARDEN PATH I 1985. Litho crayon, 23″ × 31″ (58.4 × 78.7 cm). Collection of the artist.

I taped a piece of printmaking paper to foamboard, locked that into my portable Charvoz-Carsen easel, and started drawing the garden path from direct observation. I used a no. 2 Negro pencil, a grease-based pencil manufactured by Koh-I-Noor. The manufacturer no longer makes Negro pencils, but some retailers still have them and similar drawing pencils are available from other manufacturers.

Because there is a strict limit to the amount of drawing that can be done outdoors, I worked on this picture for several

weeks, beginning each section with careful outlines that were filled in with marks characteristic of that object. The filling-in work was done in my studio with the paper lying flat on a table; all the critical marks were done while standing up outside.

Because of the complexity of the black-and-white composition, I had to exaggerate the values of certain overlapping shapes, like the daylilies that stand out in front of the bushes. The flowers were held to a very light value while the darkness of the background was intensified.

both of these artists, for she believes that unless she can confront a subject without any preconceived notion and without labored studies, her pictures are likely to be predictable and unnatural.

Perhaps the only thing all three of these artists would agree on is the right of each individual to go through the process he or she feels is most valuable. I would endorse that idea, but I also believe that an artist needs to try different approaches before being satisfied with one or the other.

The pictures on the next few pages document my efforts to study a single subject over a period of time until I reached the point where I felt I knew it thoroughly and could paint it with complete freedom.

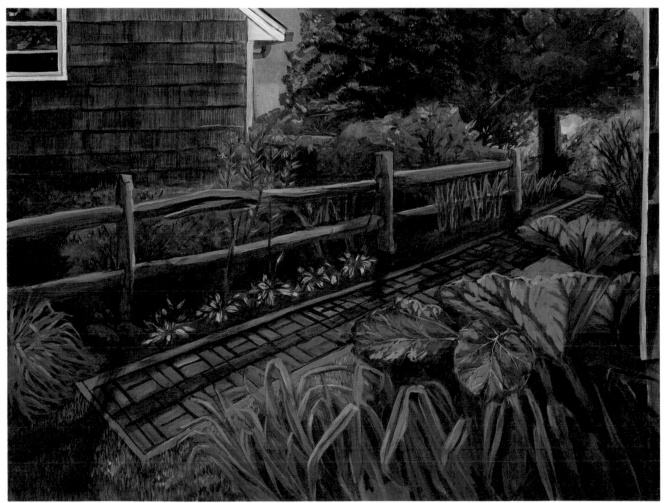

GARDEN PATH 2 1985. Oil on panel, 18″ × 24″ (45.7 × 61.0 cm). Collection of the artist.

A week after finishing the drawing of the garden path, I decided to make an oil painting of the same subject so that I would have a chance to deal with different but related problems and so I would have enough information to use in generating more paintings of the garden.

For the sake of convenience, I decided to work on a toned panel. Stretched canvas sometimes blows around like a boat sail, and a painting becomes impossible to work on when sunlight penetrates the canvas from the back side.

I used burnt sienna to tone the Masonite panel, as I find it gives a warm and vibrant tone to oil landscapes. The basic elements of the picture were sketched in with burnt umber thinned with turpentine, and then the individual parts were established with thicker strokes of paint that had been mixed with fast-drying Liquin alkyd medium.

All of my work was done outdoors because I didn't want to work with smelly solvents inside the house and I felt the picture would be better if I only recorded what I was looking at.

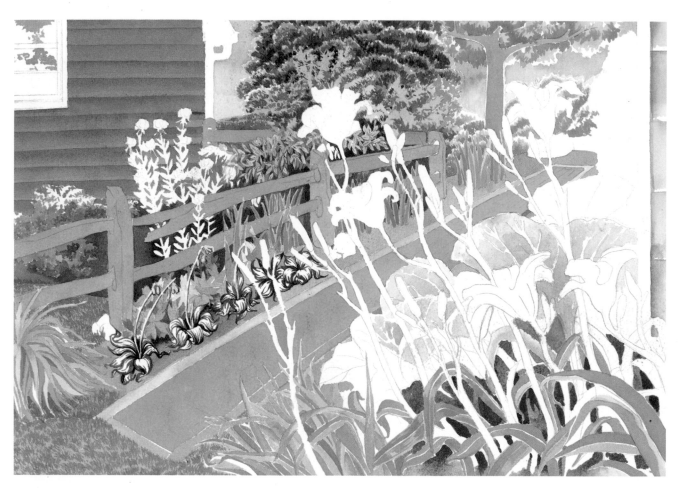

UNFINISHED GARDEN PATH

1985. Watercolor, 14" × 20"
(35.6 × 50.8 cm). Collection of the artist.

Soon after finishing the oil painting, I put it and the litho crayon drawing in front of me and lightly drew a composite of the two images on a sheet of watercolor paper. My intention was to make a painting based on these studies, in much the same way Thomas Eakins made his watercolors from oil studies.

Unfortunately, tension and a fortuitous accident caused me to abandon the painting before I finished it, but the experience of making it helped me to realize something about the need for spontaneity in painting. The problem was that I was trying to copy what I had already done. What I should have done, and eventually did, was allow myself to create a totally new, but related, picture.

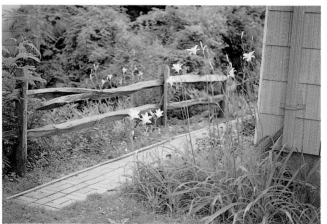

A year after making the drawings and paintings reproduced on the preceding pages, I went back out to the same location and made another attempt at a large watercolor. Some plants had been taken out and new ones planted, so the garden had changed somewhat from the last time I studied it.

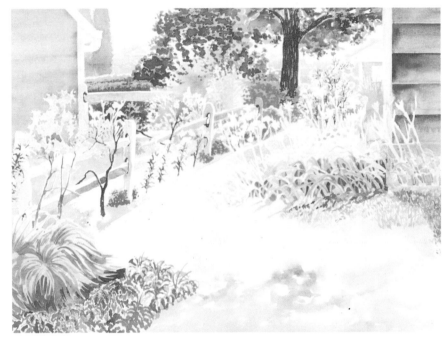

I sat in a chair perched on top of a picnic table when I first began drawing in pencil and then painting in watercolor. I wanted the higher vantage point and the more encompassing view of the garden for this larger painting. This reproduction of an early state shows how I lightly blocked in the basic composition and then started refining specific areas.

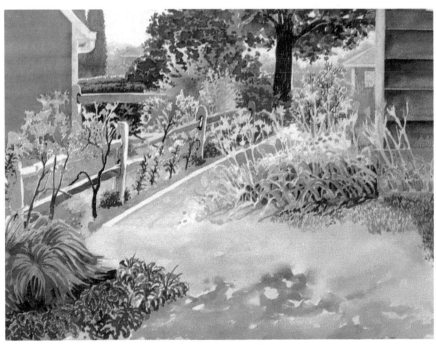

I like the way a painting turns out when you first apply broad, light washes of color in an area and then gradually move to smaller and more specific shapes, applying the paint in more opaque mixtures. You can see that at this stage the grass is still a mass of active brushstrokes while the flowers are sharply defined.

GARDEN PATH 3

1987. Watercolor,
22″ × 30″ (55.9 × 16.2 cm).
Collection of the artist.

I started this garden painting much the same way I did the first two, with direct observation of the garden path. After the initial lines were lightly sketched on the watercolor paper, however, I created a totally imaginary painting of the subject. At some point during its execution I did study the garden, photographs taken weeks before, and the three previous efforts, but for most of the painting I invented what I thought were the best elements.

I liked the idea of this being a small garden squeezed into a suburban lot, with the neighboring houses visible on the left and in the distance, so I added the parts of two houses in the background. I wanted to do more with the criss-crossing spaces in the composition, so I bent and shifted some of diagonal shapes to accentuate that movement.

I had intended to add more details to the flowers, the fence, and houses, but I felt that those kinds of specifics detracted from the drawing so I left them out of the watercolor. Sometimes a picture is better when you maintain some of the rough, general brushstrokes rather than adding so many details that the image no longer looks like a painting.

There is perhaps another and better picture of the garden path waiting to be painted, but for now I feel that this one shows that I've gained something from my two-year study of the subject.

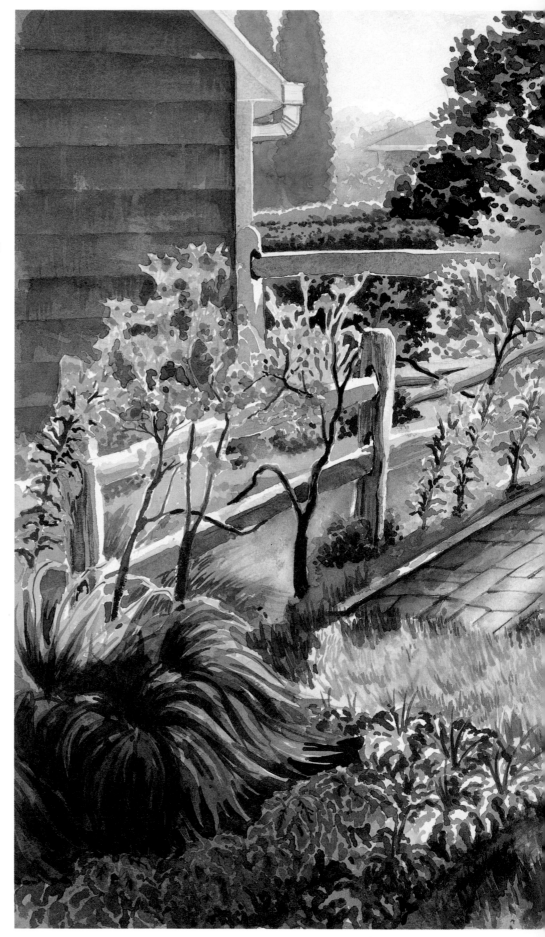

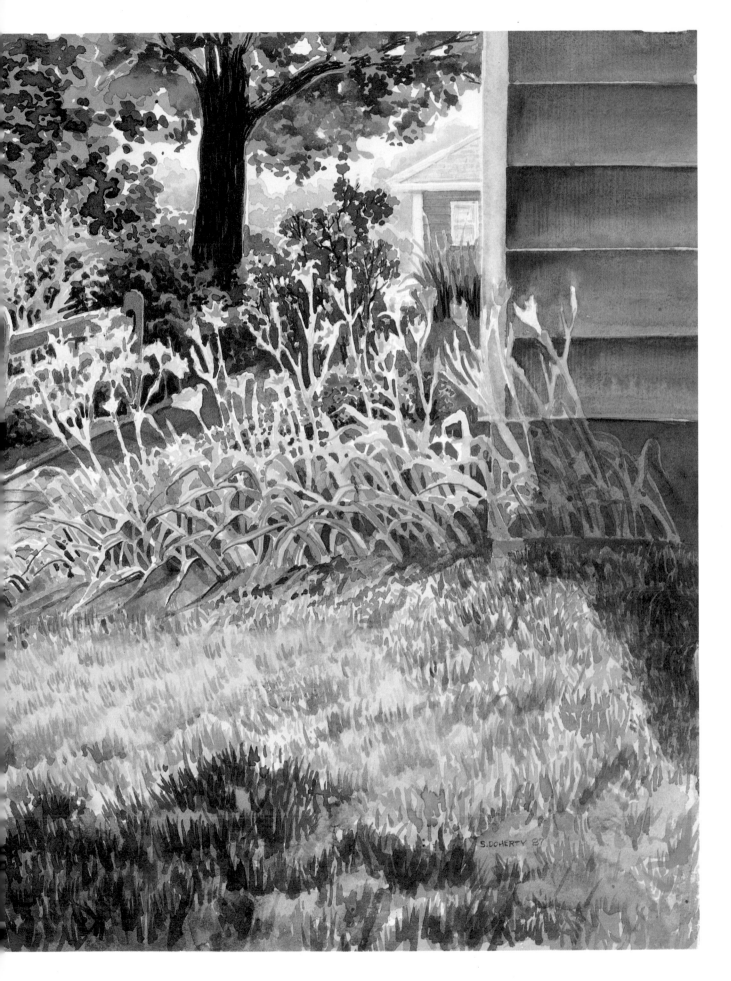

Painting Watercolor Landscapes on Location

The landscapes reproduced on this and the facing page were done on a summer weekend on the farm owned by artists Sondra Freckelton and Jack Beal in upstate New York. The paintings are shown here along with photographs that were taken as I was making the pictures. Each was completed in about two and a half hours, with only minor details being added after I was back in my studio.

Comparing these two paintings to the amaryllis and garden path demonstrations, you can see the different results an artist may get when executing a watercolor in a relatively short period of time on location. Quick, calligraphic brushstrokes of paint were used to create the general appearance of the water, rocks, trees, and flowers in the paintings shown here, whereas details were carefully defined in the other demonstrations.

The procedures followed for painting these two water-

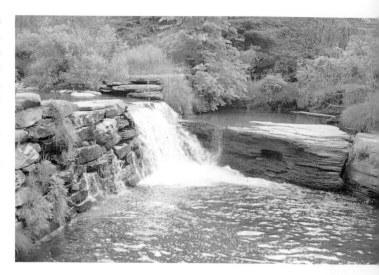

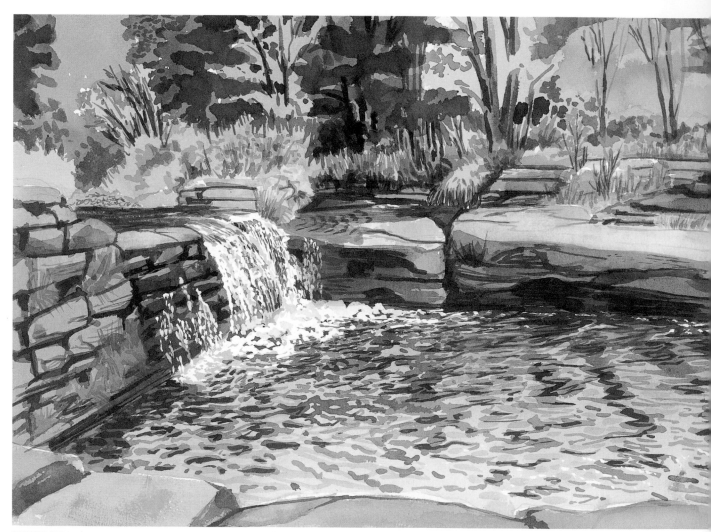

WATERFALL AT THE BEAL/FRECKELTON FARM
1987. Watercolor, 14″ × 20″ (35.6 × 50.8 cm). Collection of the artist.

colors were essentially the same. A light pencil sketch was made on the top sheet of a block of Arches 140 lb. cold-pressed watercolor paper to establish the location and scale of each section of the picture. Next, light washes of color were used to further establish the basic forms, with care taken to preserve the white paper in certain key areas.

For the waterfall painting I used liquid masking agent, or frisket, to preserve the bright white lines of the rushing water. The fluid was painted on with an old brush and allowed to dry. Paint was applied over and around the masked areas, and then the frisket was rubbed off to expose the white paper once again.

After the initial light washes of color were dry, I painted medium value colors, then darker values. With watercolor, you can choose either darker colors or more opaque mixtures of paint as the composition develops from light to dark.

THE BEAL/FRECKELTON FARM
1987. Watercolor, 14″ × 20″ (35.6 × 50.8 cm). Collection of the artist.

Gouache

Gouache paint is often called opaque watercolor because it is quite similar in composition to transparent watercolor and can be applied to look almost exactly like it. The difference is, as you might expect, that gouache is opaque and can be built up with layers of color that either partially or completely obscure those previously painted. That is, the water-based paint can first be applied in thin washes of color, then gradually built up either with dark values being applied over light or with light over dark. Illustrators, architects, and graphic designers often work with this paint because it can mimic both transparent watercolor and opaque oil painting effects and because radical changes can be made in the picture. If an illustrator's client asks to have a color changed, a pictorial element removed, or a texture modified in a commissioned painting, the medium will allow the artist to do so.

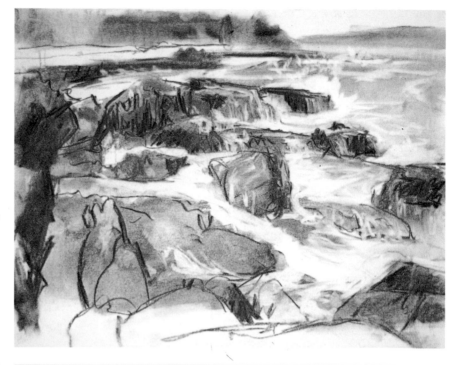

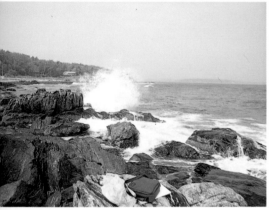

I decided to undertake this painting demonstration while vacationing with my family near Boothbay Cove, Maine. It occurred to me that I could discuss two subjects that I wanted covered in this book: how and why an artist goes about using gouache paints and how an artist might tackle one of the three most hackneyed subjects in all of realistic painting—waves crashing against the Maine (or, in another variation, the California) coastline.

Oh, how many times have we all seen those formula paintings of rolling aqua-colored waves crashing against a shoreline, spraying fountains of foamy white water across rocks? Sure, the artist worked hard to make that oil paint capture the translucent, arched waves when the force of nature was at its peak, but why should there be thousands of paintings of the very same scene?

The answer to breaking any formula, it seems to me, is to look hard at the dangerously seductive subject, discover

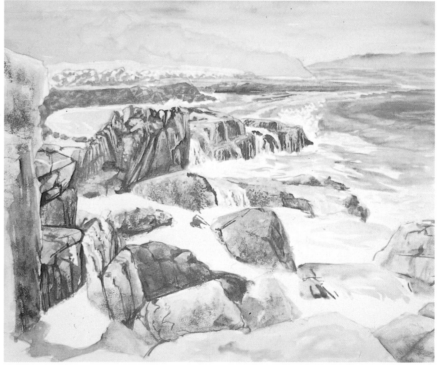

what makes it such an irresistible scene, and then ask what new interpretation can be offered. What is most interesting to me as I study what happens to the colors, the composition of darks and lights, and the patterns that make each object identifiable? Which of these phenomena can I describe in my painting?

For this demonstration I applied light washes of the paint with one no. 6 Winsor & Newton Series 7 brush, working with pans of Pelikan paint that are convenient to carry out for location painting.

The paper was bound into a pad of Stonehenge, a 100 percent rag paper that is strong enough to accept large quantities of wet paint without losing its "memory" of the original flat surface.

After walking around the peninsula where our cottage was located, evaluating possible subjects for the painting, I decided on one particular spot where the water would splash into a pile of large rocks, fan out across the tops of those structures, and then fall through the moss-covered cracks and ridges, only to

be thrown back onto the rocks by the next high-tide wave.

I parked myself on top of one of the nearby rocks that never seemed to be bathed by these crashing waves and took some photographs of what I thought would be the focus of my picture. My blue camera bag marks the spot where I sat each afternoon for three or four days as I sketched and painted my picture.

Because of my concern that this painting would ultimately wind up looking like all the other hackneyed paintings I've described, I made a real effort to study possible compositional arrangements in a charcoal drawing. I also felt I could use this sketch in the evening when working on the picture back in our cabin.

I liked the way all the forms in the picture seemed to bend around the rock near the center of the paper, almost as if they were moving away from this central image with a centrifugal force. I exaggerated that implied force and repositioned some of the rocks for a better arrangement of diagonal lines across the picture.

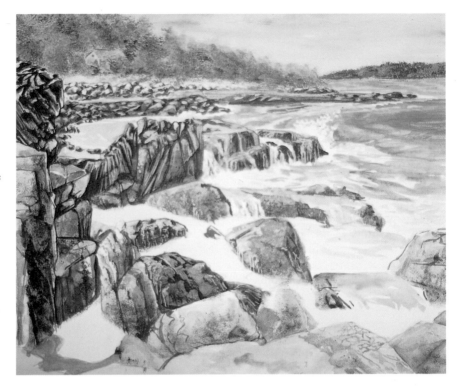

BOOTHBAY COVE
1986. Gouache, 14″ × 17″ (35.6 × 43.2 cm). Collection of the artist.

Acrylic Paints

Though various forms of water-based acrylic paints have been available for decades, it wasn't until the 1960s that they became popular with fine artists. When various forms of hard-edged and pop art styles of painting began capturing the imagination of artists, they became interested in exploring the possibilities of this relatively new medium. The flat, precise, matte surface of the paint appealed to those who wanted to make "anonymous" pictures without brush-strokes—like Roy Lichtenstein's comic-strip pictures and Andy Warhol's Campbell's soup cans. Lesser-known artists appreciated the fact that they didn't have to buy solvents, mediums, expensive brushes, rabbit-skin glue, or any of the other materials required for working with oil paints.

What these artists discovered when they first started spraying, brushing, and smearing acrylic paint was that the medium dries very fast, is insoluble once it does dry, and darkens in value as it dries to a matte finish. When mixed with various additives, the paint can be made to dry slower, can be applied as thick as plaster, and can be made to take on a gloss finish. Acrylics can be applied to almost any absorbent or non-slick surface—cloth, wood, paper, and some plastics. As you might expect, finding new ways of painting that would take advantage of these new possibilities became the focus of a lot of artwork in the 1960s.

Today, all of these possibilities are still available but there seems to be less interest in making experiments just for the sake of experimentation. Artists are more likely to select the approach that they feel most comfortable with and that allows them certain kinds of expression. Three of those approaches are demonstrated in the following paintings, all of which were derived from the photographs that are reproduced below.

HARD EDGED, FLAT-PATTERNED STYLE

Each of these three demonstrations was begun by projecting one or two photographs onto a piece of watercolor paper. The lines defining the objects and their shadows were traced onto the paper and used for a painting guide.

In this demonstration, only one photograph of the man on the scaffolding was used.

Because opaque mixtures of acrylic colors can easily be applied over or adjacent to each other, the paints lend themselves to pictures composed of vibrating, complementary colors. Keeping that in mind, I selected yellow and blue for the man's overalls, pink and purple for his shirt, orange and blue for the background shapes. These weren't creating the uneasy sense that the man was falling into the sharp, angular form at the lower left, so I painted thin lines of color around each of the shapes, using colors that would create that sense of motion.

Emphasizing the diagonal thrust of the figure and the opposing forces of the scaffolding and the windowpanes also helped to build that tension in the picture.

Because acrylics dry quickly and permanently, these continual changes in the painting were quite easy to execute. With oils, I would have had to wait several days for areas to dry that thoroughly, and with watercolors I would have found it impossible to isolate one new color from those previously applied.

Some artists complain they don't like the viscosity of acrylic paints. When used straight from the tube, the colors are stiff and don't flow as smoothly from the brush as other paints. Furthermore, the rapid drying time of the paint makes it difficult to maintain a uniform painting consistency when working over an extended period of time. Those complaints would likely not come from an artist using the approach demonstrated here.

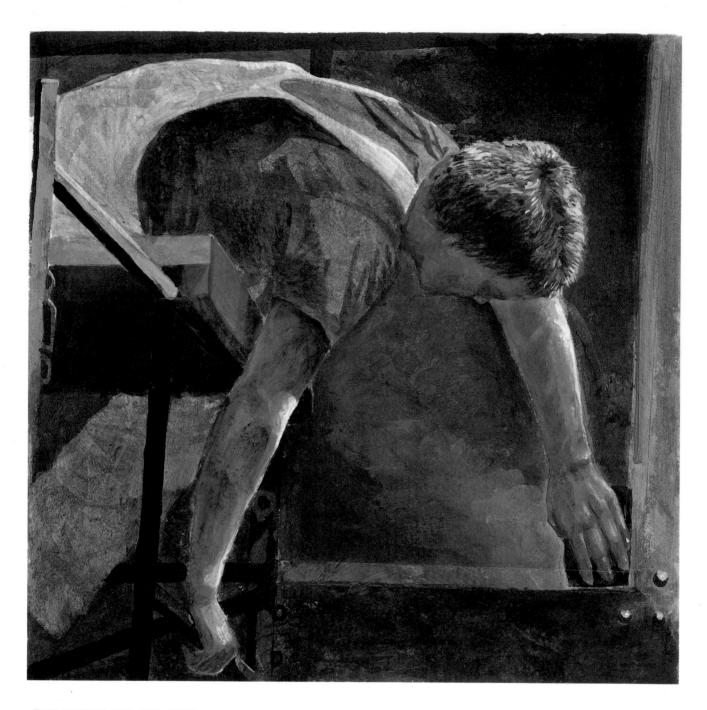

THIN WASHES AND FINE LINES

In order to demonstrate a more "painterly" way of using acrylic paints, one that resembles tempera or oil painting, I reversed the slide photograph of the window washer and projected a close-up view of the figure onto my watercolor paper.

I first painted the basic shapes with solid areas of color, simplifying the picture wherever possible. Next I laid in thin mixtures of colors to build up a rich and varied surface. Because I was using large amounts of water and was therefore diluting the binders in the paint, I added some gloss medium to the washes of color.

After applying bright colors in one section or another, I painted a thin wash of burnt umber over that area to add warmth to the colors and unify them with the rest of the picture. I wanted the bright highlights on the edges of the arms to be particularly strong, so I lowered the value of adjacent areas by coating them with the same burnt umber wash.

Finally, I used a no. 0 and a no. 00 brush to paint thin strands of hair on the head of the figure and to add detailing to the arms. In these cases I used fairly opaque but fluid mixtures of the paint so that I would not have to repeat those strokes.

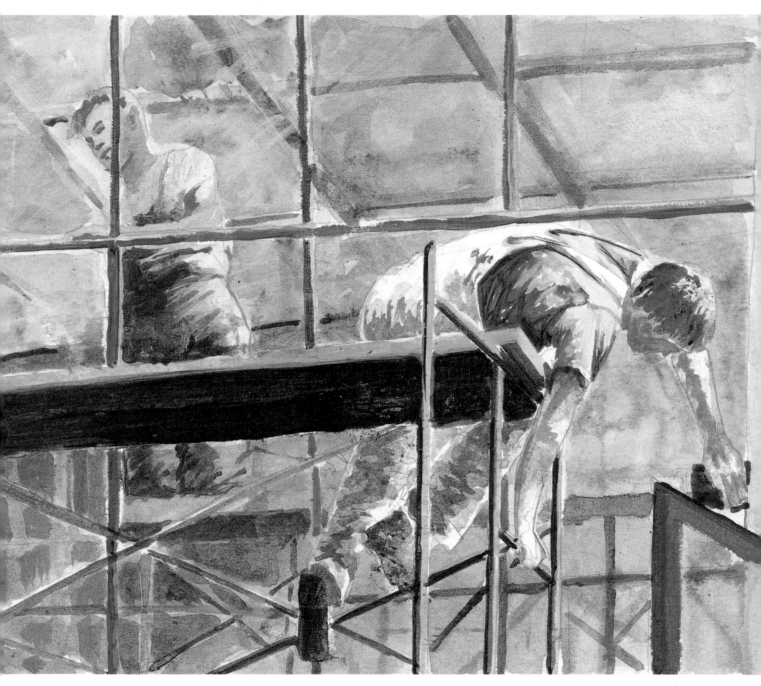

USING ACRYLICS LIKE WATERCOLORS

For this third demonstration, I used the same photograph as before but projected a second photograph of the same window washer, this one taken from inside the greenhouse he was cleaning, in order to get a composition of two figures within a larger pictorial space. Obviously I had to alter the projected outlines of the figures and the greenhouse in order to make a believable picture.

I arranged my palette of colors much the same way I would if I was squeezing watercolors out on a John Pike palette. That is, I put dabs of color around a central mixing area and then started floating those colors into a pool of water. I wanted the colors to mix slightly on the palette so that each brushload of paint would hold a blend of vibrant colors, and I wanted the

wet mixtures to keep the surface of the painting moist for as long as possible.

I started blocking in the lightest areas of the picture, reserving the white of the paper for the bright highlights in the man's overalls and along the edge of his arms. As the painted sections began to dry, I loaded my brush with darker values and hues and applied those to the picture. That process continued until the painting was finished.

In the end, I felt the need for washes of opaque white to create the appearance of the window through which we were looking at the interior figure, so I cleaned my palette, mixed up a wash of titanium white, water, and gloss medium, and used that to suggest the glass.

Egg Tempera

There are three or four artists who are most responsible for reviving an interest in egg tempera painting in this country during the 1930s and 1940s. In the Brandywine River region of southeastern Pennsylvania, artist Peter Hurd introduced the medium to his father-in-law, N. C. Wyeth; his brother-in-law, Andrew Wyeth; and, through them and the rest of the members of their illustrious family, a host of other artists who were interested in the activities of these painters. Paul Cadmus, George Tooker, Jarret French, their friends, and their students in New York also began to use the tedious but inspiring medium about the same time. Soon, many artists were using egg tempera either as an underpainting to oil painting or as an independent medium for expressing carefully composed, highly detailed pictures that depended on a slow buildup of crosshatched lines, tiny dabs and dots, and thin washes of translucent color.

The flowers blocked in with India ink

The back side of the panel

Egg tempera paint is made by combining powdered pigment with a medium of egg yolk and water. It can be purchased in prepared tubes manufactured by the Rowney or Old Holland paint companies. Because the paint can spoil or harden within a short period of time, artists usually mix up small amounts of the paint when they are working and refrigerate the colors during interruptions.

Several formulas can be found in standard artists' references, but the most commonly prescribed is a medium made from 50 percent egg yolk and 50 percent water, with the powdered pigment slowly being added until a paste of workable opacity is achieved. These reference books also advise that one work on a rigid board or paper coated with traditional gesso (not acrylic gesso). The paint

A color sketch done in gouache

surface will become brittle, so the painting surface should not be flexible, and the paint must bind itself to the absorbent gesso coating. For the ultimate protection against cracking, an artist can work on a panel that has been "cradled" on the back by interlocking strips of wood, as in the case of the panel shown at far left, which was made by artist Steve Sheehan of New Haven, Connecticut.

Egg tempera painting is difficult to do on location because the sun reflects off the bright white surface of the panel, the paints dry out more quickly, and the tedious work is difficult to accomplish with an ever-changing subject and constant interruptions. For those reasons, I take photographs and dash off color studies of my subjects, making a deliberate effort to come up with an invented picture that only resembles, rather than duplicates, my source material.

Because creating an egg tempera painting is a long and tedious process, most artists do preparatory drawings of their subject, transfer those drawings to the painting surface, establish the values with an ink wash drawing, and then begin painting. Because most of the colors are translucent, many artists will paint the shadowed areas of the composition with the complement of actual color of a particular object. That is, red would be used to paint the shadow areas of a green leaf, and purple would be used for the shadowed side of a yellow lemon.

For this demonstration, I did a number of drawings of a lily in my garden and finally settled on a circular composition for my painting. The flower was redrawn on the prepared panel with graphite pencil, and the basic values were established in an ink drawing applied on top of the pencil drawing.

I will admit that I was so taken by the beauty of the lily that I went too far in making my painting before I realized I had a dreadfully trite composition. The painting might have made a salable collector's plate for the gift store trade, I suppose, but I just couldn't let myself paint something so sentimental. Using titanium white and ultramarine blue, two fairly opaque colors, I added elements of the garden in which my flower had been growing so that the composition became more interesting. These shapes were then refined and given the same degree of detailing as the flowers in the center of the picture.

Underpainting in complementary colors

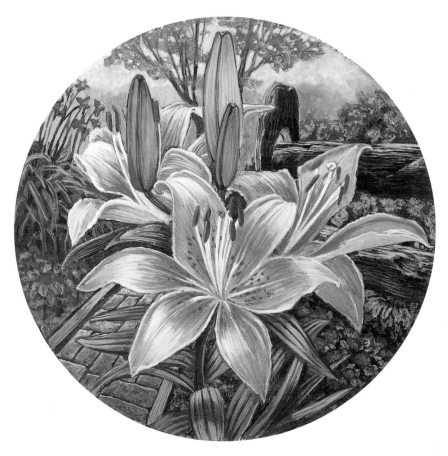

LILY TONDO
1987. Egg tempera on panel, 10¼" (26.7 cm) in diameter. Collection of the artist.

Oil Paints

For centuries the most influential works of art have been created with oil paints. The great portraits, landscapes, still lifes, and marine paintings—those that had the greatest impact on the history of art—have been made with oil paints on canvas or panels.

It is hard to say exactly why the medium has been considered more important than watercolor, tempera, fresco, or other painting media, but the fact remains that even today oil paintings are more prevalent in museum exhibitions and command higher prices in galleries and auction houses.

There are certainly great advantages to the medium—the variety of ways in which it can be applied, the luminous colors, the ease of application on large-scale surfaces. But there are limitations imposed by the physical characteristics of the medium, ones that will cause a picture to self-destruct if painted by an artist who does not understand and respect those limitations.

On the next few pages, I demonstrate some of the benefits and problems of working with oil colors, by painting the same subject six different ways. For each of these six demonstrations I followed practices employed by many artists, though I did not use all of those that could have been em-

ployed. As I have done in previous sections of the book, I kept the subject of the painting constant so that it would be easier to see how the materials and techniques can be used to create unique interpretations of a subject. Since the challenge to an artist is to control both the selection and the interpretation of a subject, this approach will hopefully be helpful in meeting that challenge.

All six of these demonstrations were done on a sheet of 100 percent rag paper covered with two coats of Liquitex acrylic gesso. There are many other appropriate painting surfaces for oil colors—most notably canvas and wooden panels—but I won't spend much time discussing those here. The only important point that needs to be made is that oil colors should be isolated from the paper, board, or canvas on which they are applied. Unless the surface of these support materials is sealed with a material that will keep the oil in the paint from penetrating the surface, deterioration will inevitably occur. There are a number of books and technical papers that describe the best ways to seal the surface of these support materials, and one of those references should be consulted if an artist is going to use anything other than manufacturer-prepared panels and canvas.

STILL LIFE
by Renee Foulks, 1987. Oil,
21½" × 19½" (54.6 × 49.5 cm)
Collection of M. Stephen
and Sara Doherty.

Techniques and Applications of Oil Paints

One of the most academic and traditional approaches to oil painting is for an artist to execute a "grisaille" under-painting, a composition of gray, white, and black colors. Thin glazes of color are applied over this "gray painting" in order to create the actual appearance of the subject. The idea is that an artist can first establish his or her subject matter and a solid composition of values before introducing color in the picture. In the French academies of the nineteenth century, students would spend years

perfecting their skills in making charcoal drawings and grisaille paintings before ever being allowed to mix and apply color to a canvas.

The simplest form of grisaille painting is one made from mixtures of black and white paint, and this demonstration was done with a se-

ries of graduated mixtures of Mars black and titanium white. Another approach might be to use combinations of warmer or cooler grays to make the underpainting; these could be mixed from burnt umber, sap green, ultramarine blue, and white.

Once the grisaille under-painting was thoroughly dry, thin transparent colors were applied over it, causing an immediate transformation of the picture even though very little pigment was being used. Several different mediums, either those available in a premixed form or ones pre-pared in the studio, can be used to paint these thin glazes. A combination of tur-pentine, stand oil, and copal varnish is one of the most common glazing mediums, as is the fast-drying alkyd me-dium called Liquin. The latter was used in preparing this demonstration.

Another fairly traditional approach to oil painting is to work on a canvas that has a "ground," or uniform cover-ing of a medium-tone color. Many artists who first apply a ground to their canvases like to begin their painting process by quickly laying in the brightest highlights and the darkest dark masses. This allows them to make a prelimin-ary evaluation of the composition and then adjust the elements. A second reason artists like to work on a grounded canvas is that the underlying color will show through the semitransparent

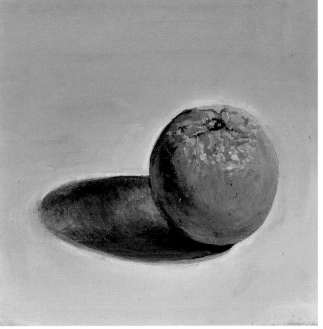

layers of oil color, thus estab-lishing a uniformity in the composition of the picture. A landscape painter might like a burnt umber or a burnt sienna glowing underneath the greens

and blues of the painting, and a portrait painter might want a rosy red to enrich the flesh tones applied to the canvas.

For this demonstration, a cold gray color—one that

matched the mid-range value of the backdrop—was applied over the entire area to be painted.

The reproduction of the fin-ished painting of the orange looks very much like the one completed in the grisaille demonstration. The difference between the two would be more obvious if you could see the actual paintings because they have distinctly different surfaces. The grisaille demon-stration has a smooth, de-tailed surface while the ground demonstration has a coarse, generalized ap-pearance because the colors had to be built up over the gray underpainting.

Next time you are in a mu-seum, look at the older por-trait paintings and you will likely see very thin dark pas-sages and heavily painted highlights. You can tell from seeing one of these portraits what kind of result you might achieve by working on a grounded surface.

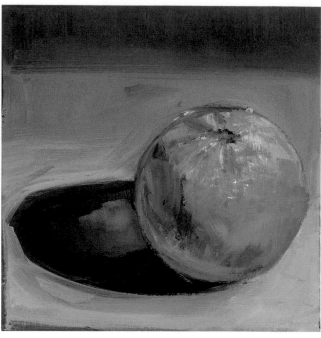

Pursuing the same idea developed in the previous demonstration, I filled the next square area with a uniform acra red oil color and then added a circular form with cadmium orange. The intention here was to establish a bright, vibrant ground on which I could create a more expressive presentation of the subject.

Using a flat bristle brush, I applied fairly thick strokes of oil color on top of the red ground, exaggerating both the color of the orange and the shadow areas. For example, a stroke of blue marks the edge of the shadow directly under the orange.

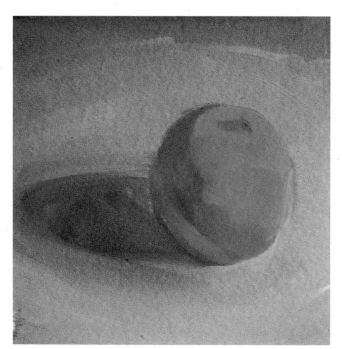

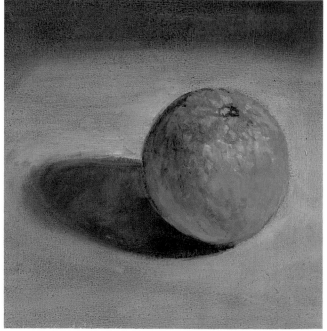

This demonstration aims to show how both underpainting and overglazing can affect the presentation of a subject. A solid square of burnt umber was first painted and allowed to dry, and then the orange and background were painted. After the surface was dry again, I applied thin transparent mixtures of the same burnt umber. The result was a softer, more atmospheric presentation of the subject.

Painting several glazes over a canvas helps to unify the colors within the picture and soften the overall presentation. The technique is particularly useful for achieving subtle transitions of flesh tones in a portrait or a misty hillside set in the deep space of a landscape painting. The glazes can be selectively applied to certain areas, changing the color or opacity as each part of the picture is developed, or brushed uniformly across the canvas.

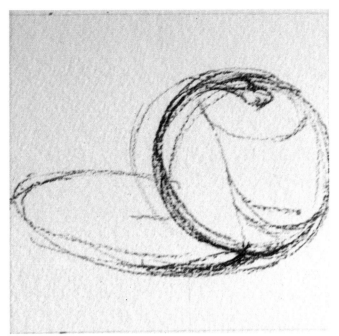

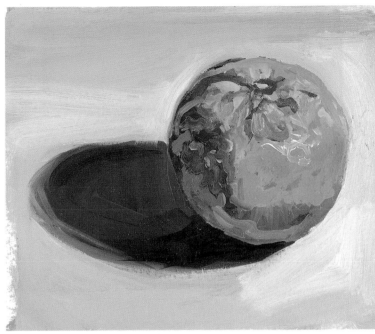

Another of the most common approaches to oil painting is to first make a rough drawing of the subject on the canvas with either a thin, dark oil color or sticks of charcoal. Soft charcoal is preferred to pencil or ink because it does not scratch the gessoed surface, it gives a clear definition to the subject, and it can be obscured with subsequent applications of oil color. Here, the orange was first drawn with a stick of General Pencil vine charcoal and then lightly sprayed with fixative.

The orange was then painted in what is often called a "painterly" style. The term "painterly" indicates that the oil color was applied in fairly thick mixtures, with the marks of the brush bristles remaining visible and apparent. To achieve this quality, artists tend to generalize the appearance of the subject, allowing the viewer to freely interpret what he or she observes.

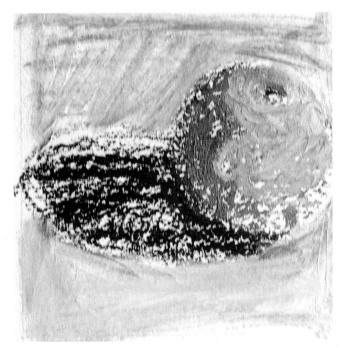

One of the newer products to attract the attention of oil painters is sticks of oil color that can be used like fat, soft crayons. Oil sticks can be used to sketch in the subject with lines of color that are then thinned with strokes of turpentine or built up to create a thick layer of paint.

You should be aware that oil sticks have a hard outer crust because the edges and tip of the stick are exposed to air and therefore dry out or "skin over." The skin of hard paint must be cut or scraped off before using the oil stick.

For this demonstration I first sketched in the subject with Shiva's Artists Paintstik and allowed the rough drawing to dry completely, then applied moist oil color with a flexible palette knife. All of this could be described as an impasto painting technique, one of several that result in thick, highly textured painting surfaces.

Demonstration:
PAINTING WITH OIL

About the time I was finishing up the charcoal still life on page 103, I decided to use the same basic idea of the drawing for a demonstration of oil painting techniques. As with every other demonstration in this book, I tried to select the materials that would be most appropriate to the presentation of my idea. In this case, as with the charcoal drawing, that idea was to record my feelings about life and death with objects, lighting situations, and compositional relationships that symbolized or transferred my feelings.

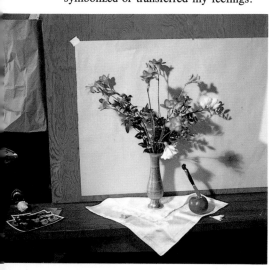

As the photograph of my still-life setup shows, I began by arranging a bunch of freesia blossoms in a brass vase and placing them on a satin napkin. Because the flowers formed a triangular shape, I folded the napkin so that it mimicked that shape.

I came up with the idea of using a decorative knife stuck into an apple to add a sense of uneasiness and uncertainty to the picture—to leave the viewer feeling that there was something menacing about the presentation of these otherwise ordinary objects. To tie them into the composition, I angled the knife so that it roughly followed the outside edge of the napkin, thus connecting the knife's shape to the two triangles.

I find myself attracted to the order and balance of symmetrical compositions, though I recognize that artists must guard against monotony when working with such arrangements in a painting. In this case, however, I thought I could use a symmetrical arrangement of central objects and play them off against a background and lighting situation that were asymmetrical. In so doing, I would have the opposing feelings of balance and imbalance, harmony and discord, order and chaos.

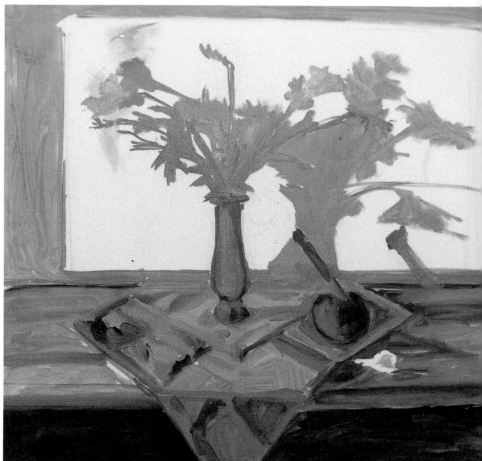

1

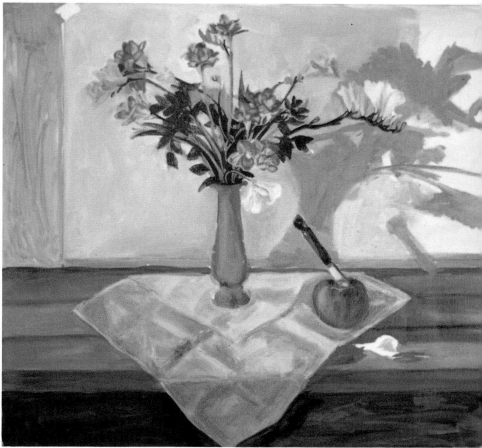

2

Since the idea for this painting came directly from a drawing, I wanted the transition from one medium to the other to be as easy as possible. For that reason, I decided to work on paper rather than canvas or board and to use a fast-drying alkyd medium rather than the traditional combination of turpentine, linseed oil, and damar varnish. The flat, smooth surface of the paper and the quick-drying paint would make it easier to develop the picture in a manner similar to the way I created the charcoal drawing.

Obviously the rag paper on which I worked had to be well sealed with several coats of acrylic gesso or rabbit-skin glue so that the oil paints would never penetrate the fibers of the paper and cause deterioration. I chose to use the acrylic gesso and applied four coats, allowing each to dry thoroughly between applications. The paper was stapled to a thick piece of foamboard so that it would remain flat once it dried. All of this made for a lightweight and portable painting surface.

1 I blocked in the basic shapes of the picture with thin washes of paint, using turpentine as the solvent, and left the white of the coated paper to define the large shape behind the floral arrangement. I recognized immediately that there were weaknesses in the composition, especially on the left side of the picture, but I felt confident enough in the basic arrangement of elements that I could focus in on the flowers before they changed shape or color.

I set the painting outside for a few hours so the smell of the turpentine wouldn't linger in my studio, and then I brought it back in to work on the flowers. I don't like working from photographs, as I've stated a number of times, so I wanted to record as much information as possible about the shape and color of the blossoms before they began to change and new ones opened up. I put the arrangement in a cool storage area whenever I wasn't working so that the changes would occur more slowly. Keeping the spotlights turned off whenever I was mixing paint or cleaning brushes was also helpful in reducing the effects of heat on the plant.

2 I used fairly thick mixtures of Liquin alkyd painting medium and the oil colors so I could create the image of the blossoms as accurately and as quickly as possible. I had to also give some definition to the strong cast shadow because its shape was defined by the flowers themselves and because the contrast between the shadow and the blossoms defined the edges of the light-colored flowers. I also needed to establish the relationship of values between the flowers, the shadow,

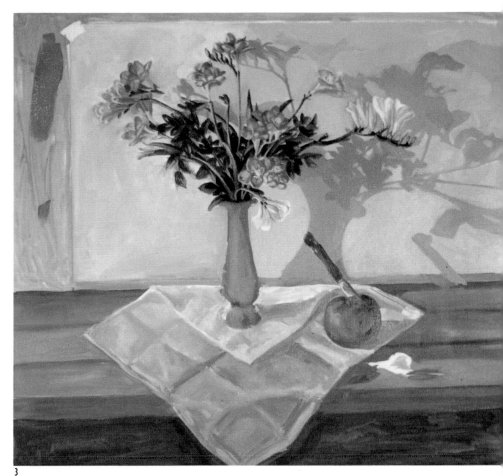

3

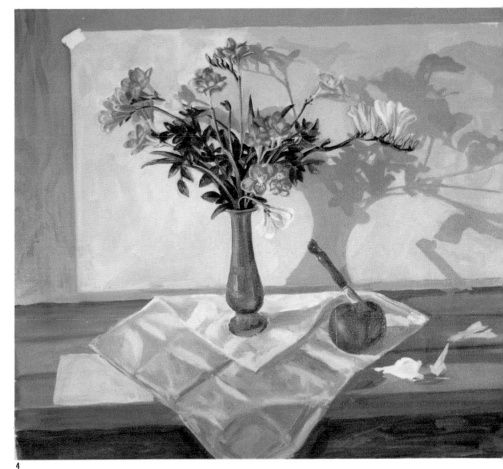

4

and the dark green leaves so there would
be a balance of light, middle, and dark
values.

3 As I finished blocking in the flowers,
I began to consider the plywood
background and dabbed on different mix-
tures of cadmium yellow, yellow ochre,
burnt sienna, and titanium white until I
came up with the appropriate hue and
value. I also added glazes of white over
the pattern of shadows on the satin nap-
kin because I wanted to achieve a soft,
subtle transition of tones that would look
like satin.

4 I was beginning to use smaller
brushes to record the specific ap-
pearance of objects rather than the gen-
eral outlines of those forms. The apple
and knife, for instance, were painted over
several days, allowing time for each suc-
cessive layer of paint to dry.

Going back to my mental notations
about the lack of interest in the left side
of the picture and the incompleteness of
the ideas being presented, I decided to
slip a black-and-white photograph under
the napkin. Photographs become memen-
tos of people and events from our past,
and I felt that including one in the still-
life arrangement, particularly a black-
and-white picture of a formal event,
would repeat the idea that objects can
become statements about the past and the
present—of life and death. We all hold
on to photographs of special moments
and people because they help us recall
both incidents and feelings. You'll note
that I blocked out the shape of the photo-
graph with titanium white, making sure
that it fit into the composition already
established.

5 In the finished painting, you can see
the detailing added to the brass vase,
the texture imposed on the sheet of paper
taped to the plywood, and the figures
painted loosely into the shape of the
photograph The branch of freesia lying
on the bench, and the bench itself, were
also given further definition. You'll note
too that I decided not to have the satin
napkin drape down below the edge of the
painting because I wanted the white shape
in the background to be the only object
to suggest the space beyond the picture
plane.

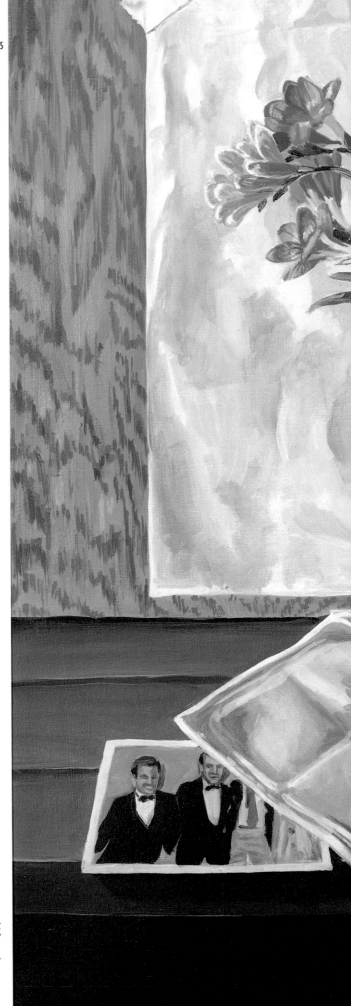

STILL LIFE WITH APPLE AND KNIFE
1986. Oil on paper, 22″ × 23¼″ (55.9 × 59.1 cm)
Collection of the artist.

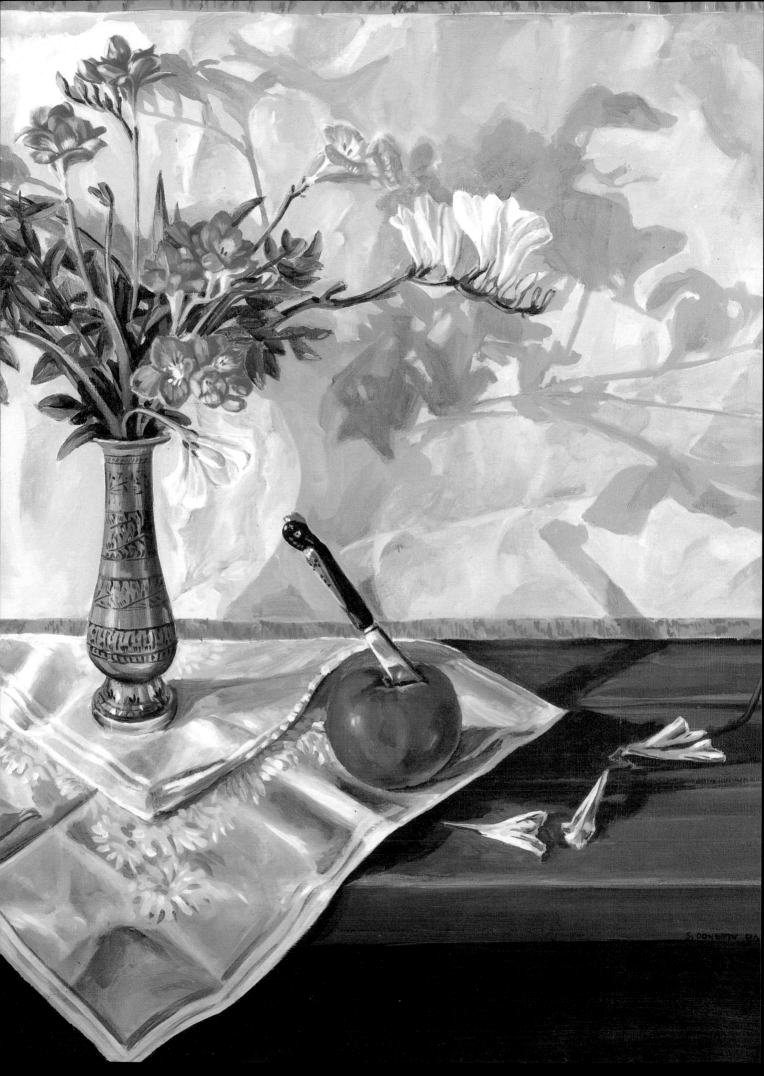

Pastels

Pastels have a great appeal for artists because of the directness and physicality of the medium. Instead of dealing with a slow-drying, smelly medium like oils, or an endlessly variable medium like watercolor, these artists enjoy making direct marks with a stick of pigment that does not change color, texture, or dryness in any appreciable way. Furthermore, there is something quite satisfying about holding the bright pastels in your fingers, moving them around at will, always working right up against the artwork.

There are, of course, several things an artist must understand about the medium before becoming involved in this hedonistic experience. First, the pastels themselves come in a wide range of colors, values, and densities. Some brands are hard, others soft, and no one manufacturer will have all the colors an artist will need. Second, the drawing surface must have enough of a "tooth," or rough texture, to hold the particles of pastel that build up on the surface as the picture is developed. Finally, consideration must be given to whether the surface is to be sprayed with a fixative either during or at the completion of the drawing process.

Because of the physical characteristics of pastels, you cannot readily mix two colors together to get a third—say a blue and yellow to make a green. With those two colors of pastel you are likely to get a dirty yellow or a dusty blue. Some visual modifications can be made as one color is laid on top of or next to another, but most artists who use the medium buy hundreds of different pastels, carefully arranging them so the exact color and value can be selected for each particular segment of a picture. Many artists supplement their collection with sticks that they make themselves using raw pigments and binders.

The drawing surface should be acid-free and sufficiently textured to hold the particles of pastel. This may be a sheet of commercially made pastel paper such as Canson Mi Teintes, which is available in a wide variety of sizes and colors; the white pastel cloth recently introduced by both New York Central Supply Company and Savoir Faire (Sennelier brand); or the various cloths manufactured by the 3M Company that are sold primarily for industrial uses. You can also make your own drawing surface by suspending pumice, marble dust, or some other micro-particled substance in an adhesive liquid and then coating a panel with the mixture. Once dry, the panel will be an excellent surface on which to draw with pastels.

Workable spray fixative can be used during the drawing process to secure what has been drawn and thereby isolate it from subsequent layers of pastel. The spray can add texture to a surface that has become so covered with pastel that it will not accept any more. A light spray of fixative can also be applied over the entire surface of a drawing to hold the particles of pastel onto the paper and prevent inadvertent smearing when the picture is being handled and framed. Spray fixatives can darken the colors in a drawing and can also give the surface a satin or gloss finish that some artists find undesirable. There is no reason a pastel drawing has to be sprayed, though it will be more fragile if left uncoated.

ANNUNCIATION WITH SHEPHERD
by Sigmund Abeles, 1983–85.
Pastel, 40″ × 30″ (101.6 × 76.2 cm)
Collection of the South
Carolina Art Collection.

New Hampshire artist Sigmund Abeles appears in this large pastel drawing with his wife, the sculptor Ann Merck Abeles. He is one of the most skillful draftsmen working with pastels, and he uses the graphic force of the medium to present figures in a loving yet unembellished manner.

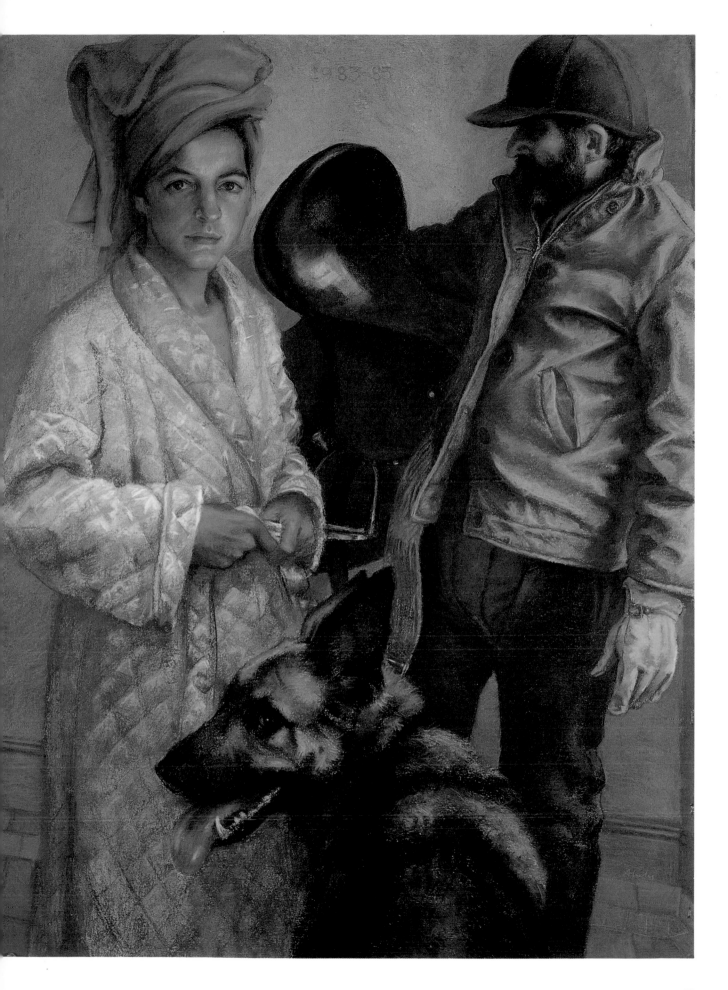

Demonstration

A PAINTERLY APPROACH TO PASTEL

The selection and arrangement of objects for this demonstration, as well as the manipulation of the pattern of lights and shadows, continues the themes explored in the charcoal drawings shown earlier in the book. Arrangements of beautiful spring flowers are illuminated by a light source that makes their cast shadows as important to the composition as the flowers themselves. In this case, the arrangement of flowers was placed on a reflective metal table, and a crystal sculpture was worked into the composition.

My first idea was to change the brown reflective tabletop into a sheet of marble by changing its color and inventing a pattern of veins and textures, as I did in the watercolor painting on page 69. I tried moving a marble cutting board around to see if it would give me enough information to invent the marble surface, but that turned out not to be the case. I decided to simply exaggerate the reflection of the objects in the rust-colored surface.

1

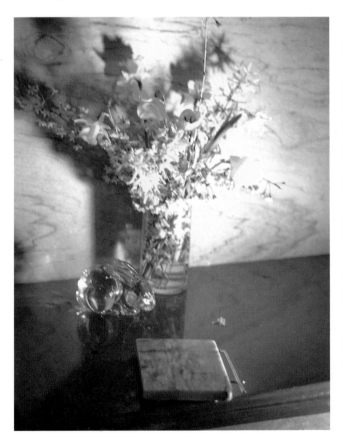

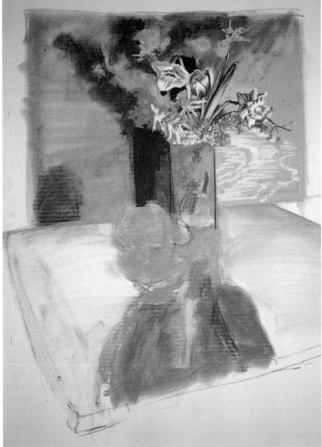

2

1 Just as I had done in beginning the charcoal drawings, I blocked in the basic shapes and divisions of the picture with quick, gestural strokes of a piece of black pastel. My concern was to establish a scale that filled but didn't exceed the dimensions of the paper and to get a sense of the general composition of the picture. As you can see, I deliberately exaggerated the angle of the tabletop to allow me room to include the reflected flowers and sculpture and to add vitality to the picture.

2 I challenged myself to draw as much of the fragile spring flowers as I could during the first day of working in my basement studio. I didn't want to have to replace flowers that would die, nor did I want to work from photographs of the original setup. I preferred to work from my original indications of the flowers and my memory, though as it turned out, the cool, moist air in my studio preserved them for the several days it took to complete the drawing. This photograph of the first stage of the picture shows those preliminary indications of the subject.

3 This detail photograph of the same first stage in the development of the drawing shows that I had recorded enough information about the flowers, the plywood backdrop, and the reflection in the tabletop to invent any part of the still-life arrangement that might change over several days.

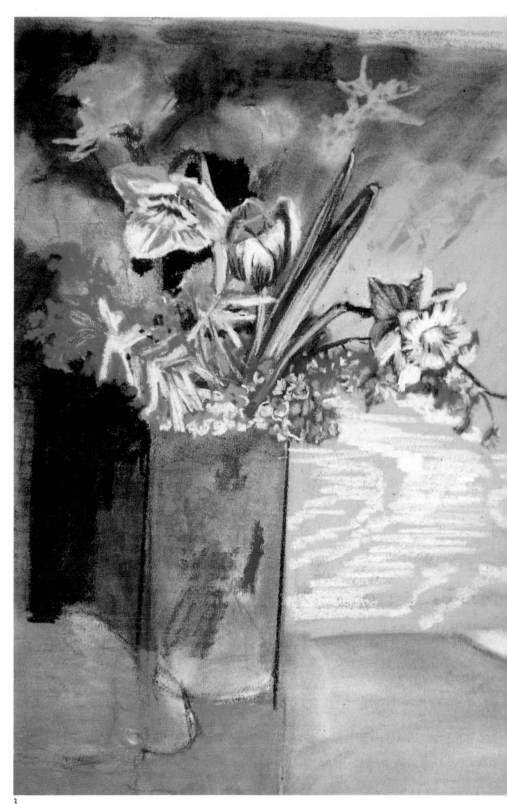

3

97

4

5

4 I continued to refine the flowers and their reflection, building up layers of pastel and then adding tighter, more refined details with Conté pastel pencils. My pastel cloth was stapled to a piece of luan plywood being held by a Charvoz-Carsen portable easel. I prefer working standing up, facing my subject and working directly from it.

5 This detail photograph shows how the surface was building up as I refined the drawing of the spring flowers. It also reveals the blue "underpainting" of the crystal sculpture.

6 The area of the pastel cloth being used to indicate the plywood backdrop was covered first with a stick of burnt sienna pastel and then with a lighter coffee-colored pastel. The second layer was drawn out in parallel lines running horizontally across the cloth so that the texture of the wood would be suggested. Additional lighter and darker colors were stroked on, sometimes in a random pattern, to add further richness to the drawing.

6

STILL LIFE WITH CRYSTAL RABBIT
1987. Pastel,
33½" × 23"
(85.1 × 58.4 cm).
Collection of the artist.

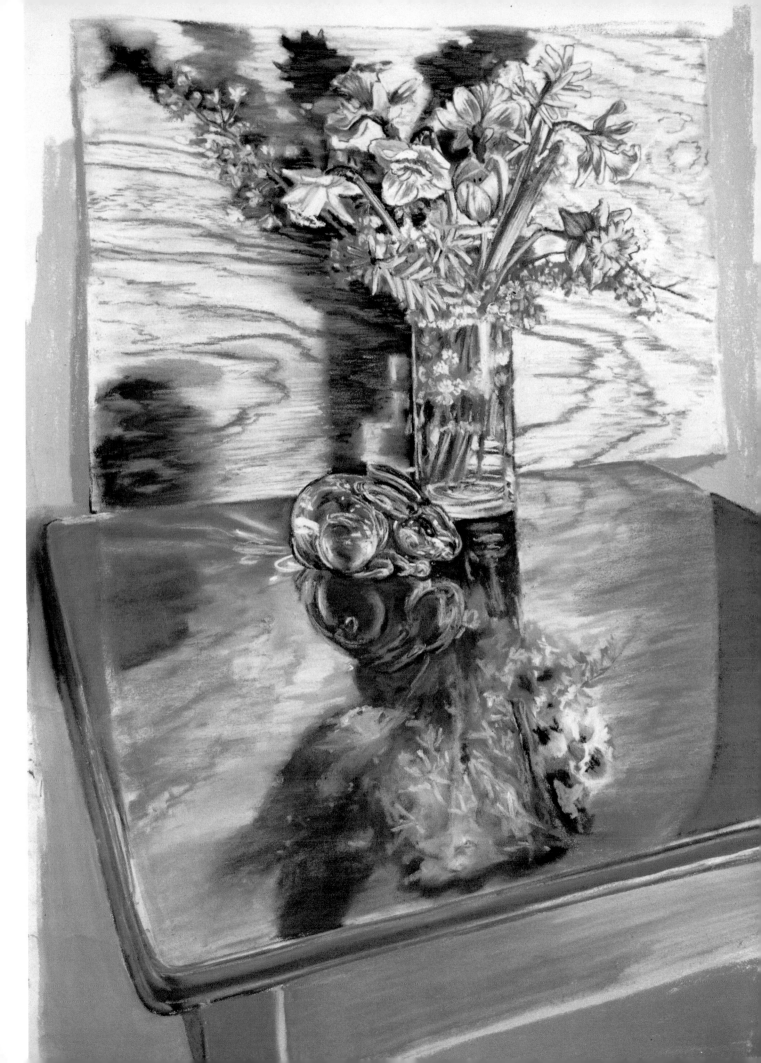

COMPOSITION

The Structure of Expression

The devices with which a painter could bring viewers' attention to one part of a painting and then lead their eyes around the canvas and through a complex illusionary space were perfected during the Renaissance and used for much the same purpose until the late nineteenth century. Every apprentice or art student learned how the control of shapes, gestures, and colors could best serve the intentions of a painting, and each was trained to be so skillful in drawing and painting that he or she could invent objects, poses, atmospheric conditions, and lighting arrangements that were both believable and appropriate. As a result, these artists could place an arm, a drapery fold, or a vase in the position that best served the composition of the painting. The careful study of either the large canvases or the oil sketches made by some of these artists provides a great deal of information about this extraordinary process.

Looking at some of the preparatory drawings made by these artists, you can see the underlying composition of geometric shapes, the directional thrust of body parts and props, and the organization of the pictorial space. The figures and architectural structures are arranged to be unified and consistent with the subject matter of the picture. The madonna and child are arranged in a triangular shape suggesting strength and unity; the line suggested by the soldier's body as he leans backward leads our eye toward some important figure; all the vanishing lines of the architectural elements converge exactly where Jesus' eye appears in the fresco of the Last Supper.

Turning to the paintings that resulted from these drawings, you can identify the adjustments that were made and the way in which color and value were handled by the artist. The less important figures are buried in shadow while the central figure is bathed in light; the deep red robe gracefully flowing across a man's tall frame holds our attention.

As you become more conscious of the deliberate structuring of composition, you can find devices that will be helpful in creating your own paintings. When you study a number of landscape paintings from the seventeenth century, for instance, you find that there is a standard progression from the foreground to the middle ground to the background in almost every picture you observe. The artists of that period learned that an effective way of leading the viewer into a broad expanse of landscape was to have him or her first step across a foreground of plants, rocks, or grasses held in shadow to reach a middle ground of farmers, horses, animals, or noblemen standing in sunlight along a path that led the viewer into a background of a distant village or mountain range bathed in a blue atmospheric effect. The path might wrap around a clump of rocks and trees, or the distant village might turn out to be classical ruins, but the spatial devices used to organize the space within the picture were common to many other landscape paintings of the period.

There are other occasions when composition seems to be more instinctive, as in the case of many late nineteenth- and early twentieth-century painters. These artists have made a conscious effort to avoid academic formulas, which they feel will restrict their creativity, and instead to organize their pictures in a more intuitive manner. Most of George Innes's landscapes are defined by the strong, glowing light of sunset that engulfs the picture, for instance, and there is none of the spatial organization described above. Picasso's figures move around in a shallow space but direct the viewer's attention with exaggerated gestures and distortions of the subject's real appearance. In these kinds of pictures, the process of selection and arrangement of objects within the picture plane seems to be controlled more by the artist's psychological makeup than by his or her intellectual point of view.

The processes by which art is created may be quite different than they were a century ago, but the people who view what artists create still approach pictures and respond to them in much the same way as they did then. Their eyes are likely to follow the lines, colors, and values that the artist has arranged. Therefore, whether artists choose to compose their pictures according to an intuitive or a formalized plan, they will still be giving directional signals that the viewer will be predisposed to follow.

The point I would like to make in this chapter is that an artist should know as much about composition as possible and should use both formal devices and personal preferences to exercise deliberate control of the viewer's attention. To my mind, time-tested formulas can be as useful to an artist as subconscious forces. The devices used by artists of the past to compose landscapes, portraits, or still lifes still suggest intelligent ways of organizing contemporary pictures, and the subconscious tendencies each artist experiences can help him or her offer unique expressions.

WOMEN OF PARIS: THE CIRCUS LOVER

by James Jacques Joseph Tissot, 1883–85. Oil on canvas, 58″ × 40″ (147.2 × 101.6 cm). Collection of Museum of Fine Arts, Boston, Juliana Cheney Edwards Collection.

While this painting may be more of a period piece than a great work of art, its composition offers an interesting study in the way elements can be ordered to control the viewer's attention. There is no question that the artist wanted us to dwell on the fair maiden who stares at us from the crowd of people watching the acrobats.

Demonstration
COMPOSITION

It has been suggested by psychologists that one of the primary motivations for making art is a concern for one's mortality. An artist wants to both hold on to the present and leave evidence of his or her own life. Making a painting serves to freeze a moment in time—a person's physical appearance, the emotions associated with an event, or a spectacular view—so that it can be enjoyed forever. The notion that the painting might last for hundreds of years also gives the artist a sense that he or she will be remembered beyond his or her lifetime.

In making this drawing I tried to deal head-on with death as a subject, not just an underlying suggestion in all artwork. Several people I knew had died within a few months of each other, and I wanted to express my feelings about those losses. I chose still-life objects that might represent these feelings and arranged them so that there was a continuous circular motion throughout the composition—with obvious implications about the circle of life—and a definite uneasiness about what was happening within the picture.

1 This photograph shows what I first came up with as a still-life arrangement. I put a vase full of dead flowers (left over from another still-life drawing) on top of pages torn from the obituary page of the daily newspaper and arranged in the shape of a cross. The two parts of a broken teacup went on either side of the arrangement and a tarnished silver plate was added in the foreground.

2 I started sketching all of these forms on a sheet of lightly sized paper with a stick of General Pencil vine charcoal, inventing the edges of the boards below and behind the objects. Thinking that I needed to introduce a living object into this arrangement of

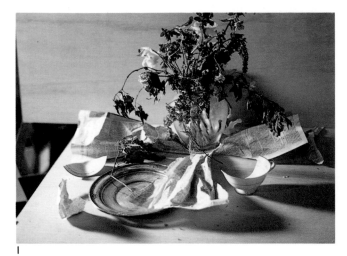

1

2

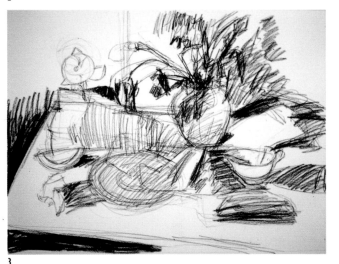

3

inanimate or dead elements, I sketched in a rose in the back at left.

3 I scribbled vine charcoal in the areas of dark shadows and further refined the drawing of various objects. At this point I was analyzing the arrangement of dark and light forms and the direction implied by the lines so that I could see how the viewer might respond to the drawing.

4 The still life was getting to be too depressing with so many dark, dead objects, so I dumped the dead flowers and filled the vase with living flowers and leaves from my garden. The long, sharp leaves seemed particularly good for emphasizing the movement of shapes, and the circular-shaped flowers worked well too.

5 Using a kneaded eraser, I removed some of the lines laid in earlier and started sketching in the flowers before they died or changed shape. I rubbed all the charcoal into the paper so I could start to build up the tones of the drawing, then added the second and third layers of soft charcoal to the darkest areas of the composition.

6 I wanted to establish the appearance of the flowers before they began to wilt or die, so I lightly sketched in the location of each blossom and then carefully and completely drew one daylily and a couple of daisies. Before the end of that drawing session I also made a quick indication of the pattern of shadows on the undrawn flowers so I could complete them even if they changed shape before the next drawing session.

7 I continued developing the flowers and leaves and began darkening the cast shadows.

STILL LIFE WITH BROKEN DISHES
1986. Charcoal,
18″ × 24″ (45.7 × 61.0 cm).
Collection of the artist.

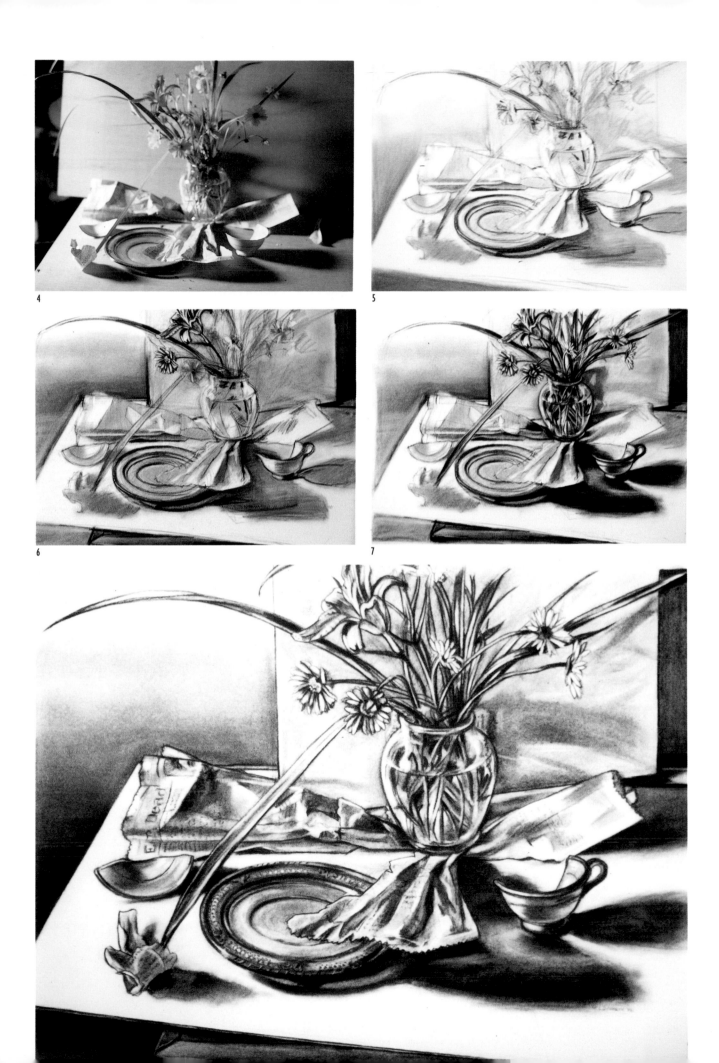

4

5

6

7

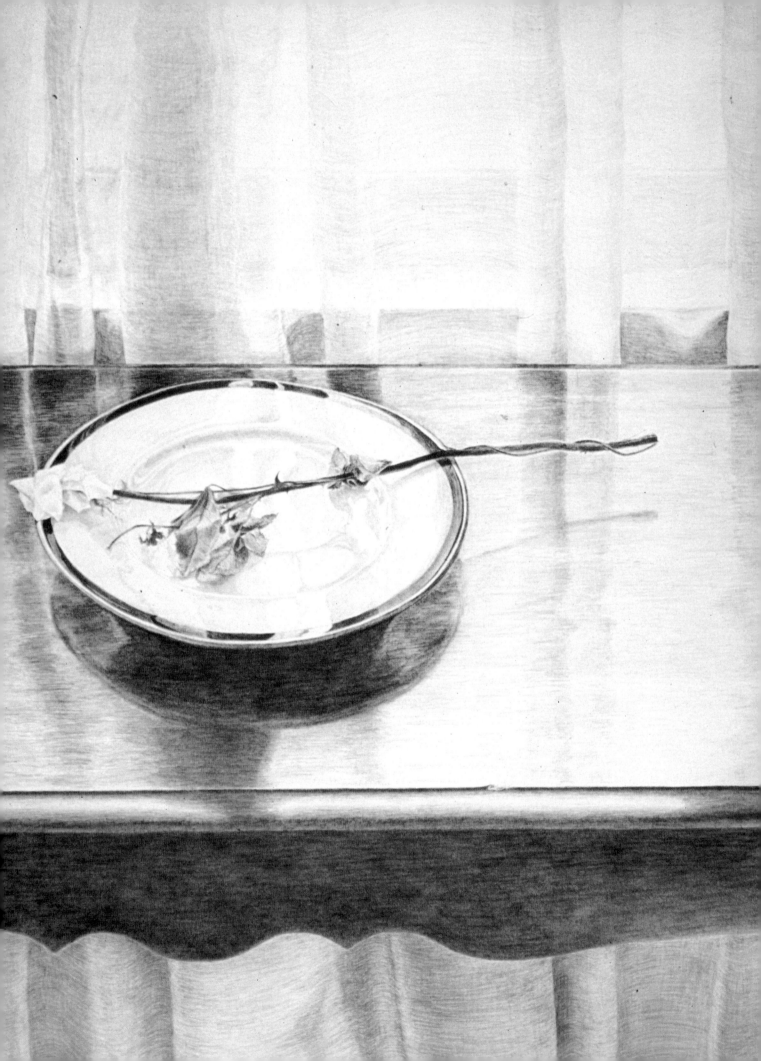

THE ROSE FROM LARRY'S FUNERAL
by Roger Mark Walton, 1986.
Watercolor, 22" × 30"
(55.9 × 76.2 cm). Collection of the artist.

THE ROSE FROM LARRY'S FUNERAL
by Roger Mark Walton, 1985.
Graphite, 30" × 22"
(76.2 × 55.9 cm). Collection of the artist.

About the time I was finishing the still-life drawing shown in this demonstration, I came across the reproduction of a watercolor I was sure was inspired by the same emotions. Roger Mark Walton's painting was given an award in the annual competition organized by the Ohio Watercolor Society and was shown in the catalog.

I wrote to Walton and he was kind enough to send a long letter describing his painting and the drawing that preceded it. Walton, who is a young artist living in Dayton, Ohio, described the creation of the watercolor entitled The Rose From Larry's Funeral: *"This was an extremely personal work for me. Larry and I were close friends for eight years, and for the last two of those years he suffered with a terminal illness. After his death I wanted to express a part of what I was feeling, so I took the wilted rose I kept from the funeral and considered how it might be used to represent the beauty and fragile nature of life. I did the drawing first and then felt compelled to move in closer on the subject for a watercolor painting."*

Demonstration

HORIZONTAL AND VERTICAL COMPOSITIONS

One aspect of composition that is of particular concern at the beginning stages of a drawing or painting is the overall shape of the picture and the way in which the subject will fit within that shape. This may seem elementary, but many pictures fail because the artist didn't give enough consideration to the allocation of space within the picture he or she created.

As this brief demonstration makes clear, a quick sketch or two will give a fairly good indication of how a subject would look in two different compositional arrangements. In trying to determine the best approach to a painting of the crabapple tree in my front yard, I did two charcoal sketches of the tree on one sheet of paper, one sketch distorting the actual appearance of the tree to fit within an elongated vertical shape, the other flattened out to work in a horizontal space. The photographs of the tree make it easy to gauge the distortions.

I finally decided on the horizontal format because I felt it gave a better sense of the sprawling tree and the thick bushes behind it. I redrew the subject with light pencil lines on a piece of paper and did a watercolor of the subject.

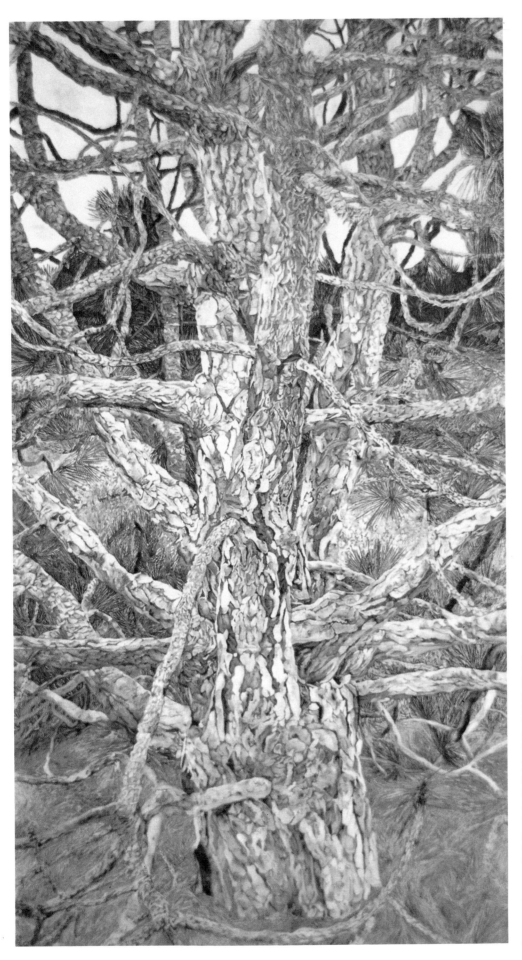

UNDER THE COULTER PINE

by Patricia Tobacco Forrester, 1976. Watercolor, 76" × 40" (193.0 × 101.6 cm) Collection of the artist.

The drawings of the tree reminded me of the work of noted artist Patricia Tobacco Forrester, so I thought it would be interesting to reproduce one of her paintings. As you see, Forrester creates an imaginary world of tangled tree limbs, vines, and vegetation with her watercolors, sometimes allowing the pattern of these natural forms to extend over several sheets of paper.

Ways of Analyzing Composition

The subject of composition deserves an entire book by itself, for there are many ways an artist can and should look at the structure of pictures. The purpose of this brief discussion is simply to introduce the notion that an artist can isolate certain aspects of either the subject of a picture or the representation of that subject in a drawing or painting. Once those aspects are isolated, the artist can better analyze and improve the composition of the picture.

To illustrate a few points about composition, I made several diagrammatic analyses of the composition of one of my watercolor paintings. The idea behind the painting was to create an imaginary scene of a man rowing across a peaceful body of water in a scull.

Even in abstract painting, horizontal lines automatically suggest a landscape, and indeed, a horizontal composition is usually the most convenient way to present a broad vista. But as I drove around the reservoir looking for a vantage point that would be both interesting and clearly identifiable as the reservoir, I kept coming up with horizontal compositions that had an unbalanced arrangement of forms. Everything important seemed to be happening on one side of the picture, with the other side being totally vacant. Finally, as I walked into the woods, the most logical solution to my problem presented itself: a vertical composition arranged so the viewer would stare through a dark foreground, past soaring trees, to a view of the water. That composition offered a balanced arrangement of shapes and suggested the idea that the man in the scull was at peace with himself.

The four diagrams at right demonstrate the compositional considerations going through my mind as I sat on a rock painting this watercolor. The most important of these considerations is indicated in diagram 1. In order to fit the line of the scull into the picture, I had to carefully balance the lines of the spillway, the hills, and the foreground shapes. I wanted the figure to be obvious but not the only point of interest in the picture. I didn't want anything moving in the same direction as the scull, nor did I want every force to work against the important shape.

Because I was working with transparent watercolor and had to plan the gradual development of values from light to dark, diagram 2 explains the second most important compositional arrangement. I had to constantly keep in mind that I wanted the water to be rendered in the lightest values, the mountains in middle values, and the foreground in the darkest values. Toward the end of the second painting session, I found myself using a toothbrush to lighten the distant hills and the reservoir, and semi-opaque mixtures of paint to darken the foreground shapes.

Diagrams 3 and 4 show the kinds of considerations an artist can make both during the painting process and at the later stages of development. Some linear and curvilinear shapes help the composition while others detract, and it is the artist's job to either add or subtract those shapes as required.

DIAGRAM 1: Diagonals that project space, move the eye across the picture

DIAGRAM 2: Pattern of darks and lights

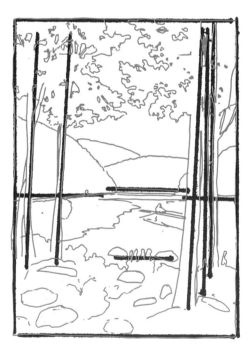

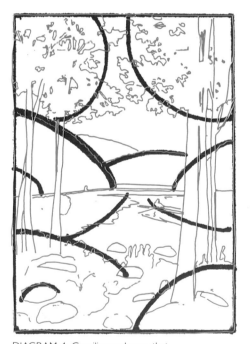

DIAGRAM 3: Horizontals and verticals

DIAGRAM 4: Curvilinear shapes that slowly move the viewer's attention.

SCULL ON THE RESERVOIR
by M. Stephen Doherty, 1987.
Watercolor, 20″ × 14″ (50.8 × 35.7 cm).
Collection of Philip Malazzo.

KNOWING YOUR OWN TENDENCIES

Looking over a body of work helps an artist assess his or her accomplishments, and it makes certain recurring patterns and themes more apparent. Sometimes, the recognition of the less obvious theme running through a series of pictures will suggest something about the artist's natural instincts.

The value of this kind of analysis occurred to me one day when I was staring mindlessly at two of my own pictures. A large drawing was hanging above the fireplace in my living room and a small gouache painting was on the adjacent wall, and as I looked at them it suddenly occurred to me that they were structured around almost the exact same composition. A strong diagonal line cut across both of the pictures from the lower left to the upper right, and a rhythm of shapes was repeated elsewhere in both pictures.

As I looked around the house at other drawings and paintings, I began to realize that many of them had very similar compositions. I wasn't quite sure why I had been gravitating to this arrangement of forms, but I suspected there was something subconsciously satisfying about having the world arranged according to this left-to-right diagonal thrust. I began to believe that must be the case when I looked at the drawing *Still Life With Broken Dish* (page 103) and realized that in trying to compose a picture about death, I reversed and rearranged that instinctive balance.

The question of what to do with this kind of self-knowledge is difficult to answer, but as with any other aspect of life, the more conscious we are of our tendencies, both conscious and subconscious, the more we can control our actions. Perhaps we want to yield to the tendencies that satisfy us, or perhaps we want to add variety to our expressions by altering those tendencies. I know that, at the very least, I am now more conscious of my own actions.

GARDEN PATH I
1985. Litho crayon,
23" × 31" (58.4 × 78.7 cm).
Collection of the artist.

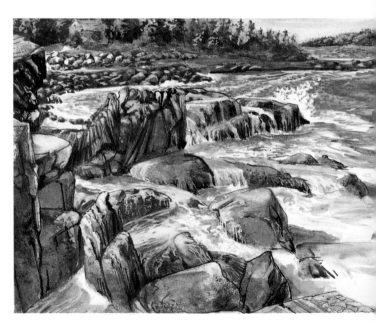

BOOTHBAY COVE
1986. Gouache,
14" × 17" (35.6 × 43.2 cm).
Collection of the artist.

Compositional analysis of *Garden Path 1*.

Compositional analysis of *Boothbay Cove*.

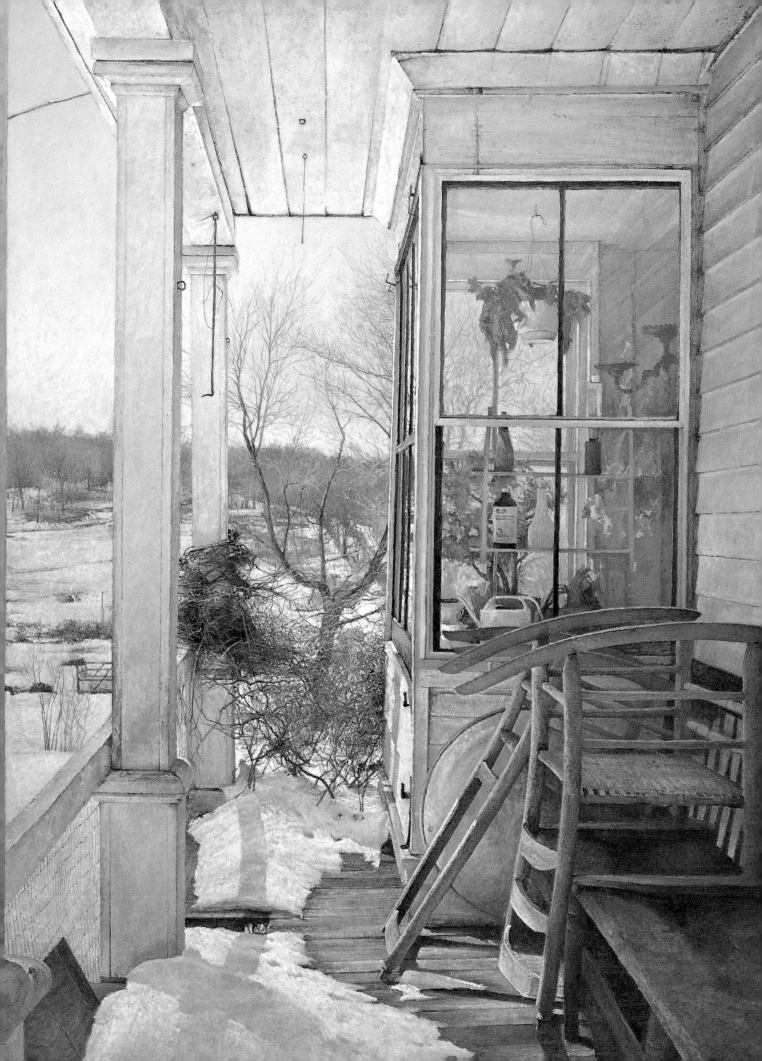

INSPIRATION
The Elusive Source of Ideas

Up until this point in the book I have examined the physical characteristics and applications of drawing materials, and I have suggested ways of pursuing ideas with these materials. The aim has been to either present the ideas completely in drawings or express them in both paintings and drawings. But one critical question I have not even asked, let alone answered, is where do these ideas come from?

I seriously considered addressing that question in the very beginning of this book because I find that many artists, particularly beginners, are at a complete loss for exactly what to draw or paint. What they tend to do is accept the subjects and styles suggested by their teacher or workshop leader, never questioning whether those approaches are really appropriate for them. As a result, I see thousands of artists who have done nothing more than copy or adapt the work of their teachers. They may paint a slightly different barn or flower or costumed figure, but the teacher's influence is so strong that the picture might just as well have been done by him or her—on an off day! I decided to address this important question now, after having discussed a process by which fresh, original, and personal expressions can be uncovered. Drawing can be that process of self-discovery, and this chapter is a discussion of the kind of subject one might explore through either drawing or painting media.

Make sure that the voices of your teachers are not overpowering your own when you consider how to execute these pictures. If the rules you've heard about color combinations, opaque and transparent paints, or compositions get in the way of your honest response to a subject, then break them. Just because your teacher never used earth colors, or didn't do preliminary drawings, or wouldn't allow you to combine compatible materials does not mean you must stifle your interest in those approaches.

Likewise, the influence of great artists whose paintings you have long admired must be minimized as you search within yourself for an artistic voice. Andrew Wyeth, Winslow Homer, and John Singer Sargent may be inspiring, but the seductiveness of their paintings should not lead you to mimic those artists' expressions. Painter Rob Evans, for example, whose work appears on the following pages, made a conscious effort to avoid the similarities that existed between his early work and that of N.C. and Andrew Wyeth. The surface of his paintings may still suggest the richness of a Wyeth egg tempera, but the image is clearly and distinctly the creation of Rob Evans.

When I discussed this chapter with a good friend of mine, he expressed concern that I was going to discuss so many negative influences on the development of a fresh and original style that I would wind up making people overly self-conscious about that development. His feeling was that people will eventually find the most appropriate subject matter and style of expression if left to work on their own. "Introduce them to the ideas that have concerned artists through history," my friend advised, "and encourage them to explore those ideas on their own. The art world is overpopulated with people who have strained too hard to be original."

My friend's concern was for what has been called the "Seventh Avenue approach to artwork." That is, like the fashion industry that is headquartered on Seventh Avenue in New York City, many artists feel that they have to come up with something that looks radically different from what's currently hanging in galleries and museums, or else they won't be noticed. As a result, they offer changes that correlate to changes in hemlines or waistlines—superficial and obvious variations on the current fashions. In the end, those artists are forgotten as quickly as last year's hat or dress.

So, in deference to my friend, I should caution that an artist is as apt to reach a dead end in painting by placing too much emphasis on being different as he or she is by becoming a clone of some famous artist.

But how do artists find ideas that meet all the criteria I have been establishing? How does one break from teachers and inspirational artists to arrive at a subject that is worth painting and a style that is worth pursuing? The answer is one that presents itself after a long series of experiences. If an artist keeps asking the question as he or she studies with this artist or that, reads books and looks at exhibitions, and creates lots of drawings and paintings, the answer seems to arrive. The artist looks at a collection of his or her work and sees that a direction has already been established. At that point, the past makes sense and the future seems obvious.

PORCH ROCKERS
by Peter Poskas, 1984. Oil, 52" × 40" (132.1 × 101.6 cm). Private collection.

When he first began painting, Peter Poskas was strongly influenced by the work of Andrew Wyeth. Through the years, the style of his work has changed to the point where Wyeth's influence is no longer apparent, but Poskas still follows the master's practice of painting the places where he lives. For Poskas, that means devoting his attention to the landscape and the structures of northwestern Connecticut.

ROB EVANS
Drawing What You Know

Artist Rob Evans has been quietly working long hours in a house that is part of his mother's family homestead in Wrightsville, Pennsylvania. The rooms of the farmhouse, which is buried in the woods on a hillside above the Susquehanna River, provide not only the workspace but also the subject matter for Evans's graphite drawings and mixed-media paintings. As he paints the subtle changes of light, the ordered simplicity, and the arrangement of interior spaces of this familiar home, Evans creates a portrait both of the structure he has known since childhood and of himself. As he walks through rooms evaluating the walls, stairs, furniture, and rugs for possible inclusion in a picture, he sees both the abstract forms and the parts that make up his own life experiences. Some of them were selected and arranged by him; others were passed down by relatives. The paintings of these objects and spaces convey his feelings and evoke in the

viewer's mind the same sense of importance that domestic scenes can have.

The approach that Evans has taken to establishing the subject matter of his pictures is one that many other artists have used successfully. By focusing on their immediate surroundings and pursuing one limited range of local subjects in a series of pictures, these artists have come up with original autobiographical subject matter.

Any artist can try the same approach by walking around his or her apartment or house shuffling through drawers of collected objects or by strolling through the neighborhood. If you try this, you may immediately recognize a tree, a chair, a view out of the window, or a plant that, because it is visually interesting and significant to your life experience, would make a great subject for a painting. If nothing jumps out at you immediately, just arbitrarily pick something you have lived with for five years

or more. Don't assign a great deal of significance to the first choice you make, as it may take several attempts before you find one range of subjects that offers the potential for a series of pictures.

Unfortunately, some people who take this approach do so in such a calculated and obvious way that the resulting pictures reveal nothing positive or unique about them as artists. Pictures of family quilts, childhood toys, and grandma's lace dress might seem perfect for an autobiographical painting, but unless they are arranged and presented to represent you, not some sentimental and generalized notion about personal history, the painting will become painfully trite. Here's where a series of drawings will help you reach that most personal level of expression. The quilt, or toy, or lace may need to be shown in an unexpected arrangement—or completely left out, if your preliminary studies tell you it is a potentially lethal subject to incorporate into a picture.

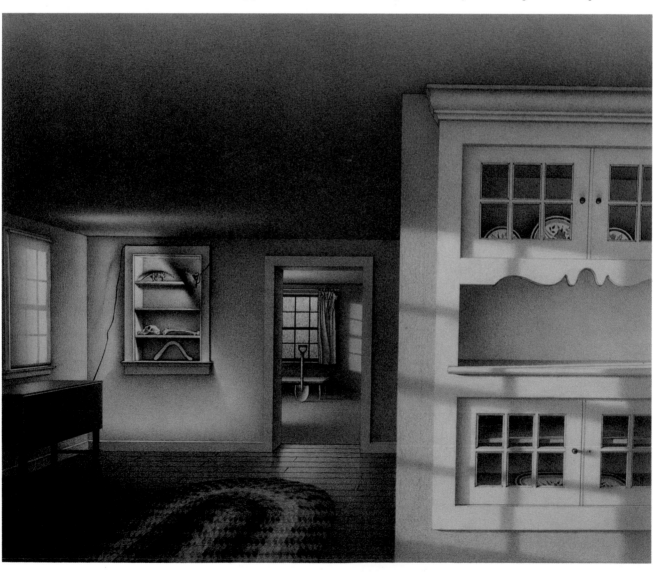

MARCH DIG (II)
1985. Mixed media,
21″ × 25″ (53.3 × 63.5 cm).
Collection of the artist.

MARCH DIG (I)
1985. Pencil, 21″ × 25″
(53.3 × 63.5 cm).
Collection of the artist.

*A photograph of the areas
of the living room and dining
room that Evans has used
as the basis of the drawing
and painting reproduced here.*

ELECTRICAL STORM
1986. Mixed media,
21″ × 25″ (53.3 × 63.5 cm).
Collection of the artist.

The photograph at right was taken from a slightly higher vantage point, but it gives an idea of the unspectacular entranceway to the house Rob Evans has been using as both the working environment and the subject matter of his recent drawings and paintings. In the case of the piece reproduced below, the angles of the door, walls, and window, as well as the strange play of lights, create a haunting feeling in the interior. The television set, which establishes a visual connection between the two rooms, also has a strange presence. The entire picture demonstrates how an artist can create a strong emotional response with an exactingly realistic depiction of a scene. At first glance we think the artist is giving us nothing more than a straightforward presentation of a scene, but we come to discover that he is creating a strong emotional response in the way he manipulates our perception of the subject.

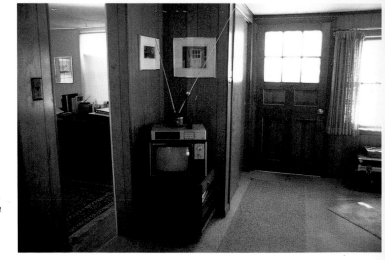

THE PATIO

1984. Mixed media, 17" × 21"
(43.2 × 53.3 cm). Collection of the artist.

Here we see the ordinary patio alongside Evans's house, first in a photograph and then in a painting. By simplifying the forms and illuminating them with the stark light attached to the porch, Evans has created a strange but appealing mood in this scene. The surface of the painting, which is difficult to appreciate in reproduction, is a richly textured combination of different drawing and painting materials. Evans spends long hours building up the surfaces of his paintings with colored pencils, watercolors, and gouache. He likes the resulting variety of tones and the rich texture of the paintings.

PAUL ORTLIP
Discovering New People and Places

While there are many artists who, like Rob Evans, only focus their attention on subjects from their immediate environment, there are also those who consider a portable paintbox to be their passport to the world outside their studio. The great nineteenth-century landscape painters, for instance, brought back the first glimpses of distant and exotic lands to the thousands of people who would have only heard of places like the Andes, Niagara Falls, and Morocco. With a few large canvases, these artists helped to give Americans a sense of pride in the country they were only beginning to know.

Today, artists routinely pack up watercolors, oils, or sketching tools and head for a nearby town or a foreign country to discover subject matter for their paintings. In part, the resulting pictures record the unique appearance of the site, but the best of them are created by artists who gravitate toward subjects that they have explored in other paintings. That is, an artist who is accustomed to painting the effect of light on a vast panorama of landscape is likely to explore those same effects in another part of the world. A painter who is intrigued by the people living in his or her hometown could be expected to paint people in any other part of the world.

While I would not expect any artist to be locked into painting the same limited range of subject matter no matter where he or she set up an easel, I would, however, be suspicious of someone whose travel paintings looked as though they were suggested by a guide for amateur photographers. If all I see are the most obvious tourist landmarks, or an inconsistent group of landscapes, figures, and still lifes that might have been done by twelve different artists, I tend to suspect that the artist is painting what the folks back home are expecting as a travel log of his or her journey.

Paul Ortlip, an artist who began traveling around the world with a sketchbook and set of watercolors as a young man, has developed both the techniques and the visual memory that allow an artist to recreate the beauty and unique character of distant lands. He has stacks of notebooks in his studios in Hackensack, New Jersey, and Highland Beach, Florida, all filled with pencil and watercolor sketches of boats, people, hillsides, street scenes, and beaches where he and his wife, artist Mary Krueger Ortlip, have traveled. As he flips through these sketches—some quick, gestural lines and others detailed studies—he can recall the circumstances that brought him there and the conditions that prevailed while he was drawing. Those aspects of the subject that first caught his attention—the lines in an old man's face, the subtle transition from sea to sky, the gnarled trees clinging to the side of a huge rock—are indicated well enough in the drawings that he can recreate them completely in his oil paintings.

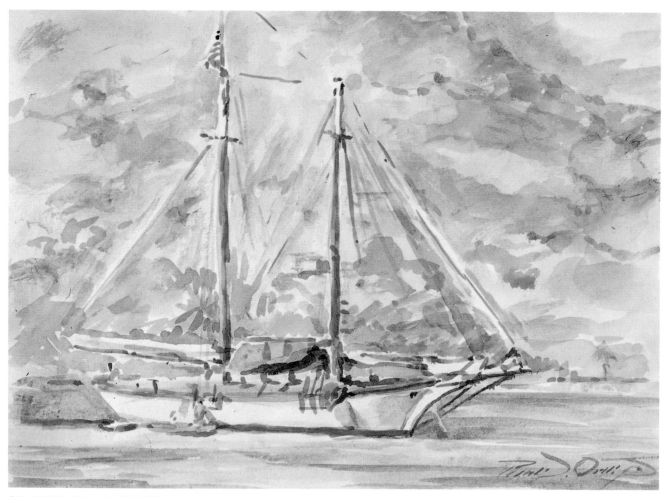

ON BOARD SHIP, ST. MARTIN'S 1983. Watercolor, 11″ × 15″ (27.9 × 38.1 cm). Collection of the artist.

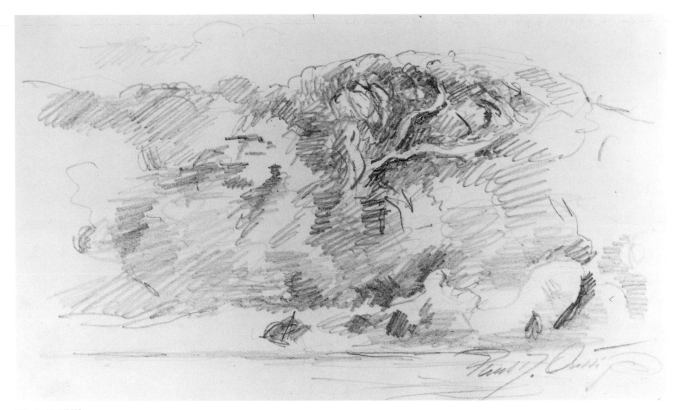

ST. MARTIN'S 1983. Graphite, 5¼″ × 8¼″ (13.3 × 20.9 cm). Collection of the artist.

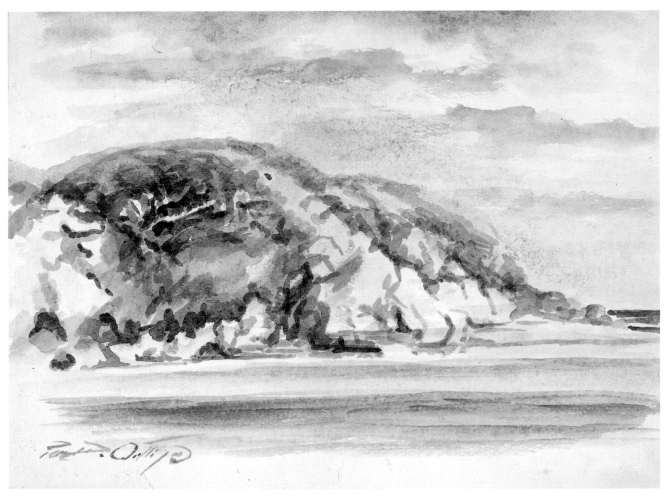

TORTOLIX, VIRGIN ISLANDS 1983. Watercolor, 9″ × 12″ (22.9 × 30.5 cm). Collection of the artist.

Demonstration

WORKING WITH HACKNEYED SUBJECTS

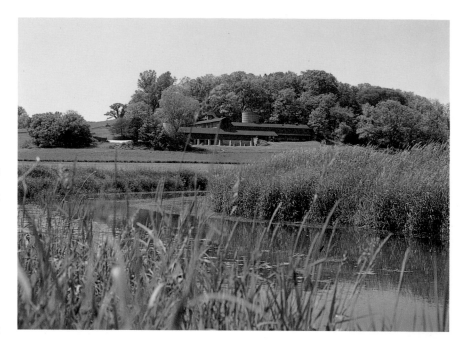

I was participating in a panel discussion and was asked what advice I might give to artists as a result of having served as a judge of a number of art exhibitions. I started listing the hackneyed subjects that appear in so many paintings, suggesting to the audience that they give up on painting those barns, crashing waves, daisies, and sunsets because a judge would be seeing so many such pictures that he or she would pass over all of them. I then felt the need to say that I understood why people were attracted to those subjects, so I used barns as my example of viable but overworked subject matter.

As I talked about a barn being an architectural form in the midst of a landscape; a red shape surrounded by complementary green shapes; a structure you can look into and through; and a simple geometric form, I began to interest myself in drawing or painting such a subject.

Fortunately for me, there was a most extraordinary barn waiting just down the road from the place where our discussion took place, and I had a couple of hours available to make the drawing you see here in stages of development. The barn is part of Taliesen, the home and studio of architect Frank Lloyd Wright.

As I worked on this drawing, I tried to think of the building as a collection of strong horizontal bands and small vertical markings rather than just a barn. I knew that I had to avoid the problem most barn paintings suffer from, which is that the building becomes a nostalgic symbol of a simplistic way of life. The viewer didn't need to know what the function of this building was, it seemed to me. The more it looked like an abstract form, the more likely it would be that the viewer could look at my drawing with a fresh vision and see *what I saw*, not what had been shown in a thousand other pictures.

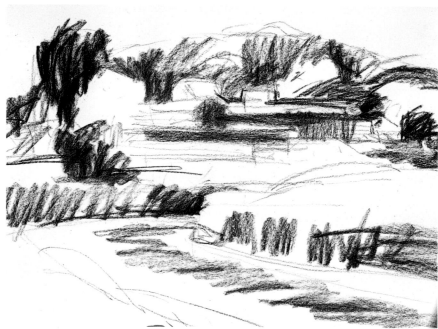

Blocking in the basic patterns of dark and light, with emphasis on the horizontal lines of the barn.

TALIESEN BARN
1986. Charcoal,
11″ × 15″ (27.9 × 38.1 cm).
Collection of the artist.

The charcoal has been smeared into the paper and additional layers have been applied to add depth and richness to the drawing.

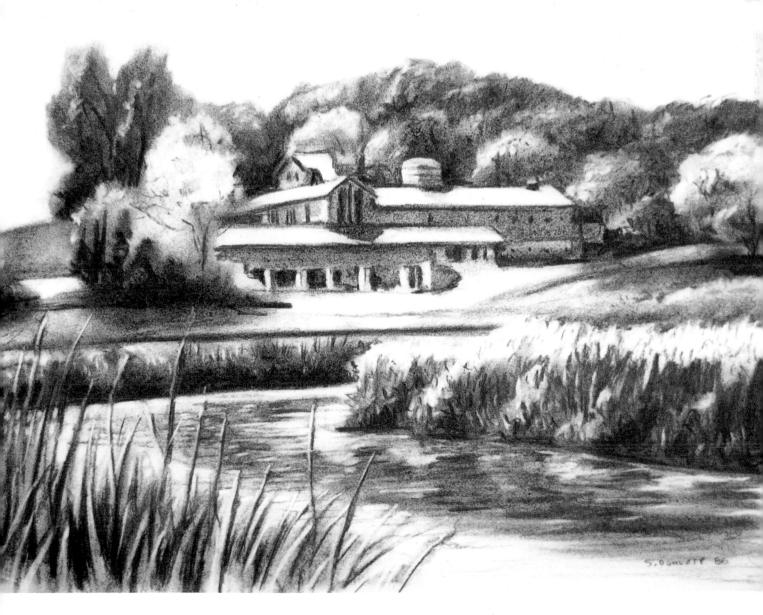

Using Photographs Advisedly

There are few issues more difficult for artists to sort out than the question of how they should or should not use photographs in the creation of artwork. I get a steady stream of "Letters to the Editor" at *American Artist* from artists who either condemn or support the use of photographs as source material by an artist. But the arguments contained in those letters often suggest the opposing point of view.

Those who are opposed to the idea point out the kinds of distortions that can occur and the tendency for an artist to concentrate on minutiae. Artists who are interested in working with those distortions or who want to incorporate the kinds of details the eye would otherwise overlook are often persuaded by those arguments.

Likewise, those who say the camera is a twentieth-century sketching tool suggest, by implication, that photographs are actually a crutch used by those who don't have the ability to draw. An artist who cannot draw is unable to edit the information presented in a photograph.

The fact is that the camera can be a very useful tool in the hands of an artist who understands its limitations and its potential. The potential is demonstrated quite clearly by artists like Robert Cottingham, Kent Bellows, and Dana Van Horn (all of whom are discussed elsewhere in this book). The glossy, detailed, high-contrast look of a photograph can be used to add a sense of heightened realism to a picture, or it can impose a very contemporary appearance on a subject that might otherwise appear dated.

Photographs can also allow an artist to continue developing paintings that were begun when the model was present. Portrait artists, for example, can seldom get their clients to sit for the hundreds of hours it takes to complete a large oil painting, so they rely on color sketches and photographs for much of their work.

But what exactly are the pitfalls of working directly from photographs? There are a number of key problems you should keep in mind when choosing to make extensive use of photographs in creating paintings or drawings.

COLOR DISTORTIONS

The most obvious thing an artist should consider is that photographic film cannot reproduce colors exactly as the eye perceives them in nature. There will always be some distortion, depending on the kind of equipment and film used in taking the photographs. Photographic prints, for instance, will always be less accurate than transparencies, and film not balanced for the specific lighting situation will produce gross distortions of the colors.

To compensate for this, many artists make quick color studies of the subject being photographed, or they bring some of the objects in the photograph into their studio when working on a painting. A flower brought in from the garden shown in the photograph will be a useful reference when trying to adjust for the color distortion.

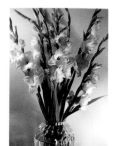
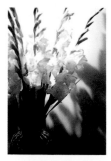
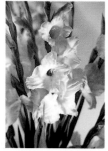
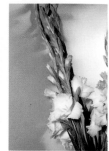
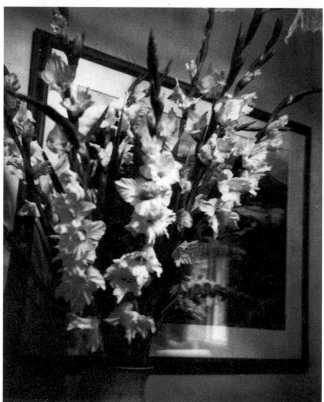

I took these photographs of gladioli with the idea that I might produce drawings similar to those I had previously done from life. As soon as the slides came back from processing I knew there was simply too much distortion in the appearance of the flowers for me to be able to respond with the same kind of drawings.

If you compare the charcoal drawing with the photographs, you can probably see the ways I consciously interpret the sensory information I receive as I sit in front of a bouquet of flowers. Seeing those forms changing over a short period of time causes me to respond in a particular way that I simply can't duplicate when working from a photograph.

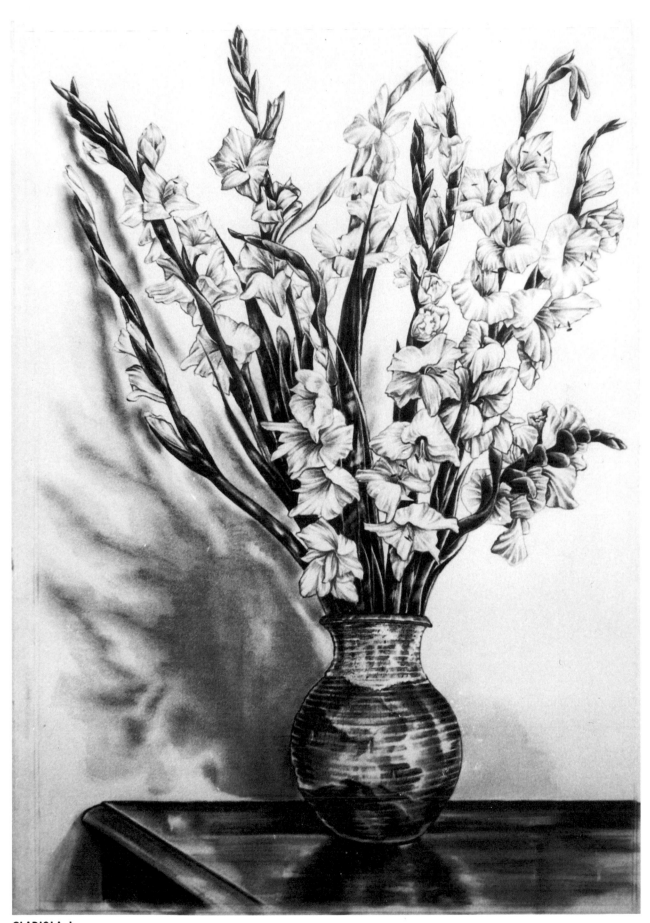

GLADIOLA I 1984. Charcoal, 32" × 21½" (81.3 × 54.6 cm). Collection of the artist.

VALUE DISTORTIONS

When you work directly from a subject, your eyes automatically adjust to give you the best perception of each part of the subject. The camera, by contrast, can only give you one exposure for each picture you take. So unless you make careful calculations and take dozens of photographs, you will wind up working from something that has generalized the way light defines the appearance of your subject. Some parts will be rich in detail, while others suffer from either overexposure or underexposure. Shadow areas and bright highlights tend to lack definition, while shapes composed of contrasting patterns of light are accurately recorded.

Many artists take three photographs of their subjects, at the exposure suggested by the light meter and at the *f*-stops just above and just below the first exposure. These artists will also take detail photographs of any area they know will lack definition in the overall pictures. As a result, they have several photographs that point out the value distortions.

LACK OF NATURALISM

Edgar Degas discovered that photographs offer a distorted view of life, and he was able to use that information to create a new compositional arrangement of forms within his paintings. Instead of following the old convention of placing his subject comfortably within the boundaries of the picture, Degas put the dancer or the jockey off to the side, leaving large portions of the painting empty. He was taking advantage of the fact that photographs offer an arbitrary and unbalanced presentation of a subject.

That fact is often lost on artists who try to transform a photographic record into a painterly image. They lack either the awareness or the skills that allowed Degas to use the photograph to his advantage. Instead, their paintings have a awkwardness that is almost comical.

The best solution to this problem is to make compositional sketches and studies from the photographs and then use those translations of the subject to make a painting.

GLADIOLA 2
1984. Charcoal,
21″ × 32″ (53.3 × 81.3 cm).
Collection of the artist.

ROBERT COTTINGHAM

Ideas with Career Potential

Great artists are often identified with artistic ideas they pursued throughout their careers, ideas that were often stated most clearly in paintings of the same or similar subject matter. Painters like Monet, Picasso, Caravaggio, and Lautrec painted the same landscape, the same model, or the exact same composition several times because it was a useful way of emphasizing their most important concerns. The repetition might have led to monotony, as it often does with lesser talents, but their ideas were important enough and the subject appropriate enough to be worthy of this approach.

Robert Cottingham is one contemporary artist who has been taking this approach to his work. He has been holding certain elements of his paintings constant while allowing others to change and, as a result, has brought emphasis to the most important aspects of his art.

Cottingham first gained public attention as one of the photorealist artists showing work in New York in the early 1970s. He and Chuck Close, Richard Estes, and a dozen other artists were given that label because they allowed their paintings to retain the appearance of the photographs used as subject matter. Cottingham made large, precisely painted pictures of theatre marquees, storefronts, and neon signs, usually cropped in such a way that the fragments of recognizable objects established a strong abstract pattern.

As often happens when any popular style emerges on the art scene, the most superficial aspects of Cottingham's paintings were used to lump him together with other so-called photorealist artists. The nostalgia associated with signage from the 1930s and 1940s and the precise rendering of those images led some to think he was offering glossy snapshots of Americana, rather than an original view of the American urban scene.

Fortunately, those who think artists are the same as fashion-conscious dressmakers moved on to some other interest while those who understood the significance of Cottingham's art continued to observe his developing work. In recent years, much of that work has been done in series where the same image, or a fragment of it, is presented at a different scale or with different painting materials or in a different composition.

SANTA FE 1987, Watercolor, 22¾" × 22¾" (57.8 × 57.8 cm).

SANTA FE
1987, Watercolor, 10¾" × 10¾"
(27.3 × 27.3 cm).

SANTA FE
1987, Watercolor, 10⅝" × 11"
(27.0 × 27.9 cm).

Cottingham became interested in the graphics on the sides of railroad cars. It turned out that one excursion to a local railroad yard opened up a whole new direction for the artist. Cottingham discovered that the signage had all the elements of a good composition, and the rough surface of the railroad cars allowed for the kind of painterly effects he was trying to incorporate into his recent paintings.

The three small works on paper reproduced here are among the first of Cottingham's explorations of railroad signage. They were followed by a series of enamel panels commissioned for a public space in Connecticut. Those panels record the logos of other railroad companies, graphic material that will likely be used in other paintings and prints.

NITE
1985. Gouache,
13" × 9¼" (33.0 × 23.5 cm).

NITE
1985. Watercolor,
13" × 9¼" (33.0 × 23.5 cm).

NITE
1985. Gouache,
13" × 9¼" (33.0 × 23.5 cm).

These three reproductions demonstrate the ways Cottingham has been using the same image to create completely different paintings. The subject, which indirectly pays homage to Edward Hopper's Night Hawks, *is presented in watercolor and gouache.*

For the watercolor, the paint was kept thin and complementary colors were used on top of each other so that the brushwork would be apparent. The combination of colors and loose brushstrokes causes the picture to vibrate.

The black, white, and gray gouache painting, by contrast, has a cold, crisp appearance owing to the thick, chalky surface of the paint. The clear distinction between the light, middle, and dark values that define the three major shapes of the painting gives a different compositional sense of the picture.

The fragment of the word "Hawks" is completely eliminated from the black-and-white gouache, as are a number of lines and patterns.

FIVE STUDIES FOR *O*

1986, Gouache and watercolor,
11¾" × 7¼"
(29.8 × 18.4 cm).

*The five studies reproduced
here document the kind of
careful analysis that goes into
the final composition of a Cot-
tingham print. They were done
in gouache, ink, and water-
color in an effort to arrive at
an arrangement of colors and
textures that would be appro-
priate for an etching. That
print was commissioned by the
Springfield Art Museum in
Missouri in connection with a
traveling exhibition of Cot-
tingham's prints that the mu-
seum organized.*

O

1986, Etching,
11¾" × 7¼"
(29.8 × 18.4 cm).

STAR

1985. Watercolor,
9¾″ × 9¾″ (24.8 × 24.8 cm).
Collection of the artist.

This neon sign has served as the subject of a number of Robert Cottingham's paintings and prints, some presented in a horizontal format and others in a square format, as in this watercolor. This recent depiction of the sign shows the artist's interest in letting the drips, dabs, and brushstrokes of the paint add texture and visual interest to the painting. The image is presented with as much care and precision as the earlier versions, but now the illusionary nature of painting becomes more apparent.

RIALTO

1985. Watercolor,
9¾" × 9¾" (24.8 × 24.8 cm).
Collection of the artist.

Theater marquees were among the first subjects to be presented by photorealist artists in the late 1960s and early 1970s. The dazzling use of neon to spell out words and create decoration, and the stylish use of enameled metal, made them attractive to artists like Robert Cottingham and Richard Estes.

The painting shown here updates a Rialto theater marquee that Cottingham used several times for paintings and prints. Like the Star *painting shown on the opposite page, it demonstrates the artist's recent interest in painterly surfaces.*

Finding Original Approaches to Common Subjects

When you walk through an exhibition of realist paintings trying to categorize the subjects artists have chosen, you can usually place most of the pictures within the categories of landscape, still-life, and figure painting. These are clearly the most popular subjects for artists, as they have been for decades.

An artist interested in working with the same common subjects obviously has lots of examples to study, but he or she also has the great challenge of trying to arrive at an approach that is original and personal. The challenge can be met if the artist can absorb and then filter the ideas explored by others to arrive at an approach that reflects his or her particular point of view. Instead of having to reinvent the wheel, as the expression goes, the artist has to design a new appearance for the wheel or roll an old wheel down a new path. The artists whose paintings are reproduced on the next few pages have successfully met the challenge just described, and they serve as useful examples for others who want to establish their own voice as artists.

One person whose landscape, figure, and still-life paintings have had enormous influence on other artists is Jack Beal. Through his lectures, writing, teaching, and—most of all—his artwork, he has convinced others that an artist does not have to abandon traditional realist subject matter in order to make contemporary works of art. In fact, he is bold enough to suggest that one good realist painter can do more to advance the course of art than a host of modernist artists.

From time to time, Beal has created paintings in series that revive long-neglected subject matter. For instance, in the late 1970s he did a series of paintings on the Virtues and the Vices. In 1987 he began a new series on the five senses, and the first painting of that series is reproduced here.

THE INTERRUPTION
by Dean Hartung, 1984.
Oil on canvas, 84″ × 35½″
(213.4 × 90.2 cm). Courtesy of
Sherry French Gallery, New York.

PENNSYLVANIA ARCH #2
by Dean Hartung, 1984.
Oil on canvas, 20″ × 30″
(50.8 × 76.2 cm). Courtesy of
Sherry French Gallery, New York.

Several dozen artists have worked with Jack Beal and his wife, the artist Sondra Freckelton, for extended periods of time. Some have served as apprentices, and others have attended workshops taught by the artists. Dean Hartung, whose paintings are reproduced on this page, worked with Beal on a large picture entitled The Painting Lesson *and attended a workshop at the Chateau de La Napoule in France with his wife, the artist Ellen Hutchinson.*

As you can see from the reproductions, Hartung's style of figure and landscape painting is similar to Beal's but remains uniquely his own. Both artists are very interested in and influenced by seventeenth-century Dutch painting and have discussed the virtues and values of art of "The Golden Age" at length. The interest in energetic paintings that tell stories reflects Beal's work (as well as the work of the Dutch masters), but the choice of subject matter and the organizational structure of the paintings are decidedly different. Hartung shows that an artist can work with the ideas expressed by other artists as a way of working toward a unique style of expression.

THE SENSE OF SIGHT by Jack Beal, 1986–87. Oil on canvas, 66¼″ × 48½″ (168.3 × 123.2 cm). Courtesy of Allan Frumkin Gallery, New York.

EDWARD SCHMIDT
Preparatory Studies

Edward Schmidt has been associated with the New York Academy of Art almost since its inception, and he continues to teach at the school. In recent years he has been directing the Academy's mural program and training and supervising young artists at the same time that he works on the commissions that come in from collectors, interior designers, architects, and real estate developers.

One recent commission came from the Loew's Giorgio Hotel in Denver, Colorado. As the drawings, preliminary color studies, and compositional sketches on these pages indicate, Schmidt developed these complex oil paintings by making studies of the individual figures and the groupings of these figures, as well as the incidental animals, trees, and still-life objects.

Comparing the early compositional studies to the charcoal drawings that followed, you can see the dramatic changes that occurred as Schmidt developed his ideas. The figures became more dynamic both in their individual gestures and in the way they occupied the pictorial space. As the work evolved from the charcoal drawings to the finished paintings, that space became cleanly divided by the stream of water that flows around the figure groupings.

The completed murals are masterful presentations of classical ideas that have relevance to contemporary life. These celebrations of beauty and revelry are far more appropriate for a modern hotel than the purely decorative abstract pictures one usually sees in such spaces.

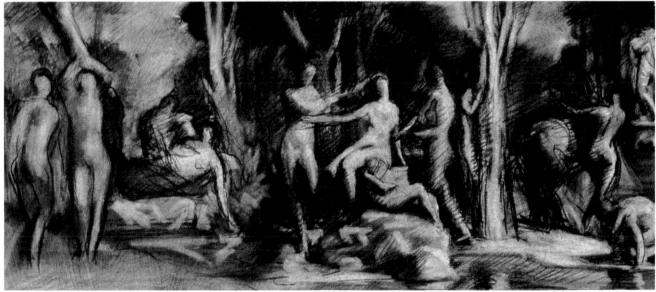

THE REALM OF BACCHUS
(top) drawing study, 1987. Charcoal,
9″ × 15″ (22.9 × 38.1 cm). Courtesy of
Robert Schoelkopf Gallery, New York.

THE REALM OF VENUS
(above) drawing study, 1987. Charcoal,
9″ × 15″ (22.9 × 38.1 cm). Courtesy of
Robert Schoelkopf Gallery, New York.

PASTORAL FRIEZE
(above left) early compositional study, 1987.
Oil on paper, 11″ × 28″ (27.9 × 71.1 cm).
Courtesy of Robert Schoelkopf Gallery, New York.

MYTHOLOGICAL SCENE
(left) early compositional study, 1987.
Oil on canvas, 14″ × 29″ (35.6 × 73.7 cm).
Courtesy of Robert Schoelkopf Gallery, New York.

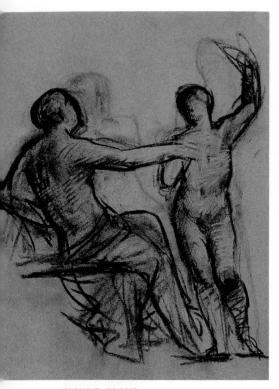

FIGURE GROUP

1987. Charcoal, 20″ × 14″
(50.8 × 35.6 cm). Courtesy of
Robert Schoelkopf Gallery, New York.

*The charcoal drawings and oil sketches
on these two pages were all done as
studies for portions of the large oil paint-
ings by Edward Schmidt that are re-
produced on pages 136 and 137. In
comparing these to the finished paintings,
you will find it difficult to locate the
figure or drapery for which these studies
might have been made. There are two
reasons for this. One reason is that an
artist such as Schmidt will make many
studies before deciding how to present the
figures in the painting; the other is that
an artist who has gone through the exer-
cise of painting drapery and flesh and
vegetation understands those subjects so
well that he or she can reinvent them
when working on the large canvas. That
is, once the artist understands how to
paint a convincing representation of
drapery, for instance, he or she can
rearrange it or invent new folds without
having to copy what was painted in the
studies.*

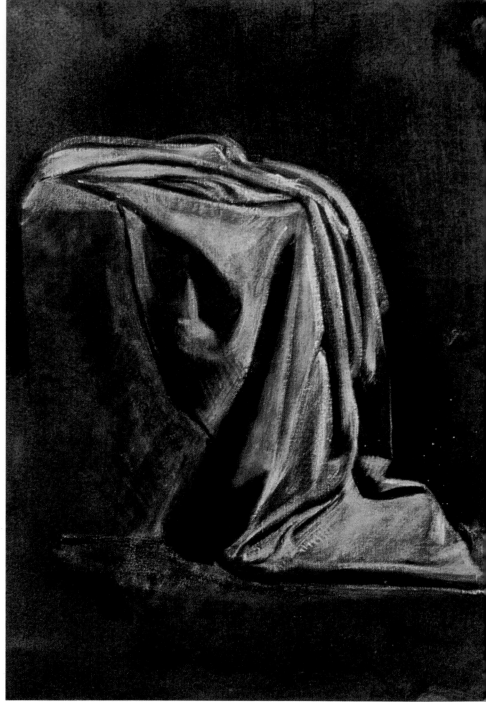

DRAPERY STUDY II

grisaille study, 1987.
Oil on canvas, 24″ × 18″ (61.0 × 45.7 cm).
Courtesy of Robert Schoelkopf
Gallery, New York.

HEAD OF NYMPH I
grisaille study, 1987.
Oil on canvas, 14″ × 18″ (35.6 × 45.7 cm).
Courtesy of Robert Schoelkopf
Gallery, New York.

HEAD OF NYMPH II
grisaille study, 1987.
Oil on canvas, 14″ × 18″ (35.6 × 45.7 cm).
Courtesy of Robert Schoelkopf
Gallery, New York.

HEAD OF NYMPH III
study for Bacchus mural,
oil on canvas, 11″ × 15″ (27.9 × 38.1 cm).
Courtesy of Robert Schoelkopf Gallery, New York.

VIEW OF FLORENCE
Oil on canvas glued to wall,
84″ × 78″ (213.4 × 198.1 cm).
Collection of Loew's Giorgio Hotel.

THE REALM OF VENUS
(above left) 1987. Oil on canvas,
7′ × 16′ (213.4 × 487.7 cm).
Collection Loew's Giorgio Hotel,
Denver, Colorado.

THE REALM OF BACCHUS
(left) 1987. Oil on canvas,
7′ × 16′ (213.4 × 487.7 cm).
Collection of Loew's Giorgio Hotel,
Denver, Colorado.

DANIEL DALLMANN
Building Symbolism Within a Painting

Art historians speak of the iconography of objects when they explain the symbolic meaning of their appearance in paintings. While the concept applies quite clearly to historical religious paintings, for instance, it can become a matter of speculation with contemporary painting where the symbolism depends on the artist's conscious and/or inadvertent use of those objects. With Picasso's famous *Guernica*, for instance, the symbolic references to the events of the Spanish Civil War are quite clear, while Salvador Dali's repeated use of limp clocks is less certain.

Daniel Dallmann is one artist who expresses ideas by building up symbolic relationships between people, objects, and spaces. This is especially clear in a series of drawings and oil studies that led to a large painting entitled *Corymb*.

The impetus for the painting was the definition of the word "corymb." As Dallmann explains: "the key to this painting is the definition of Corymb: a cluster of fruit or flowers in which the flower stalks arise at different levels from the main axis but reach approximately the same height. That started me thinking about relationships between people who are very different from one another but who seem to have some basic bond—a natural tendency to reach a spiritual closeness through family or friendship.

"I began making small sketches to excite my imagination and to suggest ways of presenting the idea," Dallmann goes on to explain. "There were probably forty or more sketches scattered over pages in my notebook, each one exploring various combinations of figures and environment. It was at this point that I began to identify some of the important elements: the relationship between the figures, the sense of unity and support, the pregnancy, the song (or poem), and the corymb symbol itself. All of these expressed closeness, friendship, and sup-

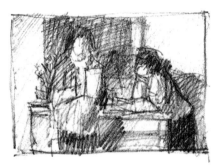

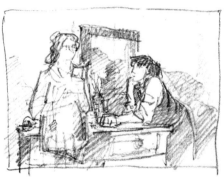

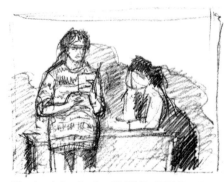

Notebook Studies for *CORYMB*, 1987. Pencil, 8″ × 10″ (20.3 × 25.4 cm).

port yet exposed the contrasts and differences accommodated by this trust."

Dallmann continued with studies of live models in an effort to better define the poses, gesture, and proportions that supported his idea. The refined studies were then enlarged by a grid system to a scale approximately 20 percent larger than life size. The model was again used as the form, lighting, and facial expressions were resolved in these larger drawings. Before they were finished, however, the artist began painting both oil studies and the preliminary stages of the large oil painting. "I do not paint *from* the drawings and oil studies but rather find it helpful to paint *along with* the drawings and studies on paper. This means that discoveries made in the studies can be quickly integrated into the structure of the painted image. Indeed, if I run into a problem with the painting, I often turn to the drawing to continue exploring until I find a solution." The oil studies on paper are done about the same time Dallmann is "still scrubbing in the value distribution with some lean pigment, usually a combination of Venetian red and chromium oxide green. The purpose of the studies is to help determine the palette, as each model has a different complexion, coloring, and lighting. The figure on the left is closer to the natural light from the window, while the figure on the right is illuminated by an artificial interior light. I had to adjust the flesh tones for each situation."

In explaining the final presentation of his ideas, Dallmann points out that "the superficial differences of fashion, coloring, gesture, activities, are contrasted with the more fundamental similarities of ritual and purpose (the book, the performance), and the common bond of gender and, more specifically, childbearing." All of those elements become symbols or suggest the theme of the painting.

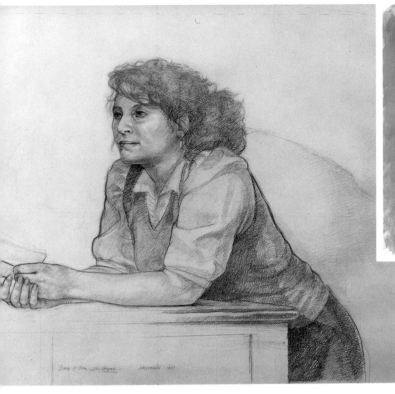

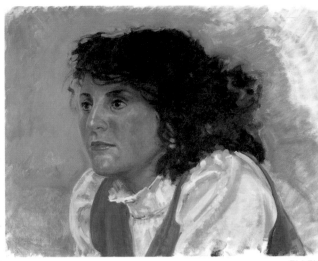

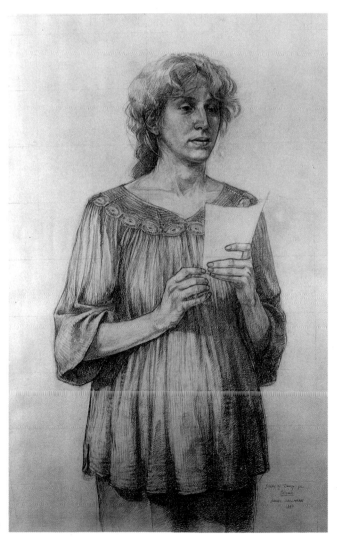

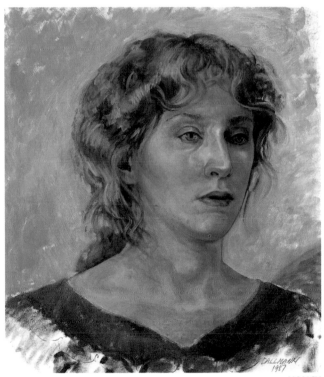

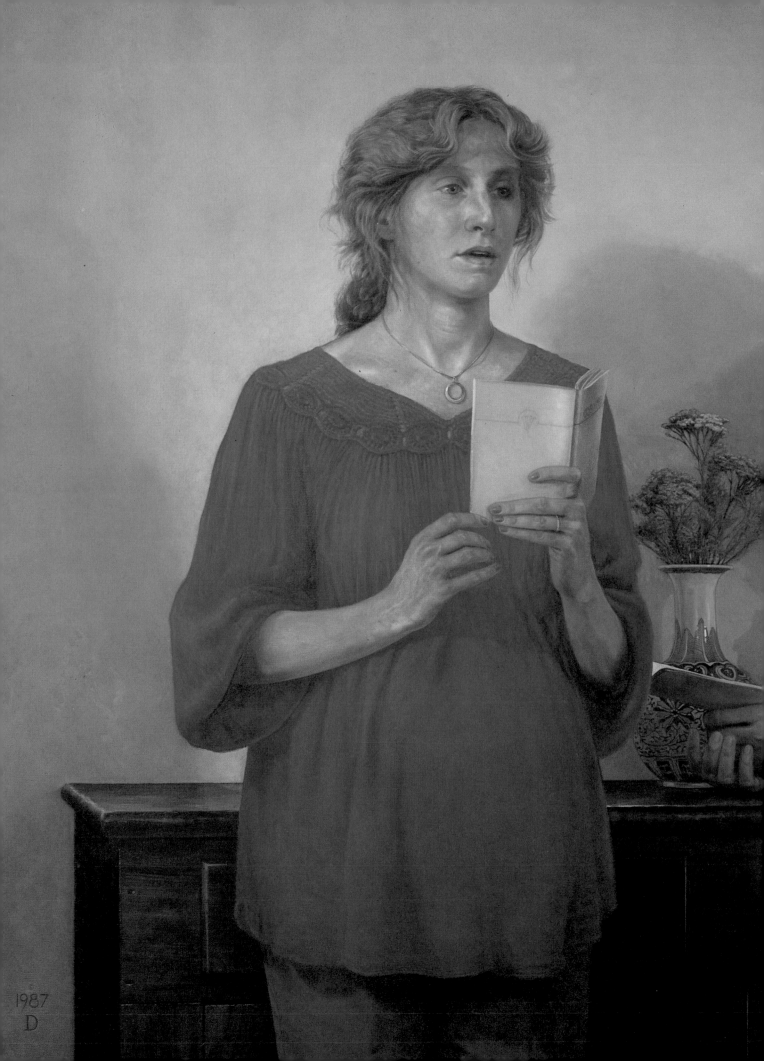

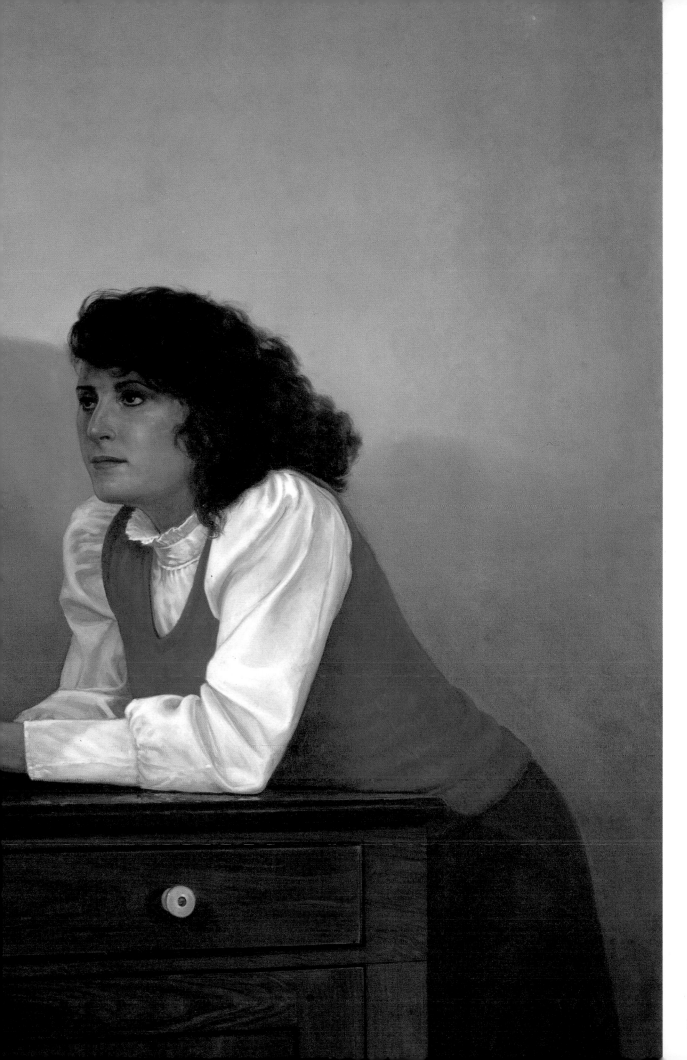

NEIL WELLIVER
Using Nature as a Source of Ideas

While many artists indicate that they draw their inspiration directly from nature, the manifestations of those inspirations are as varied as the artists themselves. Some feel a responsibility to create a literal record of what nature has presented. They must be faithful to the habits of animals and to the changes of the days and seasons. Others believe that making art is a process of adding their emotional and intellectual response to the visual perception of nature. These artists believe that, like poets, they must suggest as much as they state in their artwork.

One of the most notable examples of a painter who begins with a careful observation of nature is Maine artist Neil Welliver. While his large oil paintings owe as much to the influences of abstract painters as they do to Mother Nature, he is clearly an artist who observes and celebrates the changing appearance of the landscape around him.

One particular location caught Welliver's attention fifteen years ago and he recorded it in quick sketches. He went back to that small marsh in 1985 and 1986 to make oil studies of the conditions that existed on particular days. Those studies became the basis of a series of paintings and a woodcut print that were included in an exhibition at Marlborough Galleries in New York in 1987. Six of the oil paintings are reproduced here to demonstrate that nature can offer specific information about light and form and at the same time allow an artist to become immersed in the physical act of making a painting.

Because these reproductions are such a tiny fraction of the actual size of the canvases, it is difficult to see that Welliver works with a limited palette and fairly uniform strokes of paint. Standing up next to one of these canvases, an observer is less conscious of the picturesque scene because he or she barely perceives twigs or water or blades of grass. Instead, there is a rhythm of repeated colors applied to the canvas with uniform strokes. The artist has made little effort to disguise his actions, as many landscape painters might. Instead, he has made those actions the focus of our attention when we look at his work.

When asked why one of these six paintings is larger than the others, Welliver replied that he had to make the painting large enough so that the brushstrokes indicating the snow flurries could be made larger. "If I had painted them smaller, the brushstrokes wouldn't be significant enough," he explained.

LITTLE MARSH/HALF SHADOW
1985. Oil on canvas,
60" × 60" (152.4 × 152.4 cm).

LITTLE MARSH/LAST SNOW
1985. Oil on canvas,
60" × 60" (152.4 × 152.4 cm).

LITTLE MARSH/AUTUMN
1986. Oil on canvas,
60" × 60" (152.4 × 152.4 cm).

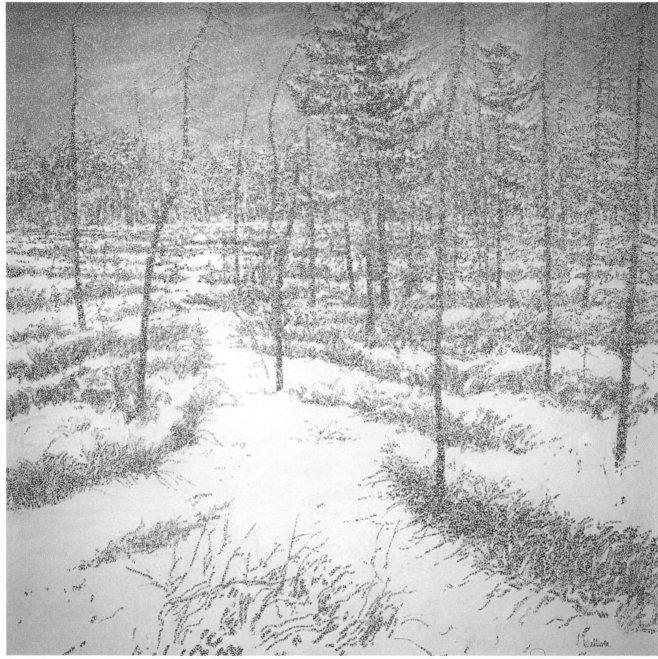

All paintings courtesy of Marlborough Galleries, New York.

LITTLE MARSH/FLURRY
1986. Oil on canvas,
96" × 96" (243.8 × 243.8 cm).

LITTLE MARSH/SPRING
1986. Oil on canvas,
60" × 60" (152.4 × 152.4 cm).

LITTLE MARSH/SUMMER
1986. Oil on canvas,
60" × 60" (152.4 × 152.4 cm).

INDEX

Page numbers of illustrations are in italics